World of Art

Belinda Thomson is an independent art historian pecca and in nineteenth and early twentieth-century French art. Sha had published widely on Impressionist and Post-Impressionist topics, including *The Post-Impressionists* (1983); *Vuillard* (1988); *Gauguin by himself* (1993); *Impressionism, Origins, Practice, Reception* (World of Art, 2000). Exhibitions she has curated or co-curated include 'Vuillard' (1991–1992) and 'Bonnard at Le Bosquet' (1994) for the South Bank Centre; 'Patrick Geddes, The French Connection' (2004) and 'Gauguin's Vision' (2005) for the National Galleries of Scotland; and 'Gauguin, Maker of Myth', for Tate Modern and the National Gallery of Art, Washington (2010–2011). In 2011 she was awarded an honorary professorship in history of art at the University of Edinburgh and in 2013 the distinction of *Chevalier dans l'Ordre des arts et des lettres*

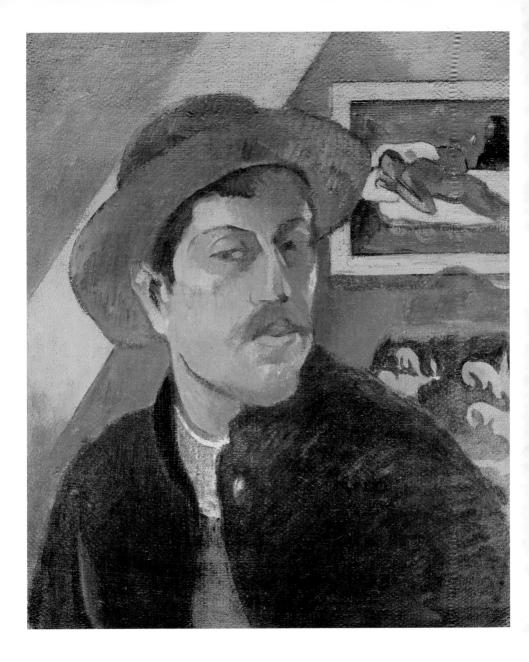

World of Art

Gauguin Belinda Thomson

New edition

For Richard

Acknowledgments

I should like to thank the staff of the following museums, art galleries and libraries for facilitating my research for this book: Department of Prints and Drawings, The British Museum, London; Musée Fabre, Montpellier; Cabinet des Dessins, Musée du Louvre, Paris; Museum of Fine Arts, Boston; Fogg Museum, Cambridge, Mass.; John Rylands Library, Deansgate, Manchester; Manchester Metropolitan University Art Library; The Open University Library; Witt Library, London. I am grateful to many other scholars of the period, in particular to those who have answered queries and provided help: Janine Bailly-Herzberg; Richard Brettell; Gloria Groom; Christopher Lloyd; Barbara Shapiro. A debt of thanks also goes to my family, to my parents and parents-in-law for enabling the research to be done and, last but not least, to my husband, for sharing ideas and discoveries, reading the manuscript with a critical eye and offering unstinting encouragement.

First published in 1987 in the United Kingdom by Thames & Hudson Ltd, 181A High Holborn, London WC1V 7QX

www.thamesandhudson.com

First published in 1987 in the United States of America by Thames & Hudson Inc., 500 Fifth Avenue, New York, New York 10110

www.thamesandhudsonusa.com

Gauguin © 1987, 2019 and 2020 Thames & Hudson Ltd, London Text by Belinda Thomson

This new edition 2020

Art direction and series design: Kummer & Herrman Layout: Kummer & Herrman

All Rights Reserved. No part of this publication may be reproduced or transmitted in any form or by any means, electronic or mechanical, including photocopy, recording or any other information storage and retrieval system, without prior permission in writing from the publisher.

British Library Cataloguing-in-Publication Data A catalogue record for this book is available from the British Library

Library of Congress Control Number 2019954887

ISBN 978-0-500-20471-9

Printed and bound in China through Asia Pacific Offset Ltd

Contents

6	Introduction		Chapter 5
		122	The Search for the
	Chapter 1		Primitive
10	The Part-Time Painter		(1891–1893)
	(1848–1884)		
			Chapter 6
	Chapter 2	156	Confronting the Public
31	The Full-Time Painter		(1893–1895)
	(1885–1888)		
			Chapter 7
	Chapter 3	178	Definitive Exile
55	Collaborative Experiments (1888)		(1895–1903)
		204	Conclusion
	Chapter 4		
80	Leader of the Symbolists	206	Appendix to the New Edition:
	(1889–1891)		Gauguin research since 1987
		210	Select Bibliography
		213	List of Illustrations
		221	Index

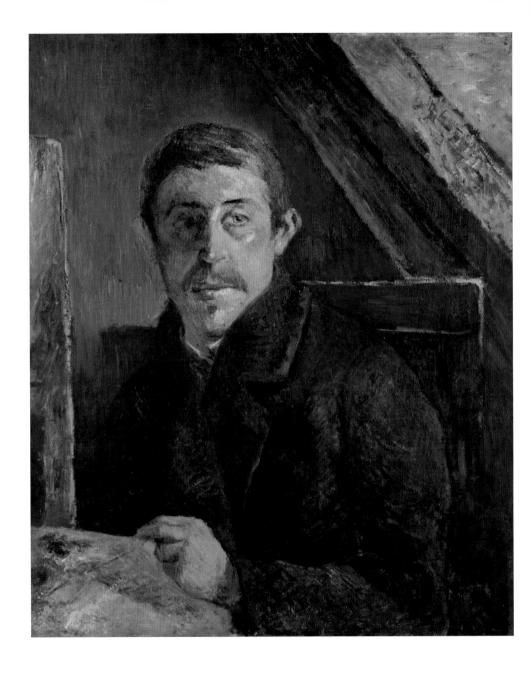

Introduction

Paul Gauguin made it his business to achieve a high public profile during his lifetime and was one of the first independent artists of his generation to gain international recognition. But his prominence has probably always had as much to do with the dramatic events of his life as with the appeal of his art. Gauguin's flight from European civilization to take up a primitive existence in Tahiti became legendary; indeed, it did much to fuel the myth of the artist as tortured soul, destined to be misunderstood and to live outside the bounds of civilized society. Gauguin himself was well aware of the advantage such personal notoriety could have for his work. It did not much seem to matter that his behaviour and character were censured rather than praised; the important thing was to be talked about.

188

'Where does the execution of a picture begin and where does it end?' Gauguin was prompted to ask this question about his own monumental canvas D'Où venons-nous? Oue sommesnous? Où allons-nous? of 1897. In a sense, it is a question that dominates this book. Few artists have been so unwilling as he was to allow their works to take their chances in the world, or been so keen to control the ways in which they were understood. In many instances, Gauguin's creative influence continued, in the form of changes to a title or authoritative written exegeses, long after a work had left his studio, and he often intervened in the equally important stage of public reception and critical interpretation. I have taken the view that the words surrounding his works of art are as vital to our understanding of Gauguin as the works themselves; only by attending to them both can we hope to evaluate the meaning and importance he wanted to have and could have had for his own time.

For the historian, Gauguin's unfortunate knack of making enemies of formerly faithful friends and admirers means that the copious documentation surrounding his life's work is more than usually riddled with misrepresentations and halftruths, and needs to be sifted carefully. Indeed, his life and work are full of contradictions. He had been a devoted husband and father but scarcely saw his wife and children for the last eighteen years of his life. He had been a wealthy stockbroker and patron of the arts but then chose the impoverished existence of an artist at the mercy of the buyer's whim. Though a profound admirer of the classical tradition, he uprooted himself from his cultural origins and exiled himself from his contemporaries and public on a remote South Sea island. The explanation for this series of paradoxes and self-denials does not lie with Gauguin alone. It has as much to do with the complex set of circumstances in which he and all other artists of the late nineteenth century found themselves, as soon as

3 Pastorales Tahitiennes, 1892

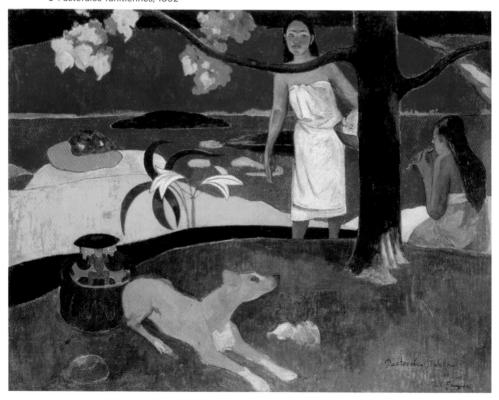

they attempted to work outside the limitations imposed by the institutions and academic conventions of their day. But Gauguin promoted the notion that within him, and outside his control, two diametrically opposed natures co-existed, the 'sensitive man' and the 'savage'. If the former side was to the fore in his early years, later on it was by cultivating his 'savage' nature that he felt able to forge ahead on his chosen 'primitive' path, hardening him against emotional and material sacrifices. He was fond of quoting Degas, who, prompted by seeing the first collection of brilliantly coloured paintings and strangely 'barbarous' carvings Gauguin brought back from Tahiti in 1893, likened him to the 'loup maigre' of La Fontaine's fable, the wolf who is prepared to starve rather than suffer the indignity of a collar and chain. It was a powerful image, but it distorted the realities of Gauguin's existence and as an explanation for his character and motivation is seriously deficient.

Any assessment of Gauguin's contribution to the history of art needs to account for the divergence of views expressed by his contemporaries. On the one hand, artists such as Claude Monet, Camille Pissarro, Paul Cézanne and Paul Signac looked on Gauguin with suspicion, variously dismissing him as a charlatan, opportunist and plagiarist; on the other, artists such as Edgar Degas, Aristide Maillol and Maurice Denis, not to mention a whole range of lesser-known disciples, including the so-called Pont-Aven group, admired Gauguin's work wholeheartedly, hailing him as the initiator of a formal and decorative revolution. Indeed, almost before Gauguin's death the first signs of that revolution were making themselves evident in the work of the rising avant-garde grouped round Henri Matisse, while the renovation of classicism, signs of which had been detected in Gauguin's later work, became a reality between the two world wars. He is proving to have new lessons to teach in the twenty-first century, beyond the liberation of form and colour from obedience to nature that was judged by modernist critics to be his most important legacy to the twentieth century. But in investigating, from our own standpoint, the significance of Gauguin's art and life, we should never lose sight of the particular and limiting historical factors that determined his ways of seeing.

Introduction 9

4 Mette Gauguin en robe de soir, 1884

Chapter 1 **The Part-Time Painter**(1848–1884)

When in 1873 Mette Gad, a young Danish woman 'sans profession', married Paul Gauguin, a stockbroker's junior in Paris, she knew nothing of his artistic leanings. So, at least, she was to claim in later years. As far as she was aware, she was marrying an independent man of twenty-five who had spent five years at sea in the merchant navy and now looked set on a promising career in finance. The wedding was a quiet affair in the town hall of the ninth arrondissement, followed by a blessing in the Lutheran church to which Mette, as a Dane, owed allegiance. No members of either family appear to have been present, both parents of Paul Gauguin having died, and the bride's mother deciding to remain in her native Copenhagen. Instead, the witnesses were Gauguin's employer Paul Bertin, a secretary from the Danish consulate, Gauguin's legal guardian Gustave Arosa, and the latter's aged father. It was probably the Arosas who offered hospitality to the newlyweds, much as they had provided the introduction and social setting for their courtship.

Cultured and comfortably off, Gustave Arosa was a successful stockbroker who had built up a substantial art collection of recent and contemporary paintings, including works by Delacroix, Corot, Courbet and Pissarro. His house in the rue Bréda drew together a varied circle of artistic figures. Whether Mette had really gained no inkling of her future husband's interest in this collection, nor of his own amateur attempts at drawing and painting, seems doubtful. In any event, she was probably warned that she was taking quite a risk in marrying a foreigner of whose family and background she knew so little. A francophile and linguist who greatly enjoyed the life of Paris, Mette Gad had a character as strong and independent as Paul Gauguin's, and it seems likely that at the

age of twenty-three she saw this marriage as a way of breaking out of the confines of her bourgeois Danish upbringing.

From letters written to Mette in 1873 by Marie Heegaard, her close friend and travelling companion, Paul Gauguin emerges as a sociable, amusing and eligible catch, somewhat lacking in social graces, but evidently making efforts to overcome his uncouthness. Some years later, however, with less amusement, Mette described him as 'mal élevé', badly brought up, a failing she was by then anxious to avoid reproducing in her own children.

Gauguin's childhood, and that of his mother before him. would nowadays be considered dysfunctional. He had never known the security of family life or a stable home, even from his earliest years, for his father, Clovis Gauguin, a republican journalist, died on board ship while taking his young family into political exile in South America. Paul Gauguin, born in 1848, was just two when they reached Peru and he spent four years there, with his mother and sister, under the protection of distant relatives. By the time he was seven, he and his family were living back in France, under the wing of a bachelor uncle. Gauguin attended schools in Orléans, boarding at a Jesuit seminary until he was fourteen, and then a pre-naval college in Paris. He was given a sound education with a strong emphasis on the classics and literature, a love of which was to manifest itself in his work both as an artist and a writer. Gauguin later remembered his brief childhood spell in Peru as a brilliantly colourful, haunting paradise. But the uncertainty of his mother's social and financial position, the need to gain acceptance from strangers and the experience of two lengthy sea voyages before Gauguin was seven were not promising foundations for a later life of solid bourgeois domesticity.

Aline Gauguin, née Chazal, Gauguin's mother, despite later considering commerce beneath her son, was forced to earn their keep by dressmaking in Paris. (She was fondly commemorated by her son in at least three paintings.) She had spent much of her youth in boarding schools, away from her own ill-matched parents who were separated and at loggerheads. Her mother, Flora Tristan, in whose care she ostensibly was until 1844, was too busy making her fortune as adventuress, and then her reputation as political activist, to provide a home for her daughter. A strange and lonely upbringing it must have been for Aline, to be fought over in successive legal battles and, in 1838, to see her father André Chazal, to all intents and purposes a mild-mannered printmaker, imprisoned for twenty years on an unproven and dubious charge of attempting to murder his wife. If Paul

5, 6, 117

5 La Mère de l'artiste, c. 1889

Gauguin knew that his maternal grandfather, from whom he may have inherited his artistic leanings, had served time from 1839 to 1855, and the reason for it, one wonders what effect the knowledge had on him. Certainly, he never mentioned it in his copious autobiographical writings, though he clearly found his maternal grandmother, whom he described as an 'anarchist blue-stocking' who 'probably didn't know how to cook', an intriguing figure; one suspects he admired her unconventional

style of life, her preparedness to follow the course in which she believed rather than simply obeying the demands of family and society. More doubtful is how far he shared her political views, her historically precocious feminism and her passionate championing of the cause of the workers. Although Gauguin was by choice and family tradition a republican, it may be that the experience of a privileged, almost aristocratic, life in Peru, followed by the usual difficulties of gaining acceptance as an artist, led him later, albeit with tongue in cheek, to hanker after an absolutist régime, a patriarchal society, in which the artist was protected, instead of the democratic system in which talent was fatally neglected.

Gauguin was sufficiently attached to the memory of his parents to name two of his children after them: Aline, his only and much-loved daughter, born in 1877, and Clovis, his second son, born in 1879. Yet his relations with his mother seem to have been somewhat stormy. She died in 1867 and in her will named Gustave Arosa as guardian of her two children, stated her desires concerning the education of her daugher Marie,

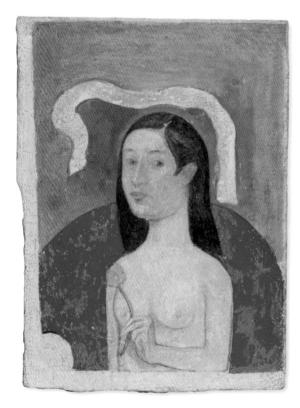

6 Portrait of the Artist's Mother (Eve), 1889–90

and effectively washed her hands of her son's future: 'He'll have to make his own way, for he has shown himself so little able to endear himself to all my friends that he's going to find himself very much abandoned.' Evidently, Gauguin came to feel that this tough approach had done him no harm, indeed that he had positively benefited from making his own way as a merchant seaman. Once his eldest son Emil reached the age of eighteen, he argued that he should be left to fend for himself, a course that was totally opposed by his wife, who did all in her power to ensure that her eldest son obtained a good position in his chosen career of engineering.

In view of his unusual family history, though it was tempered by the more sober influence of his father's side, perhaps it is misleading to think of Gauguin as a model family man who unexpectedly and inexplicably kicked over the traces of bourgeois life. It would be more accurate to see the brief ten-year period of settled and comfortable family life in Paris, between 1873 and 1883, as marking a hiatus in a life of upheaval, uncertainty and displacement. Gauguin may have been more at home in the company of painters than he had been with high financiers, but he was referred to frequently by artist contemporaries in Paris as an awkward, meddlesome outsider who had never lost the restless, roving outlook of the sailor.

Helped, no doubt, by the influential Arosa, and equipped with the necessary skills to succeed on the stock market, Gauguin rose quickly in the various finance firms that employed him. His succession of jobs, beginning in 1877, is now thought to have been deliberate, however, to gain more time to pursue his growing passion for painting. As well as attending evening life classes at the Académie Colarossi, from the time of his marriage in 1873 Gauguin devoted his Sundays to plein air painting rather than to the more conventional gambling or womanizing, as he later ironically reminded his wife. Certainly, he seems to have been painting landscapes with confidence from at least as early as 1873, as shown by the date on the Fitzwilliam Museum's Paysage. Like many painters of his generation, he recognized the current strength of the French landscape tradition; his broadly treated views, the Fitzwilliam one possibly a panorama overlooking an estuary, suggest a general awareness of Camille Corot and a more particular understanding of Henri-Joseph Harpignies. Gauguin's Paysage avec peupliers (1875) recalls another Barbizon painter, Narcisse Diaz. The acceptance and favourable critical mention of a still unidentified Paysage by Gauguin at the Salon of 1876 must have done much to kindle his artistic ambitions and shows how

8

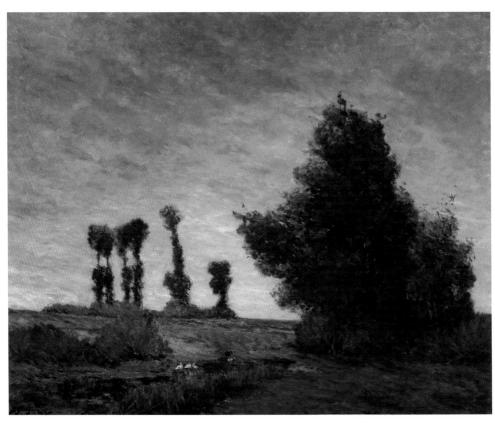

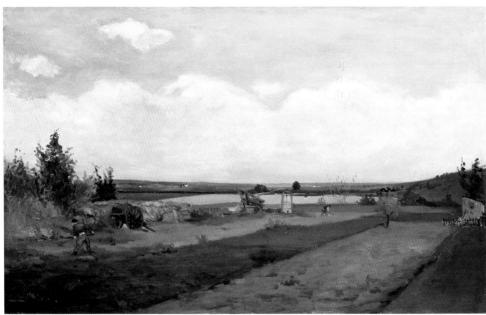

soon he achieved a level of competence within the somewhat conservative conventions of the day.

At about this time, however, Gauguin was becoming aware of the Impressionist group, who were introducing important changes to the landscape genre by their use of a palette exclusively made up of light tones, their freer paint handling and their more informal settings. Gauguin could have seen their works, which were exhibited regularly in Paris from 1874 onwards, and his assured and sizeable suburban landscape Les Maraîchers de Vaugirard (1879) shows that, although he was still an amateur, he had moved beyond his exploration of standard and acceptable landscape motifs, just as had the Impressionists. He was now set on a course of independent painting that would henceforth lead him to disdain exhibiting at the official Salon.

By 1879 Gauguin had begun to follow his guardian's example of investing in contemporary works of art, partly, no doubt, because he firmly believed they were important and undervalued, and partly because he needed constant access to examples of Impressionism from which to learn. Building on an already developed taste for the naturalistic Barbizon landscape tradition, which was well represented in Arosa's collection, Gauguin primarily offered his patronage to the less commercially successful landscape Impressionists Armand Guillaumin, Cézanne and Pissarro. It is thought that Gauguin was first introduced to Pissarro at Arosa's house some time in the early 1870s. In any event, by 1879 Gauguin was simultaneously playing the roles of pupil, patron and dealer to Pissarro, receiving some sort of informal instruction in painting from the elder painter, acquiring occasional works himself and looking out for potential buyers among his stockmarket acquaintances, thereby supplementing or by-passing the efforts of Pissarro's dealer, Paul Durand-Ruel, Gauguin's income in 1879 seems to have been very comfortable and his future as a collector probably looked rosy. Although of very different temperaments, Gauguin and Pissarro were to maintain this mutually beneficial relationship until artistic and personal disagreements began to drive them apart during 1885 and 1886. Thus if any one person could take the credit for actively encouraging Gauguin's artistic ambitions at the outset it was Pissarro, as Gauguin acknowledged on the eve of his death. Thanks to Pissarro's intervention, Gauguin was invited to participate in the Impressionist group's fourth exhibition

⁷ OPPOSITE TOP Paysage avec peupliers, 1875 8 OPPOSITE BOTTOM Paysage, c. 1873

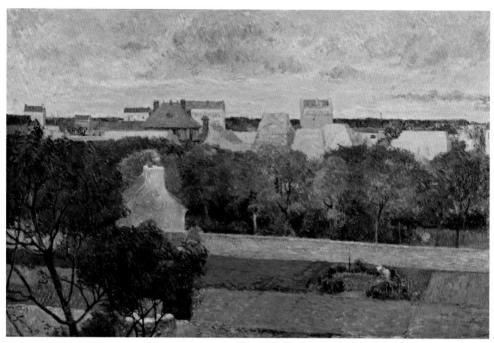

9 Les Maraîchers de Vaugirard, 1879

in April 1879, and although his submission was too late to get into the catalogue (he figured instead as the owner of three Pissarros), it nevertheless showed a certain unorthodoxy, or perhaps simply a desire to attract attention on the artist's part. He sent in a piece of sculpture, a marble bust of his son Emil.

In Les Maraîchers de Vaugirard, Gauguin was painting the view from the first floor of his own house in the impasse Frémin. It would have been almost unthinkable to seek out such an unpromising location, with its high horizon, blankedoff horizontal planes and mere glimpses of an unpicturesque roofscape. The authority for tackling just such a view clearly came from the Impressionists, and more specifically from Pissarro, who had been painting similar working landscapes round his home town of Pontoise for a decade. The broken. fussy brushwork was a new feature in Gauguin's search for an appropriate style, though he also used strong, unvariegated and somewhat acid expanses of green, setting them off with smaller areas of complementary orange-red. Seen as a stage in a learning process, it is less a study of light and atmosphere than an attempt to vary his paint handling by a lighter, more flexible touch and to modernize his landscape settings, to address the

suburban motif which was coming to be recognized as the hallmark of landscape Impressionism. In other landscapes done at this period, his preoccupation seems to have been increasingly to capture minute changes of colour, judging from the picture notes he made on a preparatory drawing for a nocturnal landscape of 1881. By trying at this time to attune his eye to Impressionist concerns for the evanescent effect, in *Les Pommiers de l'Hermitage*, for instance, or *La famille du peintre au jardin, rue Carcel*, Gauguin's compositions, like Pissarro's, began to suffer from a loss of focus, and the paint texture became somewhat dense and cluttered.

13, 14

11

An awareness of such shared problems no doubt led Gauguin and Pissarro to take a keen interest in the technical progress being made by Cézanne, a long-standing friend of Pissarro. They may all have worked together during the summer of 1881. To judge from the amusing sketch of a picnic made later by Georges (Manzana) Pissarro, Camille's second son, the Pissarro home at Pontoise became something of a landscapists' colony. Guillaumin was another regular visitor and Gauguin and he established good relations that year; indeed, several critics found close similarities between their paintings. At this so-called period of crisis for Impressionism, much discussion

10 Camille Pissarro, The Côte des Bœufs at L'Hermitage, near Pontoise, 1877

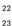

11 Georges Manzana Pissarro, *An Impressionist Picnic*, c. 1881, with (from left) 'Guillaumin, Pissarro, Gauguin, Cézanne, Madame Cézanne, and young Manzana', according to inscription

focused on the problem of giving unity to a painting's surface while retaining the spontaneity of the initial sensation. Hence Gauguin's half-serious suggestion, made in a letter to Pissarro in 1881: 'Has M. Césanne [sic] discovered the exact formula for a work that would be accepted by everyone? If he should find the recipe for concentrating the full expression of all his sensations into a single and unique procedure, try, I beg you, to get him to talk about it in his sleep by administering to him one of those mysterious homeopathic drugs and come directly to Paris to share it with us.' Cézanne was in the middle of developing his very individual system of regular parallel brushstrokes but was presumably either too taciturn or too unsure of himself to share 'recipes', so Gauguin resorted to another, simple and effective method of learning - he bought several of Cézanne's paintings. By the mid-1880s he owned no fewer than six, including a Nature morte and the Mediterranean landscape Montagnes, l'Estaque, both of which played a crucial part in his growth to maturity as a painter.

It was at the 1880 fifth Impressionist exhibition that Gauguin made his real public début as a painter. Although he included

a marble bust of his wife, the group of oils he submitted seemed to rank him as a landscapist, hesitantly following the example of Pissarro. Most of the critics gave him only the most dismissive of mentions. For the sixth Impressionist group exhibition the following spring, Gauguin put together a more varied range of work, including with several landscapes and still lives a large oil study of a nude, a statuette of a Parisian woman, and a painted plaster medallion of a café-concert singer holding a bouquet. As a collector, Gauguin's tastes were not restricted, encompassing drawings of contemporary city subjects by Honoré Daumier, Jean-Louis Forain and Degas, as well as the landscapes of Pissarro, Guillaumin and Cézanne. Gauguin's selection of exhibition works in 1881 seems to demonstrate on his part a desire not to be too readily categorized; indeed, it shows that three-dimensional work in a variety of media was an interest from the outset of his career, parallel to his painting. Pissarro's drawing of Gauguin carving his statuette dates from the summer of 1880, and Gauguin claimed to have made his first experiments in woodcarving at the age of seven, on the long voyage home from Peru. It had surely been no coincidence that when he and his growing family had moved to the suburb of Vaugirard in 1877, into a house at the end of a cul de sac, his neighbour and landlord was the sculptor Jules-Ernest Bouillot, and an adjoining studio was rented by another sculptor friend of Gauguin's, Jean-Paul Aubé. It was here that Gauguin picked up the rudiments of clay modelling, armatures and carving, the technical knowhow that he was able to share with his master Pissarro a few years later. His earliest productions in marble, while adhering to the

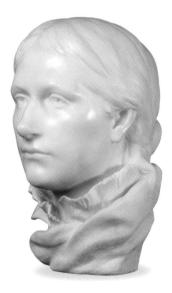

12 Portrait bust of Mette Gauguin, 1877

12

15

53

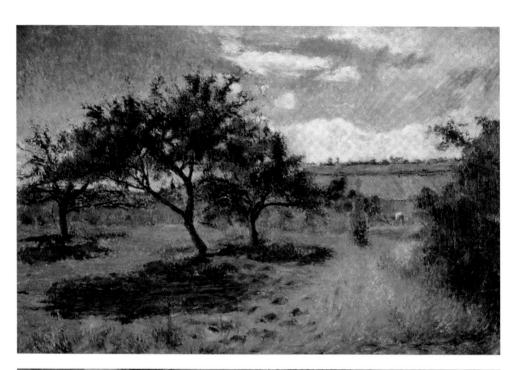

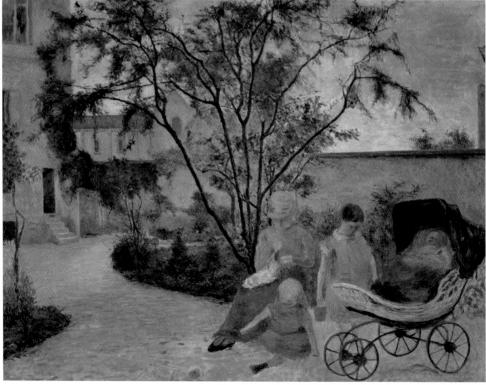

conventions of late nineteenth-century academic sculpture, show a remarkable plastic sense. It was not long before Gauguin was experimenting with the more adventurous media pioneered by Degas in his *Little Dancer of Fourteen Years*, first exhibited at the sixth Impressionist show in 1881. Gauguin's portrait bust of his son Clovis, which he exhibited at the seventh show in 1882, used a similarly unorthodox technical 'realism', a mixture of painted wax for the head and carved wood for the body.

17

Between 1879 and 1882 it must have been a matter of considerable anxiety for Gauguin that his work should earn the acceptance and approval of other members of the Impressionist group. Pissarro's support could, after all, be said to be coloured by a certain degree of self-interest. Among the original members of the exhibiting society, both Monet and Renoir were suspicious of his inclusion from the outset, and it was to Gauguin, among others, that Monet referred when he complained in 1880 of the formerly tight-knit little group opening its doors to all-comers and losing its essential character. In fact, in 1880 and 1881, neither Monet nor Renoir exhibited with the Impressionists, submitting work to the Salon instead. Such shifting of ground, reneging on their preliminary joint declaration of independence from the Salon, was strongly opposed by Pissarro and Degas, yet it was they who had been responsible for introducing new blood into the movement in Degas's case in the form of Federico Zandomeneghi, Mary Cassatt and Jean-François Raffaëlli.

Whatever shortcomings Gauguin may have felt as a practising artist, he was a skilful politican, his role as collector giving him a certain status, and he quickly established himself as a voice with some authority in the group. He participated vociferously in the arguments over the organization of the 1882 spring show, to the extent of 'playing the dictator' according to Eugène Manet, and campaigned with Pissarro to get rid of Raffaëlli. In 1881, Raffaëlli had effectively stolen the show by his enormous submission - thirty-four paintings and drawings - which he had justified, presumably, on the grounds of their small scale. Raffaëlli specialized in representations of urban types, the rag-pickers and dispossessed of the modern city, a factor that endeared him to the naturalist writers and critics. But Gauguin argued with some justification that from a technical point of view his work had nothing to do with the concerns of Impressionism, and threatened to withdraw his own submission if Raffaëlli were to be admitted. It was

¹³ OPPOSITE TOP Les Pommiers de l'Hermitage, III, 1879 14 OPPOSITE BOTTOM La famille du peintre au jardin, rue Carcel, 1881

a disgruntled Degas, however, who withdrew in protest at the rejection of his protégé, and as a result the 1882 show had a very different character from that of the previous year; Monet and Renoir participated once more, and landscape subjects were dominant. Gauguin's submission was almost unanimously slated in the press, although it included such unusual, thought-provoking works as the study of his daughter Aline asleep, *La Petite rêve*, a strange foretaste of his later preoccupations with the world of the unconscious.

It was perhaps Gauguin's anxiety to disassociate himself from the 'opportunistic' Raffaëlli that prevented him from enjoying the first unequivocal critical praise he received. from the pen of Ioris-Karl Huysmans. A naturalist novelist and disciple of Zola, Huysmans had taken to art criticism in the late 1870s, perhaps as a way of sorting out his own aesthetic ideas. Raffaëlli, who seemed to be producing the closest visual equivalent of what Huysmans was trying to do in literature, earned his special praise, but in his review of the 1881 Impressionist exhibition he applauded Gauguin's Etude de nu. Suzanne cousant for the unswerving honesty of its execution. Gauguin had struck a vehement note of realism by representing the bodily imperfections and practical, mundane task of his model. Huvsmans's admiration of Gauguin's Etude de nu in fact led him to launch into a diatribe against conventional treatments of the nude in contemporary art, where any attempt at realism, he argued, such as the inclusion of a discarded crinoline in Courbet's Femme au perroquet, was undermined by the falseness of the pose and arrangement of the subject.

Since Huysmans's various pieces of criticism seem to have remained unpublished until 1883, when he collected them in one volume entitled *L'Art Moderne*, the praise was not read by Gauguin until that year. To judge from his analysis of Huysmans's criticism in a letter to Pissarro of May 1883, he was already sure enough of himself and his ambitions by that date not to have his head turned. 'I am still flabbergasted by the fulsome flattery he throws in my face', he wrote, 'and despite its flattering side I can see that he is only seduced by the literary aspect of my nude woman and not by her qualities as a painting. We are still a long way from having a book which gives an account of Impressionist art. Would that I was a writer, I would like to produce it, there's something that needs to be done.' As well as revealing his acuity as a reader, this letter touches on concerns that would recur at various points

16

¹⁵ Etude de nu. Suzanne cousant, 1880

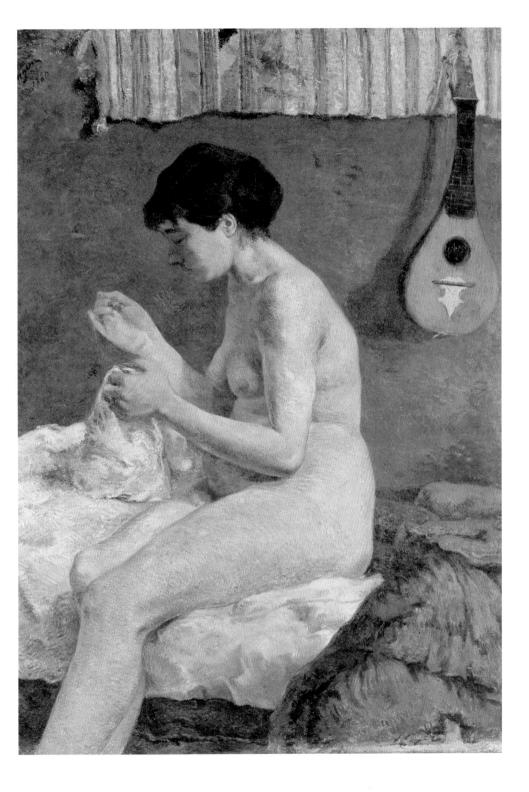

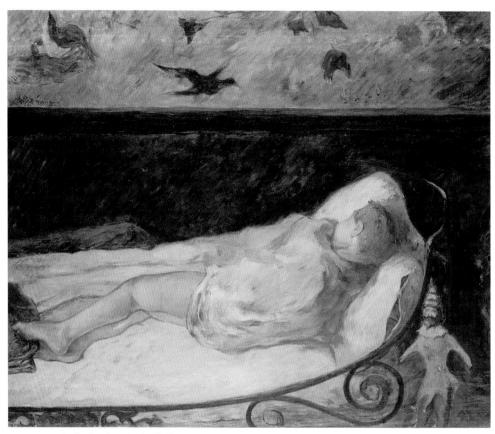

16 La Petite rêve, étude, 1881

in Gauguin's career: his mistrust of critics, his reluctance to be thought of as a literary painter and, paradoxically, his own literary and journalistic ambitions. At various stages Gauguin was to write short and more extended pieces of informal art criticism, often as an immediate response to something he had read. In fact, *L'Art Moderne* provided the catalyst for Gauguin's so-called *Notes Synthétiques* of 1884/85.

Despite the studied coolness of his reaction, Gauguin cannot fail to have been heartened by the terms of Huysmans's praise. He had been described as an artist who could draw; indirectly he had been compared with Rembrandt. His wood carving had been judged modern with a touch of the gothic, which counted as high praise at a time when the virtues of the gothic were being rediscovered. Gauguin was clearly buzzing with new ideas in 1883, ideas for arranging new exhibition venues, for tackling

the dealer network head on, for exploring the possibilities of Impressionist tapestry.... He was, therefore, not pleased to learn of the proposal, advanced primarily by Durand-Ruel, to abandon the annual Impressionist group exhibition in favour of a series of individual exhibitions at his gallery. Durand-Ruel argued that whereas the group shows sparked off much hostile publicity, one-man shows would be treated more seriously. Gauguin tried to convince Pissarro that the Impressionists' strength lay in their keeping a united front, warning him that such a development would not serve their interests, but of course it was artists such as himself and Guillaumin, artists who lacked Durand-Ruel's backing, who stood to lose most.

Gauguin's earnings on the stock market had dwindled sharply since the financial crisis of 1882, coinciding with the crash of the Union Fédérale bank. Indeed, the dampening effect of this crash had led Durand-Ruel to adopt his new, more cautious strategy of support for the Impressionists. In the face of these practical difficulties, in this first year of leaner living, Gauguin finally decided to 'take the bull by the horns', as he put it, and commit himself wholeheartedly to an artistic career. Painting had been increasingly occupying his thoughts and his time, and he felt he no longer had the energy to keep two careers going in tandem. Gauguin calculated that he would soon compensate for the immediate loss of income

17 LEFT Bust of Clovis Gauguin, 1881 18 RIGHT Camille Pissarro, Paul Gauguin sculptant la Dame en promenade, 1880

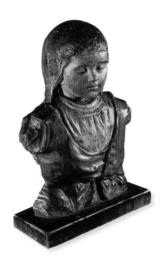

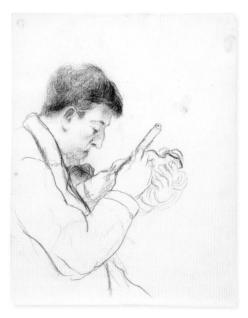

by putting all his business sense into conquering the art market. He was confident that with the right administrative skills and the right contacts, both of which he had, painting could be a viable enterprise. Pissarro was at first bowled over by this determination and courage on Gauguin's part. It was not long, however, before he grew more sceptical of Gauguin's commercialism in general and in particular of his professed special understanding of the bourgeois public.

Gauguin's greatest difficulty, he well knew, was going to be supporting and holding together his family. His wife, he ruefully acknowledged, could not cope with financial hardship. Two years before, they had been living in considerable style, with servants, a comfortable house and garden in the rue Carcel, as recorded in several of his Vaugirard paintings. Now they would need to find cheaper accommodation out of Paris. In October 1883, when he broached the subject of a move to Rouen with Mette, the family consisted of four children with a fifth on the way. From every point of view Gauguin had timed his change of career badly.

After less than a year of a cramped and uncomfortable existence in Rouen, where the bourgeois buyers turned out to be more elusive than Gauguin had predicted, Mette removed herself and two of the children to Copenhagen. Emil, the eldest,

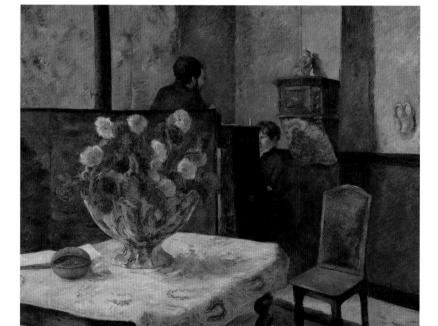

19 Intérieur du peintre à Paris, rue Carcel, 1881

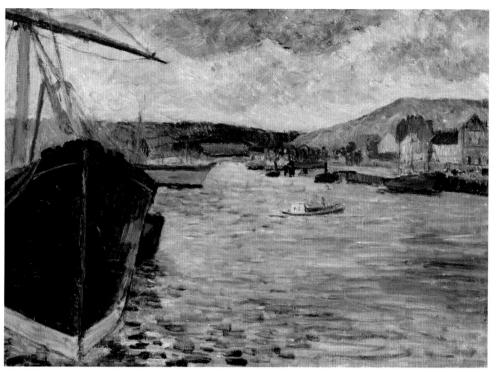

20 Le Port de Rouen, 1884

had already been sent there to receive the benefit of a Danish education. Gauguin shamefacedly followed a month or so later with the two others.

The motives that led this apparently successful businessman to sacrifice family and career to the elusive dream of becoming a painter were given literary elaboration as early as 1919 in Somerset Maugham's best-selling novel The Moon and Sixpence. Some thirty years later, an edition of the artist's letters to his wife, which began with their first separation in 1885 and continued until 1894, revealed a more enduring marital relationship and more complex set of motivations than Maugham had imagined for his fictional hero Strickland. Nevertheless, one suspects that, as for Mrs Strickland, it was several years before Mette Gauguin realized that painting was a threat to her happiness which she was powerless to fight. She was not unappreciative of her husband's breadth of artistic talent – later she was astounded by the quality of the works he sent home from Tahiti - but at this early stage she could not understand or forgive his seemingly demonic urge not just to

paint, but to produce intractable, unsaleable works. She might have adjusted well enough had Gauguin been turning out safe, accessible *plein air* landscapes like her Norwegian brother-in-law Frits Thaulow, for whom, incidentally, Gauguin had nothing but scorn. But she was aware of the demands the life of artistic independence made on families like the Pissarros, of whom she had become fond, and was not prepared to martyr her own or her children's lives and well-being to the uncertainties of such an existence, to throw up the security, respectability, sociability and education that she held dear.

The differences of experience and upbringing that existed at the very outset of the Gauguins' marriage made it difficult to ride out this storm, particularly as Gauguin seems to have fallen for the nineteenth-century notion that artistic genius could not thrive in the shackles of normal social ties and responsibilities. Given the circumstances, he and Mette remained remarkably close, determined up to the last to make a go of the separate lives they embarked on in 1885, to get Gauguin launched as a painter with a steady income in order that they and their children should benefit and resume family life. Being one-sided, Gauguin's letters to his wife touch on some, but probably not all of the issues involved. They bear witness to alternating rancour and tenderness, anger and resentment at emotional and sexual rejection, self-justifications dissolving into dashed hopes, self-pitying recriminations and frustrated paternal feelings. Confident calculations, predictions and taunts led to misunderstandings and ensuing bitterness over money, and it was these that finally led Mette to break off communications in 1894.

Chapter 2 **The Full-Time Painter**(1885–1888)

While living with his in-laws in the picturesque but unwelcoming city of Copenhagen, various inconveniences prevented Gauguin from getting on with his painting. The long cold winter effectively ruled out *plein air* landscape work, the available oil colours were inferior to those in Paris, and the Gad family, for whom Gauguin was a virtual stranger, disapproved of his painting at all. Although he had made his resolve to devote himself solely to art, the impossibility of earning money in this way had forced him to compromise and for a period in early 1885 he ostensibly worked as agent for a French tarpaulin manufacturer. It is doubtful whether many of the deals he tried to set up came to anything. For one thing, he spoke no Scandinavian languages and had to rely on his brother-in-law to sound out the Norwegian market. In any case, he was much more occupied by the problems of picturemaking, as he tackled scenes in and around Copenhagen or still lives indoors. The occasional news about the art world in Paris which he received from newspapers and from faithful friends was a lifeline.

To Gauguin's surprise, he found that his connections with the Paris Impressionists carried some weight in the Danish context and as a result his work generated a degree of interest and gossip, whether in the form of disapproval from the more conservative figures of the art establishment or secret emulation from the younger men. No doubt he exaggerated the shocking impact his reputation for 'impiety' made on this puritanical, hidebound society, a society whose gentility is merely glimpsed through the doorway in his *Nature morte dans un intérieur*. Certainly, he exaggerated or simply misunderstood the situation when an exhibition of his paintings, held in May 1885 under the auspices of the Society of the Friends

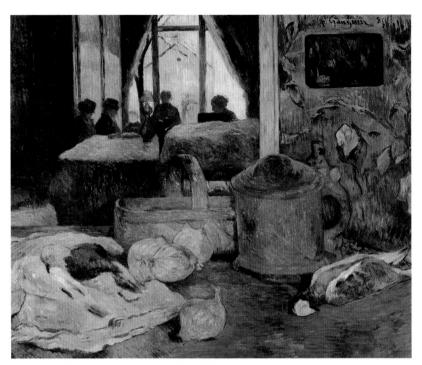

21 Nature morte dans un intérieur, 1885

of Art, lasted only five days; his exhibition was not closed with peremptory haste, as he believed, for this was the normal length of the Society's exhibitions; it was, however, passed over in the Copenhagen press, which suggests a certain cold-shouldering of the outsider to which Gauguin was quick to take exception. His attitude to the Danes remained sour for the rest of his life. In fact, his experiences in Copenhagen led Gauguin to describe himself for the first, but by no means for the last, time as one of the 'martyrs' of painting. The self-portrait, *Gauguin devant son chevalet*, externalized this mood, playing up the image of the bohemian artist, isolated in his garret.

The frustration of life in Denmark and of being absent from the heart of things in Paris, as indeed he was to be for most of the remainder of his career, seems to have had a positive side; it helped to clarify Gauguin's thinking about art and to crystallize his ambitions. This was a period when he studied his own collection of pictures closely. Writing to an artist friend, Emile Schuffenecker, he observed that just as one could read character from hand-writing, so an artist's temperament could be deciphered from his marks and style. An artist such

as Cézanne, he argued, judging from his fondness for heavy, passive forms and deep intense colours, and from his widely spaced handwriting, had a mystic, contemplative, oriental nature. In a letter dated May 1885, he imparted some of his technical ideas to Pissarro, who had recently criticized the dull tonalities from which he felt Gauguin's Rouen landscapes suffered. Gauguin sounded remarkably sure of where he was

22 TOP Paul Cézanne, Montagnes, l'Estaque, c. 1877-8 23 BOTTOM *Paysage provençal d'après Cézanne*, 1885, inscribed 'Dédié à M. Pietro Krohn, Copenhague, 1885.'

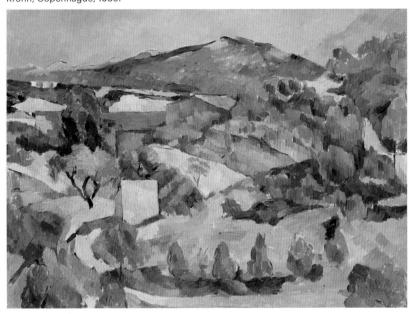

heading, arguing that these dull effects were a necessary stage in his determination to achieve an unvariegated overall surface, a matt quality which was the very opposite of the slick, eve-catching surfaces he so disliked in the work of many contemporaries. He presumably meant such artists as Henri Gervex and Jules Bastien-Lepage whose influence was marked in the work of the Danish artists. Whether or not he was vet fully conscious of the consequence, the ambition to paint in this broad, matt way would involve following a very different course from the one Pissarro was currently advocating – the use of small, even, but separate touches to achieve an overall unity. It was some years before the anti-Impressionistic effects Gauguin had in mind were visibly realized in his paintings. For the time being, perhaps to mollify Pissarro, whose advice he seemed to be rejecting, he spoke with satisfaction of having attained a lighter, more flexible execution in his latest efforts to capture the first greens of spring. The comparison between his own work and the timid efforts of the Danes had confirmed him in the belief that mediocrity was the greatest scourge of art; there was no need to be afraid of producing an 'exaggerated' art: on the contrary, extremism offered the only real way forward.

Gauguin used exactly this argument about the positive quality of exaggeration in art in his *Notes Synthétiques*, a factor which makes a date of 1884/85 for these writings a certainty. Indeed, there were contemporary reasons for his focusing on the question; 'exaggeration' was a charge that had frequently been levelled in the past at Delacroix and at the romantics in general. Delacroix's posthumous reputation was just then in the process of being salvaged, somewhat tardily, in a major retrospective exhibition at the Ecole des Beaux-Arts. A great admirer of Delacroix, Gauguin was furious at having to miss this event, and was avid for reports of it, even asking a friend to purchase on his behalf a photograph of Delacroix's Shipwreck of Don Juan. Now that the genius of Delacroix had been officially sanctioned, most of the reviewers were put in the awkward position of trying to justify the hostility of former critics to Delacroix's supposed excesses.

It is surely no coincidence that the arguments Gauguin advanced in his *Notes* echoed the well-known precepts of Delacroix: the important role of colour in drawing, the science of colour harmony and the relation between painting and music. Gauguin contended that the expressive means at the disposal of the writer and musician were inferior to the range of colour and tonal variation available to the painter, a range so mind-boggling in complexity (albeit simpler than nature herself) that any critic presuming to judge a painting would

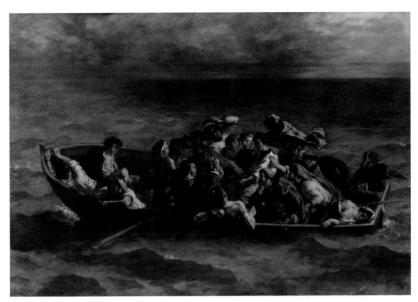

24 Eugène Delacroix, La naufrage de Don Juan, 1841

need to have some prior instruction in the science of colour as well as 'special sensations of nature'. This jibe was directly aimed at Huysmans who had 'ignorantly' complained of the over-use of blue in the paintings of the Impressionists. The merits of juxtaposing pure colours, as opposed to using impure mixed colours, and the interdependence and inseparability of colour and line were Gauguin's chief themes. One could describe them as anti-academic preoccupations that followed on naturally enough from his involvement with Impressionism, but they were also highly topical ones; indeed, they were exercising the theoretical mind of another new member of the Paris avant-garde, Georges Seurat, at this very time.

Gauguin knew he as yet lacked the necessary mechanical expertise and manual dexterity to put his ideas into practice, but he was sure he could remedy this by sheer hard work and repeated exercises. 'Don't perspire over a picture, a strong emotion can be translated immediately: dream on it and seek its simplest form.' This typically romantic self-admonition was passed on as advice to Schuffenecker. Emile Schuffenecker, like Gauguin, was a disaffected stockbroker who had taken the decision to become a full-time painter. (It is worth noting in passing how many of Gauguin's future associates in the art world had previously followed other callings; his case was by no means unique. Guillaumin was obliged to subsidize his

painting by night work for the *Ponts et Chaussées*, Vincent Van Gogh had worked as an art dealer, teacher and preacher, and the critic Octave Mirbeau was another former stockbroker.) The great advantage Schuffenecker had over Gauguin was a steady investment income. He had put a large inheritance into a profitable gold business, which enabled him to survive in comfort as an independent painter, despite his modest talent. a fact that increasingly rankled Gauguin. He had sunk his own capital into a much more risky commodity, modern painting: although occasional sales of pictures helped him to survive at critical moments, his collection needed more time to mature before it could count as a successful investment. Gauguin had also made some mysterious speculation in the context of Spain's current political struggles whereby he hoped to make money out of a victory for the revolutionary republican party led by Ruiz Zorrilla. He served the latter as a clandestine courier in August 1883 and 1886, but power remained in the hands of Spain's ruling monarchist party and the hoped-for financial gains were not forthcoming. Given their common backgrounds and joint commitment to independent painting, it was naturally to 'good old Schuff' that Gauguin turned in a crisis. The family situation in Denmark became so awkward and rancorous by the summer of 1885 that he decided to return to Paris, intending to work on whatever jobs he could find, at least until he should manage, as he put it, to carve himself a niche in the art market. His wife and children remained in Copenhagen, apart from Clovis who accompanied him. They had Mette's family and friends for support and Mette could earn some income from translation work and French teaching.

After spending a few weeks in Dieppe and making a flying visit to London, Gauguin spent a cold and uncomfortable winter in rented accommodation in Paris, selling part of his collection to Durand-Ruel and earning a few francs by sticking posters in the railway stations. Clovis fell ill, and eventually Gauguin's sister stepped in, providing the necessary funds to instal him in a boarding school.

From 1883 to 1886 Gauguin scarcely devoted more time to his art than he had done previously when in full-time employment. The disruptive moves and the restless search for the next meal left him little time or concentration for his painting. It was thus hardly surprising that the group of works he submitted to the long-delayed eighth Impressionist exhibition, held in the spring of 1886 in the rue Laffitte, marked very little stylistic development from 1882, rather a narrowing down of his artistic range. He sent in eighteen canvases, fourteen of them landscapes, and only one wooden sculpture. There

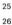

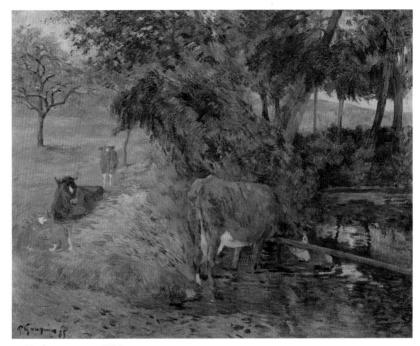

25 Vaches au repos, 1885

was a consensus of critical opinion about Gauguin that year. His work showed conscientious effort, even a latent talent, but his landscapes were somewhat monotonous, their heavy, brooding atmospheres suggesting to the critic Paul Adam the malevolent powers of nature. With hindsight, we can say that these were appropriate words to have chosen. Beside the several views of farmyards and meadows, including *Vaches au repos*, his small canvas of *Baigneuses à Dieppe* must have stood out as something rather different: again, with hindsight we can see it as the first instance of a recurring theme, the woman in the waves. Stylistically, too, it oddly presaged later works with its single, strong horizontal band of emerald green for the distant sea and the dance-like arrangement of the four female silhouettes in the foreground.

The relationship between avant-garde art and literature was cemented in 1886. One of the lengthier reviews of the Impressionist exhibition was penned by Félix Fénéon, a young critic with an eye to future trends. He was of the new generation of poets and writers who were growing tired of the naturalist creed and its endless fascination with the seamy side of contemporary life. Under the banner of Symbolism, they

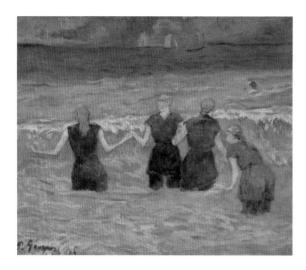

26 Baigneuses à Dieppe, 1885

wanted to create a new poetry of evocation and idea, nuance and suggestion, and they were looking for signs that artists would move in a parallel direction. In his review, Fénéon gave due credit to Gauguin for the unusual density of his colour, but classified him with Guillaumin, Monet and Sisley as one of the adherents to the original, arbitrary procedures of Impressionism. Ultimately, his praise and attention were given to Seurat and his group, whom he was shortly to dub the Neo-Impressionists, and their radical overhaul of Impressionist technique. He wrote at length about Seurat's huge canvas *Un Dimanche à la Grande Jatte*, explaining the theoretical rationale for treating luminous atmospheres by means of dots of pure colour, and hailed Seurat for going beyond the 'fleeting glimpses' of Impressionism and setting down a more permanent synthesis of nature. There was no doubt that Fénéon saw Seurat as the key figure for the future of avantgarde painting.

Gauguin must have had Fénéon's article among others in mind when he wrote to his wife in June 1886, in surprisingly optimistic tones, that their exhibition had 'once again brought the whole question of Impressionism up for discussion, and favourably'. The lukewarm critical reactions to his own works seem to have acted on him like a spur, partly, no doubt, because he was basically unsympathetic to the ideas and pictures that had won most of the honours. Georges Seurat, placed now in a position of authority, was not a generous young man. A situation arose in the studios of Montmartre that summer that highlighted a growing state of tension between Seurat

and Gauguin, and left bitter feelings on both sides. Having been offered the temporary loan of his studio by Seurat's leading adherent, Paul Signac, Gauguin found his entry was challenged by Seurat, who occupied the adjacent studio. Angry letters were exchanged, Gauguin was accused of being boorish, Guillaumin and Pissarro were appealed to. Finally, in a fit of pique, Gauguin complained to Signac, 'I may be a hesitant and unlearned artist, but as a man of the world *I will allow no one* to mess me about.'

Time was short for Gauguin if, at the age of thirty-eight, he was to achieve his grand ambitions, and he clearly felt threatened by the new rage for the 'little dot' that took hold in 1886. To his dismay, it had already swept up Pissarro, and Schuffenecker was just one of many independent painters who, lacking Gauguin's resolve and confidence and anxious to be in the swim, converted from a loosely Impressionist technique to a variant of pointillism in the wake of the 1886 exhibition. Although Gauguin turned out one or two dotted canvases himself, no doubt to satisfy his curiosity, he made no secret of his disdain for 'scientific' Impressionism.

27 Georges Seurat, Un Dimanche à la Grande Jatte, 1884, 1884-6

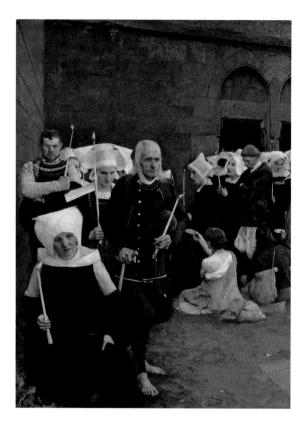

28 Pascal Dagnan-Bouveret, *The Pardon* in Brittany, 1886

Gauguin turned down the chance to exhibit again with the Neo-Impressionists that year, either at the Independents' salon or at a group show in Nantes. Instead, he decided to make Brittany his location for the summer. This move represented a disassociation from the art circles he had hitherto frequented and relied on: Pissarro already considered his one-time pupil to have defected to the rival camp of the so-called 'romantic' Impressionists, because of his rejection of the pointillist option, and he predicted that agreement between them would henceforth be difficult.

Brittany was the favourite summer destination for art students from the teaching studios in Paris, and months before Gauguin had spoken of his intention of taking up summer residence there, attracted like everyone else by its reputation for cheapness. What expectations Gauguin had of the pretty village of Pont-Aven as a place to paint would be hard to say. Certainly, he did not have quite the same objectives as most of the cosmopolitan group of artists who flocked there annually.

He had hitherto shown no interest in painting folkloric, antiquated customs, for instance, and working peasant figures had featured only marginally in his landscapes. As for the well-known strength of religious faith among the Breton people, it is doubtful whether Gauguin would yet have seen picturesque religious ceremonies as potential subjects, though they were clearly proving to be popular for the contemporary Salon painter Pascal Dagnan-Bouveret.

Apart from having the freedom and time to paint landscapes under the still 'revolutionary' banner of Impressionism, Gauguin's only fixed artistic objective was to work on ceramics that winter in Paris with Ernest Chaplet, an employee of the expanding Haviland studio. Gauguin had been introduced to Chaplet by the Impressionist exhibitor Félix Bracquemond, himself a keen ceramicist. Even before leaving Paris, Gauguin had begun work on recycling and simplifying motifs used in earlier works. In Brittany, his concentration on drawing, particularly on spare, simplified drawings of figure and animal motifs, related to his plans for ceramic decoration. It is probable that Gauguin had already seen how Kate Greenaway's children's illustrations had been adapted for decorative use

29 LEFT Vase with Breton Girls, 1886-7 30 RIGHT Ceramic designs, 1886-7

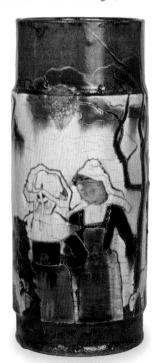

28

on ceramics at the Haviland studio, and he also knew the children's drawings of Randolph Caldecott, whose artistic pilgrimage through Brittany had preceded Gauguin's arrival by some eight years. The deliberately naïve style of these successful British illustrators (admired by Pissarro and praised by Huysmans in *L'Art Moderne*) seemed appropriate to the rural motifs and quaint costumes that presented themselves to Gauguin in Pont-Aven.

His more resolved colour drawings were a basis from which he later worked up painted compositions in the studio, using for the first time large-scale figures in a landscape setting. His most important 1886 Breton picture. Les Quatre Bretonnes. was painted from drawings back in Paris during the winter, as was the large Deux baigneuses of 1887. So established was Pont-Aven as an artists' colony that the village women expected to earn extra money through modelling, and Gauguin's sense of artistic 'otherness' did not extend to rejecting what was on offer. The importance of drawing as a way of achieving simplicity and strength in a composition was a lesson Gauguin had already learned from Pissarro, and it was reinforced by Degas's impressive group of nudes drawn in pastel which had been exhibited at the 1886 eighth Impressionist show. It was these artists' examples that were foremost in Gauguin's mind when he worked on his large pastel drawings from posed Breton figures. Not content to record unfamiliar dress and Celtic physiognomy. Gauguin tackled the sort of awkward, arresting poses favoured by Degas, a woman seen from behind, arms akimbo, for example, another foreshortened and in profile, adjusting her shoe. Gauguin spent time studying the nude as well, but his oil painting La Baignade au Moulin du Bois d'Amour, which was painted directly en plein air and used one of the most complex figural arrangements Gauguin had so far essayed, displayed a curious mishmash of influences. Cézannesque in subject, it was strongly indebted to Degas in design and boldly painted in spots of pure colour. Also somewhat confused in composition and technique was La Bergère Bretonne, a painting for which Gauguin made numerous small, individual drawings in his sketchbook. It is possible that this was one of the paintings he prepared quite carefully in the studio, before taking the canvas out of doors. But the striations of bright colour, probably added as a final touch with a fine sable brush, seem to militate against the generally uniform, dense tones employed in the landscape.

33

35

36

34

31

32

30

³¹ OPPOSITE TOP LEFT Bretonne assise, 1886

³² OPPOSITE TOP RIGHT Bretonne (Study for Les Quatre Bretonnes), 1886

³³ OPPOSITE BOTTOM Les Quatre Bretonnes, 1886

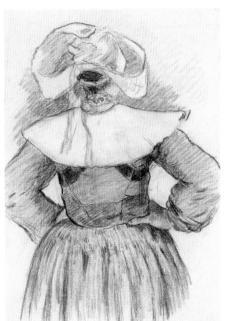

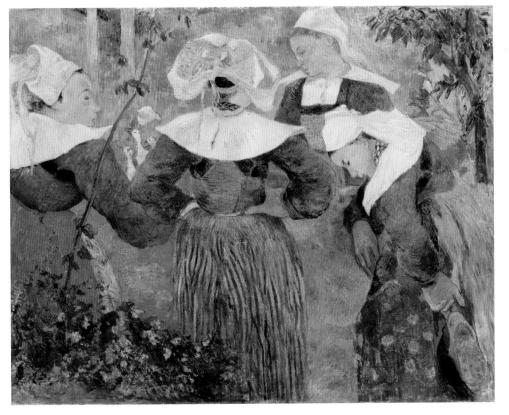

34 LEFT Edgar Degas, Femme nue debout, c. 1880–3 35 RIGHT Study for Deux baigneuses, 1886–7

Works such as these evidently scandalized the other itinerant artists, and just as he had in Copenhagen, Gauguin revelled in his capacity to provoke outrage. He admitted to being gingered up by the proximity of easily offended conservatives. According to two separate witness accounts, the reason Gauguin attracted attention during his three-month stay was as much due to his outlandish looks, demeanour and pugilistic prowess as to his strange manner of painting. Considerably older, more experienced and more widely travelled than most of the student-age residents, Gauguin had a certain authority and when he pronounced on artistic matters people listened. The disciple who attached himself most closely to Gauguin was

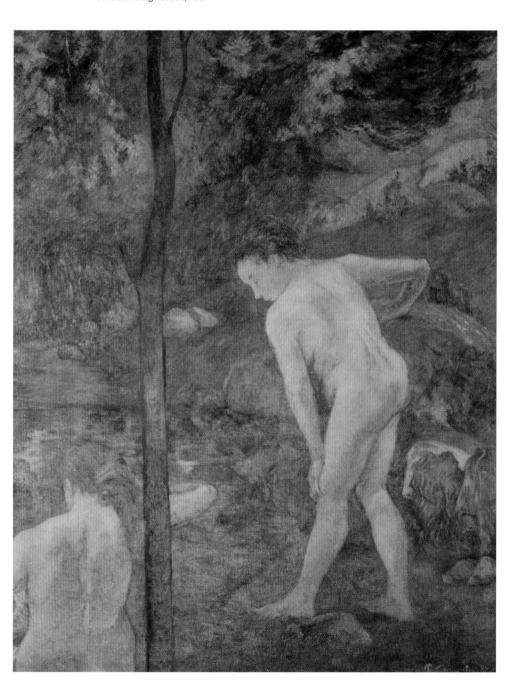

Charles Laval, a former pupil of Léon Bonnat, and his studious profile appears at the right edge of Gauguin's *Nature morte au profil de Laval*. In colouring, the painting pays homage to Cézanne, but it also characteristically contrives to include an unexpected item, in this case one of Gauguin's ceramic pots. It is likely that the painting was completed in Paris.

37

29

43

38

Gauguin's finances were still in a critical state when he returned from Brittany, and a month in hospital, caused by an acute attack of angina, left him completely out of pocket, despondent and bitter at the start of 1887. However, the studies he had brought back furnished him with ideas for his ceramics and in the space of a month, working alongside Chaplet in the rue Blomet in Vaugirard, he turned out fifty-five pieces of pottery. The energy he expended in this output was formidable and only explicable in view of his high hopes of making money from the sale of ceramics. The series included some functional. conventionally shaped pieces, the cylindrical Vase with Breton Girls, for example, in which for the first time Gauguin employed the cloisonnist technique of flat areas of colour, demarcated by firm lines, here incised and gilded. Another important piece was a *jardinière*, elaborately painted and glazed with modelled figures and animals, the same ones he had used in La Bergère Bretonne. But most of the pots were stranger and cruder, like the stoneware jug or the pot represented in the *Nature morte*, hand-modelled and reminiscent in form of the pre-Columbian

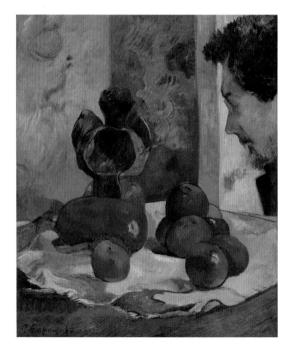

37 Nature morte au profil de Laval, 1886

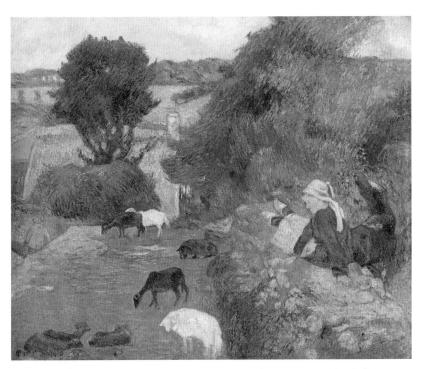

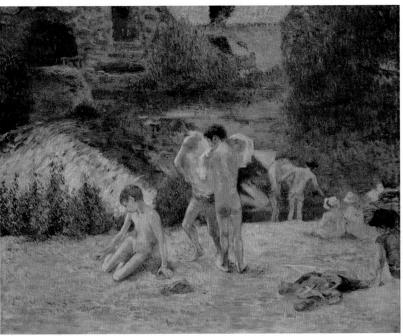

38 TOP La Bergère Bretonne, 1886 39 BOTTOM La Baignade au Moulin du Bois d'Amour, 1886

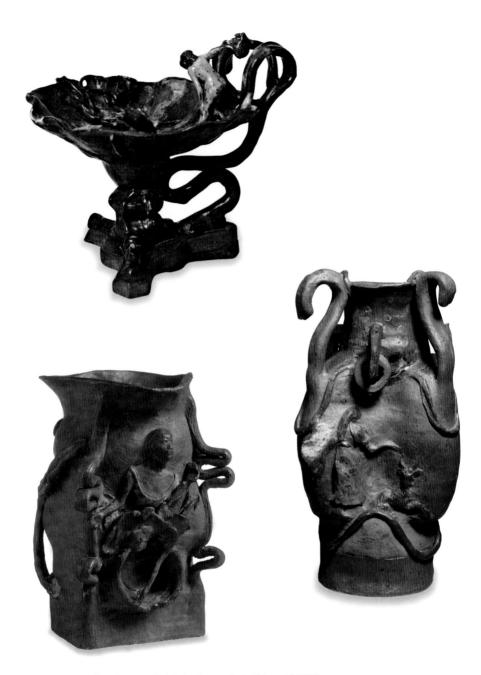

40 TOP Cup decorated with the figure of a bathing girl, 1888 41 BOTTOMLEFT Vase decorated with the half-length figure of a woman, 1886–7, exhibited 1893

42 BOTTOMRIGHT Vessel with women and goats, c. 1886-7

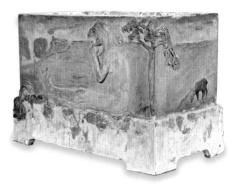

43 Rectangular jardinière, 1887

40, 41,

42

pottery he had known from his childhood in Peru. In these, Gauguin stretched the medium to its limits, exploiting its primitive connotations, and the unconventional results were, with some reservations, admired by Chaplet, Bracquemond and others. However, not surprisingly, they proved difficult to sell, and once again Gauguin's optimistic forecast turned out to be ill-founded.

By the spring of 1887 Gauguin's financial situation was desperate and his only thought was to escape from the miasma of debt and recrimination in which he found himself. A short-lived panic in Paris about a possible war with Germany was seized on by Gauguin as a potential way out of the impasse, but it was a false alarm. Entrusting the pots to his colour merchant Arsène Portier, with Charles Laval Gauguin joined a ship bound for America in April, planning to hole up on the island of Taboga in the Gulf of Panama and there renew his physical strength. Plans went awry, and Gauguin felt he had no alternative but to earn his passage back to the Caribbean island of Martinique by working in some capacity on the Panama Canal, then under construction. Laval and Gauguin

The Full-Time Painter (1885-1888)

had glimpsed Martinique, which was a French protectorate, on their journey out and it had struck them as offering a paradise for the painter. The climate, the landscape, the brilliantly coloured flora and fauna and the easy-going native population proved to be as enchanting as they had imagined. They rented a 'case à nègre' and set to work with a will. Unfortunately, Gauguin had contracted dysentery while working in Panama so that, despite the new attack and enthusiasm he felt ready to bring to his painting, and his attraction to the possibilities of colonial life, his energies were progressively sapped by the illness. At the end of a four-month stay, after sending a series of pitiful letters to his wife and Schuffenecker, he returned to Paris, in worse physical shape than when he had left.

Gauguin judged the dozen or so canvases he brought back with him to be far better than his Pont-Aven work. Certainly. they are characterized by a greater degree of freedom and boldness in drawing and colour juxtapositions; Gauguin's already established fondness for dense, airless effects, and strong reds set against greens, was appropriate to the tropical vegetation and began to work effectively in a painting such as Les Mangos, Martinique, one of the four works in which he included substantial figures. The poses of the two women in the foreground carry a strength and conviction that is powerfully expressed in the preparatory drawing, and there is nothing casual about their insertion into the composition, whose spatial intervals and balancing vertical and horizontal accents have been carefully considered. It works both as a linear and as a colouristic design, the small striations giving the painting something of the quality of a tapestry, the medium in which Gauguin had been so keen to experiment a few years earlier. He achieved a similar surface richness in Allées et

45

44

44 Martiniquaises, 1887

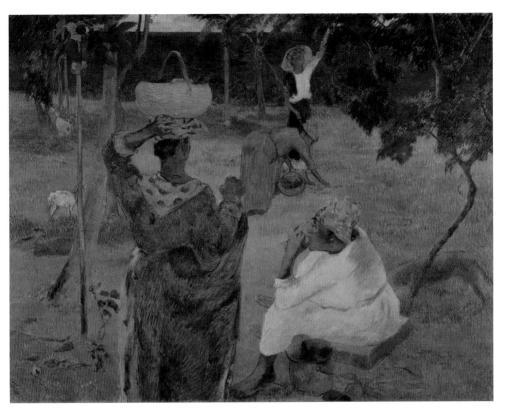

45 Les Mangos, Martinique, 1887

47

venues, Martinique, a painting later owned by Degas, and in the pure landscape Végétation tropicale, Martinique.

These pictures were seen and enthused over at Portier's gallery in Paris by two Dutchmen, Theo and Vincent Van Gogh. Gauguin's encounter with the Van Gogh brothers in late 1887 was to have important implications, as he was not slow to realize. Theo Van Gogh was a picture dealer who had been employed by the Goupil firm (now known as Boussod, Valadon and Co.) in Paris for nine years. Sharing an apartment block in Montmartre with Portier, the colour merchant who had been acting in a spasmodic way as dealer on Gauguin's behalf, Theo had met other clients of Portier's, the Pissarros father and son, and Guillaumin. Recently, he himself had begun to take an interest in selling the work of these independent painters. Indeed, since 1886 he had succeeded in infiltrating a few works by Degas, Pissarro and others into the upstairs showroom of Goupil's gallery in the boulevard Montmartre, and was striving

46 Allées et venues, Martinique, 1887

hard to introduce them to the firm's clientèle, who were more used to the work of accredited Salon artists. He was spurred on by the encouragement of his elder brother Vincent, who had arrived in Paris in 1886 from The Hague, anxious to further his artistic career. Vincent Van Gogh quickly established contacts with a wider group of artists, fellow pupils from the Cormon studio such as Emile Bernard, Henri de Toulouse-Lautrec and Louis Anguetin, and others such as Paul Signac and Lucien Pissarro. Undoubtedly, Vincent helped to extend his brother's knowledge of the most recent trends in painting. Theo had made overtures to Camille Pissarro in the autumn of 1887. aware that the painter's new pointillist technique was not finding favour with Durand-Ruel, and in December 1887, on the strength of seeing the Martinique works, he offered to take on a small group of Gauguin's recent canvases, to hang next to those of Pissarro and Guillaumin. Gauguin was of course delighted, particularly as he had as yet failed to elicit any sort of firm business commitment from another dealer. He made much of the importance of the new arrangement in a letter to Mette of December 1887, stressing that the gallery's central address, unlike Portier's, would mean that exhibits had a better chance

48 Bord de mer, Martinique, 1887

of catching the attention of the public and the critics. Indeed, through the gallery he had already sold paintings to the value of 900 francs. It was becoming, so he boasted, the 'centre for the Impressionists'.

Gauguin was an optimist and had the capacity to respond immediately to the slimmest of favourable augurs. His endeavours were receiving endorsement from an important practical quarter. This was just the fillip he needed at a time when his health and strength were weakened. There is no question that he now had a will to work, but he was equally convinced that for him, as for Vincent Van Gogh, Paris was not the best place to work in. It was too expensive, it involved too much wrangling and money grubbing, there were too many diversions and the stimulus of new ideas, constantly fermenting among the younger artists, could be counterproductive. Writing to Mette early in 1888, he explained that as he was on the point of being launched, he needed, over the next seven or eight months, to make a 'supreme effort' for his painting. Just as Van Gogh left Paris for Provence, Gauguin left Paris in early February for Brittany, and took up residence once again, at the Pension Gloanec, in Pont-Aven.

Chapter 3 Collaborative Experiments (1888)

A few weeks after arriving in Brittany, once the weather and his health permitted, Gauguin set about his campaign. He now had a much clearer notion of what Brittany could offer him as a painter. He wanted to 'imbue himself with the character of the people and of the landscape'. He contrasted his own interests with the 'Parisianist' preoccupations of his old comrade Schuffenecker. Whereas Schuffenecker was now caught up in the sort of modern social theme favoured by the Neo-Impressionist group (and currently tackling the subject of road-menders), Gauguin felt more at home with the rustic: 'When my clogs resound on this granite soil, I hear the dull, matt, powerful tone that I'm after in painting....' Were it not for that renewed insistence on the 'dull, matt, powerful tone' (a foreglimpse of the crude primitive qualities he was soon consciously and assertively to set against the sophisticated, slick, photographic finish of contemporary Salon painters), there would be nothing to differentiate Gauguin's ambitions from those of the numerous other peasant and rural painters working throughout the regions of France in the 1880s. It was a widely held belief that the Bretons had somehow retained their primitive, Celtic character and that this was due to their harsh existence at the mercy of the elements, toiling at the unvielding granite rock of their peninsula. Arriving in Pont-Aven in winter doubtless made Gauguin more aware than he had been two years before of the underlying harshness of the terrain.

The painting season had not yet opened so Gauguin was temporarily free of distracting influences and could pick up the threads of his development as a painter from where he had left off in Martinique. In *Hiver, ou petit Breton arrangeant son sabot*, one of the earlier works done in 1888, Gauguin continued to use the combination of loosely Impressionistic

technique, heightened colour and Degas-like figure drawing. The vertical composition faithfully conveys the cramped. intimate feel of the steeply wooded valley of the Aven, with the church and town glimpsed through the still-bare trees. but the action of the boy in clogs, surely included as a sign of 'Bretonness', carries echoes of the ballet context from which the pose was taken. An uncharacteristically luminous and delicate spring landscape, Les Premières fleurs, les Bretonnes aux Avins, exemplifies Gauguin's continuing stylistic equivocation: although unscientific and unvariegated, the small vertical dabs of brushwork seem to have been inspired to some degree by pointillism. He was not yet approaching the powerful, matt simplicity of which he had spoken. Ironically, this particular canvas was well received in Paris, and later in the year there was talk of Degas buying it. A work in which Gauguin felt he had achieved a more essentially Breton character was La Ronde des petites Bretonnes, painted in June 1888 and inspired by the traditional celebrations at hay-making time. Some of the dance forms evidently harked back to druidic festivals, and one senses that here Gauguin was starting to attune himself to those archaic aspects of Breton life that had long epitomized the romance of Brittany for poets and painters. La Ronde, thanks no doubt to its quaint though rather sentimental and hackneved theme, proved readily marketable, attracting attention from various quarters and selling eventually for 500 francs to a client of Theo Van Gogh's.

It was not until July, however, when Pont-Aven had once again been invaded by the 'band of simpletons' from Paris who considered Gauguin a madman, that he could congratulate himself on having struck a truly original and independent note in his painting, on having gone beyond anything he had achieved before. After working on a series of studies of boys bathing, his nudes, so he claimed, were now 'not at all Degaslike'. The latest, *Lutte Bretonne* or *Enfants luttant*, showed a fight between two lads by the river, no doubt limbering up for the traditional wrestling bouts that took place after the religious pardons. Essentially Breton though the subject was, its treatment was 'absolutely Japanese by a savage from Peru', he explained to Schuffenecker. In a letter posted at much the same time to Vincent Van Gogh, he included a sketch of the composition.

As these letters make clear, there was no question of Gauguin's working in a vacuum just because he was installed among strangers in Pont-Aven, nor of his forgetting his artistic pedigree. Japonism was then a live issue among the younger artists in Paris; Vincent Van Gogh had organized an

50

51

49 Hiver, ou petit Breton arrangeant son sabot, 1888

exhibition of his own substantial collection of Japanese prints in Montmartre that winter, and his correspondence was full of references to the Japanese printmakers. Gauguin's mention of Degas indicates that he was still conscious of the elder Impressionist as a powerful but sometimes oppressive presence looking over his shoulder. In fact, shortly before leaving Paris, Gauguin would have seen his own painting *Deux baigneuses* hanging in the Goupil gallery next to the latest Degas pastels

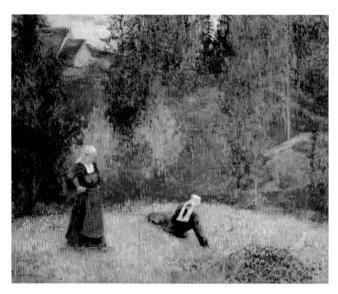

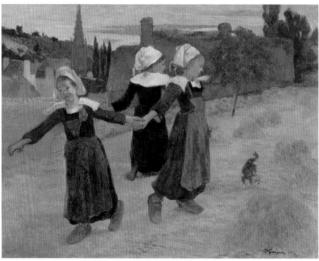

50 τον Les Premières fleurs, les Bretonnes aux Avins, 1888 51 ΒΟΤΤΟΜ La Ronde des petites Bretonnes, 1888

of women in their bathtubs, an interesting contrast between contemporary rural and urban interpretations of the nude theme. Gauguin made a series of small copies of the Degas pastels in his sketchbook, and reused a number of the daring, often ungainly poses in later works. Gauguin's letters from Brittany also reveal, indirectly, how close a watch he kept over his critical status in Paris. Certainly, he took considerable note of the writings of Félix Fénéon, now established as regular

art correspondent, with a monthly calendar, for *La Revue Indépendante*. Fénéon wrote at length about *Deux baigneuses* and several of the Degas nudes in the February edition. Earlier, he had praised Gauguin's rare skill as a potter, but there had been a sting in the tail: Fénéon had described Gauguin as *grièche*, an arcane word loosely translatable as sore-headed or unpleasant. This set down publicly and for posterity the reputation for awkwardness Gauguin had earned himself in his dealings with fellow artists in Paris. The slight to his character, far from passing unnoticed or unfelt, was referred to on several occasions by him in letters that year. It is significant that from this date onwards Gauguin cultivated the image of himself as a 'savage from Peru', which was in a sense a way of acknowledging and excusing his ungentlemanly reputation.

Despite Fénéon's reservations about Gauguin's personality, he was the first critic consistently to draw attention to Gauguin's art, and in May 1888 he was arguing that a Gauguin one-man show was now due, believing it would reveal what a 'powerful and isolated artist' he was. Such support must

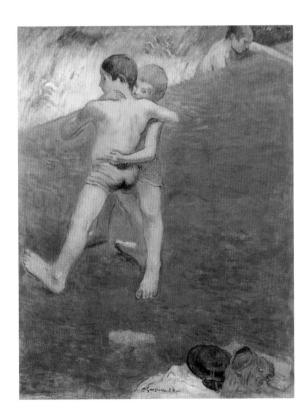

52 Lutte Bretonne, 1888

have considerably boosted Gauguin's confidence. Nor was it an idle suggestion. La Revue Indépendante had a small space in its offices where a number of exhibitions were arranged throughout 1888, the artists involved ranging from Manet, who had died in 1883, and the fashionable Besnard, to men such as Guillaumin, Pissarro, Seurat, Signac, Luce and Dubois-Pillet. the last five all adherents of Neo-Impressionism. Sure enough. in November 1888, an application from Schuffenecker having been rejected, an invitation to mount his first ever Paris oneman show was sent instead to Gauguin, no doubt at Fénéon's behest. But it is a measure of Gauguin's proud, combative and unforgiving nature that he turned this invitation down, partly out of lovalty to Schuffenecker, but more importantly on the grounds that the editorial board of La Revue Indépendante was fundamentally antagonistic towards him, and he was not going to be seen compromising with the enemy camp. His letter of refusal, although ostensibly humble and self-deprecating, was heavily loaded with irony. 'Feeling for the past three years that my strengths as an artist were nowhere near sufficient to keep up with the modern progress being introduced among the Impressionists who've so rapidly been replaced by the Neo-Impressionists, I have resolved to work on my own, away from all group publicity. - My studies of the tropics are insufficient as exact records of nature and I believe La Revue Indépendante will be powerless to give them the clarity and luminosity they lack....' For all his professed indifference to critical opinion and disdain for the views of literary men, this letter reveals, on the contrary, how susceptible Gauguin was to criticism; rather than suffering in silence as the equally touchy Cézanne would have done, he could not resist rising to the bait.

By the time he received this invitation, Gauguin had in fact already accepted another, to exhibit in February 1889 with the enterprising Belgian independent artistic organization, Les Vingt. Gauguin planned to stage an open assault on the 'little dot' there, knowing that his works would be seen and compared with the latest works of Seurat. Despite his claims to be shunning all group publicity, it is clear that Gauguin kept himself informed of the latest initiatives within the Parisian avant-garde. Although the letters to Theo and Vincent Van Gogh, which began early in 1888, were initially concerned with strictly practical and commercial matters, over the months they revealed Gauguin's increasing need for a sympathetic ear, and his deliberate construction of an artistic persona. He was seeking to impress himself on their mercies as a brilliant, but maligned and suffering genius for whom encouragement, sales and support were a lifeline. In order to provide that support,

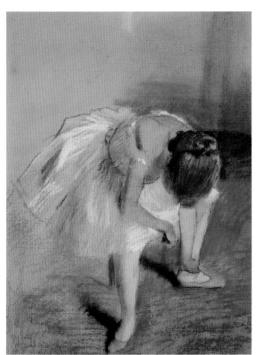

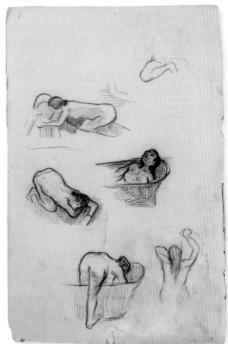

53 LEFT Edgar Degas, Danseuse ajustant son soulier, 188054 RIGHT Page of sketches after Degas, c. 1888-9

as well as companionship for his brother Vincent, Theo hit on the scheme of persuading Gauguin to leave Pont-Aven and instead share studio space and living expenses with Vincent in Arles. This involved delicate negotiation; Vincent was enthusiastic but nervous about the plan; Gauguin presented himself as by no means unwilling, yet prevaricated throughout the summer months, pleading poverty and debts in Pont-Aven and proposing alternative measures for keeping artists such as themselves in pocket, a sort of artist/dealer co-operative with himself as administrator and Theo as dealer. He allowed himself to play the prima donna, confident that this promised financial act of faith on the part of Theo Van Gogh was a sound indication of the dealer's high estimation of his work, even though sales continued to elude him.

Prompted by Vincent's tendency to give a detailed literary commentary of his work in progress, Gauguin had begun to reciprocate. He expounded not only his general artistic principles (for instance, his endorsement of Vincent's view that exactitude had no importance in art, that art was essentially

an 'abstraction' from nature which had to be pondered and then simplified) but also, for the first time in his career, analysed what he considered the more important paintings he was working on. This very activity of describing in words the technique, style and underlying meaning of his works arguably encouraged Gauguin in the direction of a more self-conscious, literary art: in short, pushed him towards Symbolism. His correspondence with Vincent Van Gogh in the summer of 1888 was crucial to Gauguin's consciousness and subsequent construction of himself as a Synthetist and Symbolist.

There was another, possibly more important, catalyst that encouraged Gauguin's recognition of his true artistic direction

55 Louis Anquetin, Avenue de Clichy, cinq heures du soir, 1887

that summer. Emile Bernard, a precociously talented and intense young man, formerly a student with Van Gogh and Anguetin at the Cormon studio, came to Pont-Aven on Vincent's advice to seek out Gauguin. They had met each other there two years before, without any useful exchanges or meeting of minds. On this occasion, Bernard knew more what to expect of Gauguin and approached him in the spirit of an admirer. Gauguin for his part was immediately impressed by the work Bernard had brought with him from Saint-Briac, some highly simplified primitive drawings on Breton themes, inspired by stained glass and the popular woodblock *Images d'Epinal*. Lacking Gauguin's years of experience. Bernard also lacked his inhibitions, and his experiments in simplification and caricatural drawing, although proceeding along similar lines to Gauguin's, were much bolder. In association with Louis Anguetin, for a year or so Bernard had been painting portraits, still lives and urban street scenes using bold, flat or striated colour areas, surrounded by heavy black lines. In May 1888, reviewing a group of these works in La Revue Indépendante. Edouard Dujardin had dubbed the style 'cloisonnism', by association with the *cloisonné* technique in enamelling, whereby metal partitions or cloisons are used to divide one area of brightly coloured enamel from another. Gauguin, as we have seen, had already used a similar technique in his ceramics, and had been experimenting with flat colour areas in his most recent paintings. Bernard's example seems to have persuaded him that cloisonnism had some decorative advantages for painting too, particularly the increased brilliance it lent to the colours in the enclosed areas. But cloisonnism was never to play a particularly dominant role in Gauguin's painting.

More importantly, the arrival of Bernard, who was a practising if somewhat wayward Christian, and his attractive and devout sister Madeleine, seems to have awakened Gauguin to the artistic inspiration to be found in Breton churches, calvaries and stained glass and to the potential of Breton piety as a pictorial theme to set against the despised 'Parisianism'. Increasingly, the curious pardons were being exploited as tourist attractions. At the same time, scholars of Breton life began to see signs of their being irreversibly modernized to bring them in line with Roman orthodoxy. In the hands of artists such as Jules Breton, Alphonse Leleux and Dagnan-Bouveret, Breton religious festivals were already a well-worked theme, and when both Bernard and Gauguin turned out their crude, almost caricatural drawings and paintings of Breton women at prayer or in the fields that summer they were in a sense satirizing the seriousness of the Salon artists' attention to illusionistic realism.

In September 1888, Bernard painted an important canvas, *Les Bretonnes dans la prairie*, or *Pardon à Pont-Aven*, a bolder, more complex figure painting than any he had yet produced. The subject was based on the annual pardon that took place in Pont-Aven in September. Shortly afterwards, probably in response to witnessing the same pardon, Gauguin produced a composition of similar formal daring but greater literary complexity, which he entitled *La Vision du Sermon. La lutte de Jacob avec l'Ange*.

The art historical controversy surrounding the relationship between these two paintings has nearly obscured the fact that they were the fruits of a mutually beneficial working partnership that lasted for some two months. The collaborative links between Gauguin and Bernard embraced Charles Laval to some extent, and were keenly monitored by Vincent Van Gogh, who had engineered the encounter in the first place. The energy and excitement engendered by their joint experiments and discussions were expressed in the letters of both Gauguin and Bernard, letters in which, incidentally, Gauguin refers to 'le petit Bernard' and Bernard talks about Gauguin as 'le maître'. Gauguin chided Schuffenecker for his timidity and conservatism in contrast to young Bernard who 'feared nothing'; were Schuffenecker to come and join them in Pont-Aven, they would have someone to argue against in their heated discussions. They were 'tormenting Impressionism to death', as Gauguin put it, and the three of them were like 'tailleurs en peinture', by which he meant either stone-cutters or tailors, an analogy which presumably referred to the crudeness of their working methods or to the way their compositions resembled flat, coloured shapes pieced together.

As in the case of *Lutte Bretonne*, a parallel with the techniques of Japanese artists is clearly valid in the case of La Vision, with its asymmetrical composition, and its diagonal tree trunk separating the flattened upper and lower parts of the picture space. These biblical wrestlers, supposedly evoked in the minds of the praying women by the priest's sermon, have a synthetic. Japanese quality and may well have been derived from illustrations of wrestlers in Hokusai's celebrated Manga albums. Gauguin's stated plan of donating his painting to the local church, where its colour and simple shapes would rhyme with the stone pillars and stained glass, may also have had a bearing on the painting's decorative drama. He was not surprised, however, by the refusal of the two local priests he approached to accept his gift, and nor should we be. Gauguin had scarcely shown himself to be a member of the faithful and, quite apart from its unconventional and crude appearance, the painting was very much the product of a sceptical onlooker,

57

58

56 Madeleine Bernard, 1888

projecting ideas such as 'rustic and superstitious simplicity' onto a group of worshippers, rather than an expression of orthodox devotional feeling. For all Gauguin's expressed anxiety to keep on good terms with the inhabitants of Pont-Aven and clear his debts with its traders, there is no evidence that they accepted or understood him, or that he succeeded in breaking through their natural mistrust of the outsider.

From the 1890s onwards, Bernard made public the claim that in embarking on *La Vision* Gauguin had changed his style beyond all recognition in response to his own bold example; moreover, he later accused Gauguin of taking for himself,

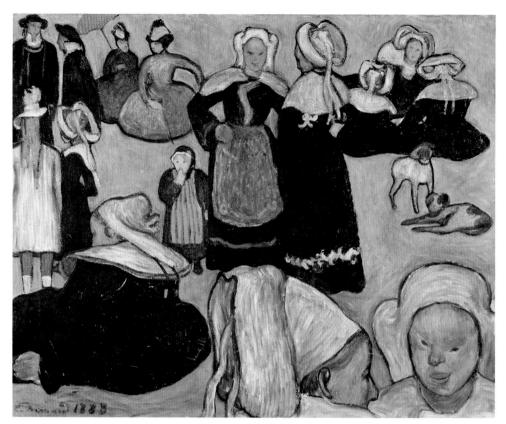

57 Emile Bernard, Les Bretonnes dans la prairie, 1888

and away from its true originator, all the credit for the new, revolutionary Synthetist style. It is undeniable that Gauguin and not Bernard came to be recognized as leader of the new avant-garde movement, but the justice of Bernard's claim is hard to establish, since both parties in the dispute were prone to take umbrage and, in their writings, to distort the facts to suit their own interests. Certainly, Bernard was not the only artist to fall foul of Gauguin's cavalier approach or to accuse him, rightly or wrongly, of piracy. By persuading Bernard to part with Les Bretonnes dans la prairie in exchange for one of his own works, and transporting it to Arles where it was copied by Vincent Van Gogh, Gauguin must have seemed to be making somewhat free with Bernard's discovery or, at the very least, acknowledging its usefulness to him. But when, in an unpublished article, Gauguin defended himself against Bernard's charge, he could speak from an unassailable position

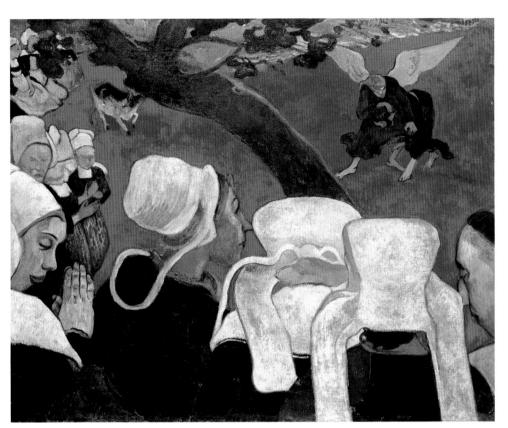

58 La Vision du Sermon. La lutte de Jacob avec l'Ange, 1888

in pointing to the consistency of his own record as an artist, in contrast to Bernard's erratic stylistic progress after 1888.

Shortly before taking up the Van Goghs' invitation to go to Arles at the end of October, Gauguin sent Vincent a self-portrait. The latter had requested his friends in Pont-Aven to paint one another's portraits and send them to him but in the event Gauguin, Bernard and Laval each found it easier to depict themselves. This was the first self-portrait Gauguin had produced since 1885, and the task seems to have intrigued him. Over the next year or two he turned again and again to his own image as a source of inspiration, as a motif for symbolic elaboration. In the accompanying letter to Vincent, he expounded the portrait's intended meaning, sensing that the underlying ideas surpassed the work itself. In so doing Gauguin tacitly accepted that Symbolist meanings might fail to function in the absence of a sympathetic exegesis (a danger that

of course became increasingly acute in the twentieth century as artists' concepts were translated into more and more abstract forms). Gauguin inscribed his self-portrait Les Misérables and explained that his associating himself with Jean Valjean, the hounded and victimized hero of Victor Hugo's novel, was a way of symbolizing the plight of the Impressionist artist in contemporary society. Each element of the picture encoded a specific meaning: for example, the high colouring given to the flesh was meant to suggest the intense heat of the potter's kiln and thus the fires of creativity; the yellow floral background, like the wallpaper in a young girl's bedroom, signified the purity of the Impressionist, untainted by academicism.... This complexity was not entirely to Vincent Van Gogh's liking but the gist of the message Gauguin surely intended to convey was received loud and clear. The Van Gogh brothers hastened to assure him that by their good offices he would be cossetted. nurtured and restored to good health in Arles.

The extended anticipation of Gauguin's arrival in Arles had brought Vincent to a state of high nervous tension. He had long cherished the dream of setting up an artistic brotherhood and was most anxious that Gauguin should find the Yellow House to his liking. He had fitted it with the essentials for a shared existence, and decorated Gauguin's room with his own recent

59 Autoportrait. Les Misérables, 1888

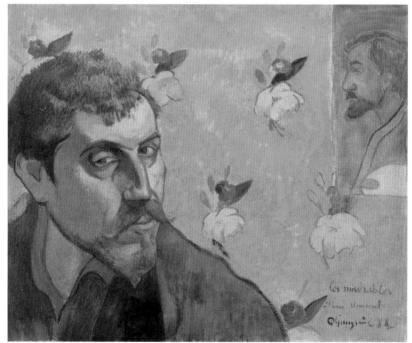

paintings. As Gauguin planned to stay for six months, he did not hesitate to make himself at home, immediately setting about reorganizing the kitchen, ordering a new chest in which to store their belongings and an enormous roll of sackcloth on which to paint. He prided himself on his ability to run a more efficient household than Vincent, citing as evidence of his practical nature his years at sea. Everything suggested he intended to enjoy not having to foot the bill. Yet both artists were keen to impress on Theo, who was paying, the advantages of the new arrangement in terms of productivity.

In fact, it turned out to be a remarkably prolific period for them both, Gauguin, as Vincent had feared, was unimpressed by the landscape possibilities around Arles. The flat, treeless Camargue had none of the intimacy, variety and definition he had come to love in Brittany. Nor was he interested in the magnificent Roman remains. He turned his attention instead to the local women, an interest that developed naturally enough from his most recent Breton work. Partly thanks to Bizet's popular musical setting of Alphonse Daudet's drama. the Arlésiennes were famed throughout France for their spirit, beauty and dignity of bearing. In contrast to the Bretonnes, whose starched, rounded and sometimes comical coiffes harked back to the middle ages, Gauguin found the women of Arles more sophisticated, reminiscent, with their black pleated shawls and elegant coiffure, of the virgins of ancient Greece, while at the same time suggesting a source of beautiful 'modern style'. Ouite what he meant by this is hard to say. In his painting entitled *Café de nuit à Arles*, for which his portrait drawing L'Arlésienne. Mme Ginoux, in strong, simple controlled lines was the preparatory study, Gauguin uncharacteristically tackled a modern genre subject, even including such mundane details as the soda syphon and the prostitute's hair curlers. (Van Gogh painted the model at the same sitting, but preferred Gauguin's drawing to his own, later copying it.)

Although Gauguin probably treated this subject in order to demonstrate his misgivings about Vincent's earlier handling of the same theme, as he did on several occasions in Arles, he seems to have judged his *Café de nuit* as something of a false departure. On its completion, he turned to painting a grape harvesting scene, *Vendanges à Arles. Misères humaines*, working partly from memory and using considerably less deliberation. 'Too bad for exactitude', he jokingly wrote to Bernard, referring to the Breton figures he had included. Here, possibly for the first time, he worked directly onto coarse sackcloth instead of canvas. Describing the picture to Theo Van Gogh, he alluded to its exclusively male perspective, which might shock potential

63

64

62

buyers. This note throws light on the presumably sexual nature of the misery that afflicts the central seated figure, watched over by the woman identified by Gauguin as 'from Le Pouldu' in the traditional black hood of mourning, and points to a reason for the disarray of her clothing and the irregular absence of a *coiffe*. In Gauguin's view this was his most successful painting of 1888. Only subsequently have critics given greater prominence to *La Vision*. Gauguin made repeated use of that hunched, brooding figure in later works, usually retaining the meaning of sexual transgression or, more specifically, the fall of Eve.

In a later account of their work together, Gauguin claimed to have diverted Van Gogh away from his disorganized attempts at Neo-Impressionist arrangements of colour complementaries. which resulted in incomplete and monotonous harmonies. towards more clashing resonances, encouraging him to juxtapose strong, flat areas of colour as he himself was doing. He also persuaded Van Gogh to follow him in undertaking compositions from memory, based on earlier sketches, away from the motif. The series of sunflower paintings which Van Gogh began prior to Gauguin's stay, as decorations for his bedroom, were initially done directly from the subject during the summer flowering season, as Gauguin's only portrait of him shows. Van Gogh's later sunflower paintings, on the other hand, were clearly done in part from memory, with some latitude for abstraction from the motif. Possibly, in this series, Van Gogh was emboldened by Gauguin's example to simplify his colour scheme, reducing it almost to the single colour yellow, indeed venturing further in the direction of simplification than Gauguin. Yet Vincent was hardly the compliant pupil Gauguin later suggested and was not to be shaken from his more firmly held convictions. In letters of early September they had established their essentially different attitudes to subject-matter. Whereas Van Gogh was forever in search of poetic motifs, Gauguin believed that poetry could be found in any subject and depended on the expressive manipulation of forms and colours. This essentially naturalist, formalist approach was a legacy of his years as an Impressionist but was no longer a strictly accurate account of his more recent artful and selective use of subject-matter. The imaginative use of memory championed and demonstrated by Gauguin in his painting Arlésiennes au jardin public, mistral was essayed by Van Gogh in his parallel painting of the public gardens, Memory of

60 OPPOSITE TOP *Volpini Suite: Misères humaines,* 1889 61 OPPOSITE BOTTOM *Vendanges à Arles. Misères humaines,* 1888

58

60

68

66

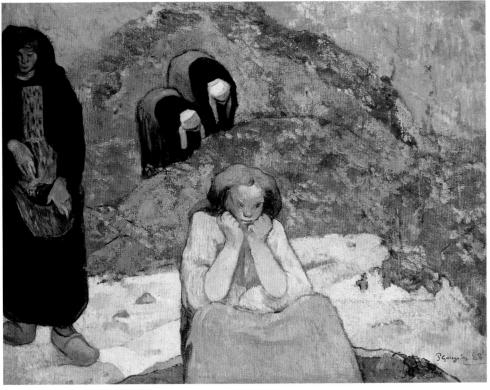

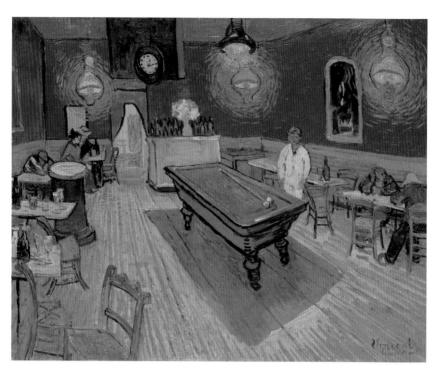

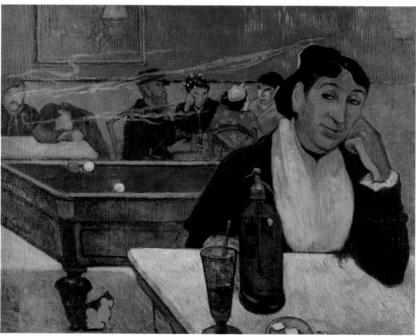

62 ТОР Vincent Van Gogh, Le café de nuit, 1888 63 ВОТТОМ Café de nuit à Arles, 1888

64 L'Arlésienne. Mme Ginoux, 1888

the Garden at Etten, into which he introduced memory images of his mother and sister in his home town of Etten. But Vincent quickly rejected this working method, to which he found himself temperamentally unsuited.

In a letter to Bernard of December 1888, written shortly after a visit they made by train to Montpellier, to see the Musée Fabre, Gauguin revealed considerable disagreement between himself and Van Gogh over the artists they most admired. Van Gogh tended towards the romantics and realists - Daumier, Daubigny, Ziem and Théodore Rousseau, 'all people I feel nothing for', Gauguin wrote, but he hated Ingres, Raphael, Degas, 'all people I admire'. Though enervating, these discussions with Vincent had the useful effect of clarifying in Gauguin's mind where his true stylistic allegiances now lay. The artists he admired, who all belonged within the classical tradition, were united by their calm, pondered, powerful drawing and their deliberate avoidance of chance effects, of slick or sloppy paint handling. Van Gogh, on the other hand, preferred those artists who expressed emotion through vigorous brushwork and colour. It is noticeable that Gauguin omitted Delacroix, realizing perhaps that to admit to their equal admiration of the great romantic would undermine the thesis he was constructing. Indeed, on a previous visit to Montpellier, Gauguin had made a copy of Delacroix's impressive portrait of Aline la mulatresse.

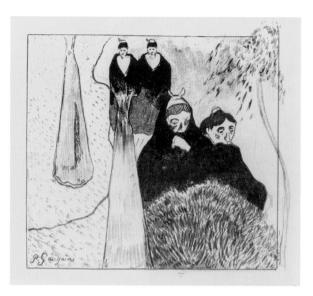

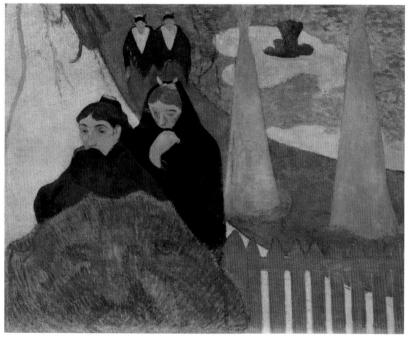

65 TOP Volpini Suite: Les vieilles filles (Arles), 1889

66 BOTTOM Arlésiennes au jardin public, mistral, 1888

67 OPPOSITE TOP Vincent Van Gogh, Memory of the Garden at Etten, 1888 68 OPPOSITE BOTTOM Van Gogh peignant des soleils, 1888

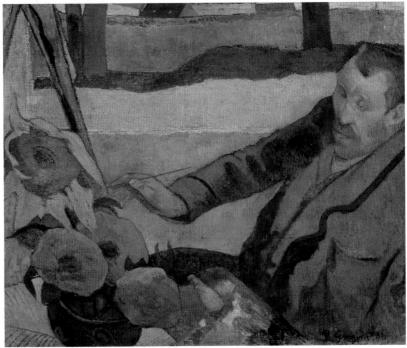

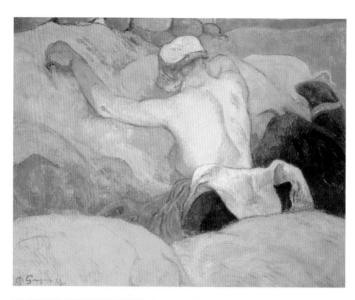

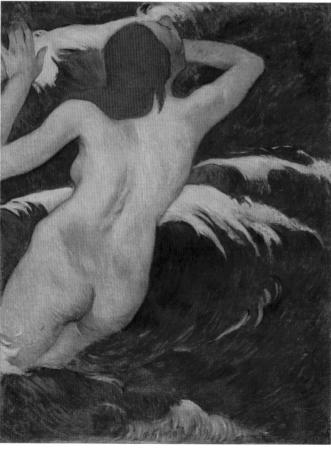

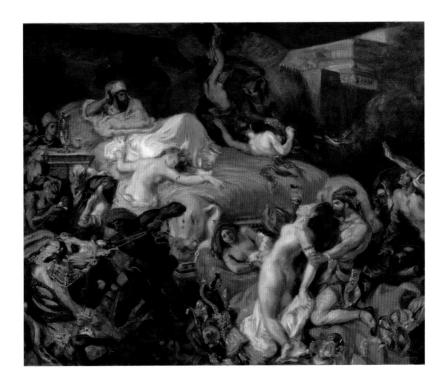

Whether there was a reference to a figure from Delacroix's Sardanapalus in Gauguin's Arles painting Dans les foins, or yet another reminiscence of Degas, this erotic nude subject, based on fantasy, marked a new departure for Gauguin and a sharp divergence from Van Gogh's subject-matter. Ondine or Dans les vagues, a somewhat similar fantasy image of an abandoned nude woman seen from behind, again reminiscent of Degas's and Delacroix's contorted nudes, seems to have been conceived in Arles. Although it bears the date 1889, it appears in reverse in the background of his Arles self-portrait. Painted on the same coarse sackcloth he had purchased while there, and referred to by Van Gogh in a letter, this self-portrait was one of the last pictures Gauguin made in Arles, perhaps intending it as a companion piece to and contrast with his portrait Van Gogh peignant des soleils. By his inclusion of a recently worked, highly synthetic image within the self-image, Gauguin established

69 OPPOSITE TOP Dans les foins. En pleine chaleur, 1888

69.71

70

72

⁷⁰ OPPOSITE BOTTOM Dans les vagues, 1889 (see ill. 72, painted against a reversed detail of this picture)

⁷¹ ABOVE Eugène Delacroix, La Mort de Sardanapale, 1844

72 Autoportrait, c. 1888–9 (see ill. 70)

a format for self-portraiture which he repeated on several later occasions.

After dispatching a consignment of five recent canvases to Theo, word got back to Gauguin from Paris that Degas had seen them and, with the exception of Vendanges à Arles, which he could not fathom, had enthusiastically admired them. Theo may also have passed on reports of Degas's envious interest in the energetic working relationship Gauguin and Van Gogh seemed to have established together, so different from his own feelings of incapacity. Once again, however, it was to be a short-lived collaboration. Both artists were beginning to realize by late 1888 that such a charged atmosphere could not be sustained without a catastrophe; the break came on 23 December when, after a drunken argument, in an inflamed state, Vincent lunged at Gauguin with a razor. Gauguin fled and discovered the next morning that in remorse Vincent had turned the blade on himself, slicing off a part of his ear. Having ascertained that his companion's life was not in danger, Gauguin removed himself from the scene and returned

hastily to Paris, cutting short his stay in Provence by some four months.

Although the experiment of working with Van Gogh was ultimately disastrous, once the memory of this violent incident had receded, there was no reason for either artist to feel it had been a wasted or negative period in their careers. Gauguin had turned out a varied group of paintings, mostly of high calibre. In conversation he and Van Gogh had touched on many vital topics; together they had reviewed their positions in the light of the history of art; Gauguin's talk of the tropics had inspired Vincent's enthusiasm, making the plan to return there seem a more reasonable and tangible one, one worth working towards. On returning to Brittany in spring 1889, Gauguin found his response to its character had gained new focus and purpose now that he was able to contrast it with the south, and many of the projects for picture-making which he followed through in 1889 stemmed from the discussions that had taken place in Arles.

Chapter 4 Leader of the Symbolists (1889–1891)

Lodged once again in Paris with the Schuffeneckers, Gauguin seems to have lost no time in resuming the work he had left in abeyance the previous winter and renewing contacts with the artistic and social world. Just two days after his arrival, he attended the public execution by guillotine of an infamous murderer, Prado, an experience he later recalled in his autobiographical writings. Although there was nothing exceptional about attending executions in Paris at this date, in view of Gauguin's own recent brush with death the event must have had a particular poignancy. There is every reason to connect it with the strange ceramic *Vase Autoportrait* he made in Chaplet's new studio early in 1889, with its closed eyes and pooling of red-stained *flambé* glaze round the apparently severed neck. Here, once again, Gauguin played on the image of the artist as society's pariah and victim.

Given Degas's recent expressions of interest and support, it is quite possible that Gauguin took the opportunity of visiting the elder artist in his studio. Such a visit would explain the continuing vestiges of Degas's influence in his paintings of early 1889. In Degas's studio Gauguin might well have seen the artist's copy of Holbein's Anne of Cleves, the painting that has often been seen as the source of Gauguin's portrait of the inn-keeper's wife in Pont-Aven, La Belle Angèle. Portrait de Mme Satre. He would also have been exposed to Degas's recent pastel studies of the nude, all the more relevant to Gauguin's current preoccupation with the nude theme. In the important canvas entitled Femmes se baignant. La vie et la mort, for instance, which developed conceptually from the paintings Gauguin had done in Arles, the right-hand figure seems to bear a general resemblance to Degas's women bathers. The left-hand figure, though, who symbolizes death, came from a very different

74

77

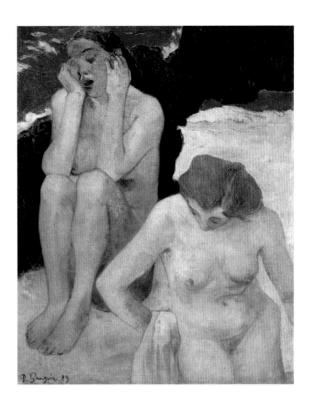

73 Femmes se baignant. La vie et la mort, 1889

source (as Wavne Anderson was the first to demonstrate): it indicates Gauguin beginning to venture beyond the Louvre and the art galleries, and to explore the lesser known corners of Paris, notably the newly formed collections of folkloric. 'primitive' and ethnographical items, many of which had been gathered on recent archaeological and colonial expeditions. Gauguin based the pose of his death figure on the almost foetal pose of a Peruvian mummy, a somewhat gruesome exhibit at the Ethnographical Museum in the Trocadéro Palace. A borrowing from such an unlikely, non-European source contradicted Gauguin's indebtedness to Degas, as he was not slow to realize. Writing to Schuffenecker in the summer of 1889, he expressed growing misgivings about the naturalism of Degas, arguing that his dispassionate observations carried the 'smell of the model' and lacked a sense of mystery. By so deliberately giving his own nudes titles that suggest their symbolic or allegorical significance, Gauguin was surely trying to distance himself from what Degas had achieved.

The nude was traditionally a vehicle for allegorical presentation. The portrait, however, was a genre in which

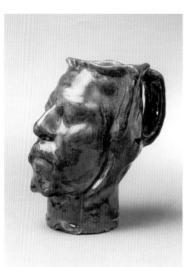

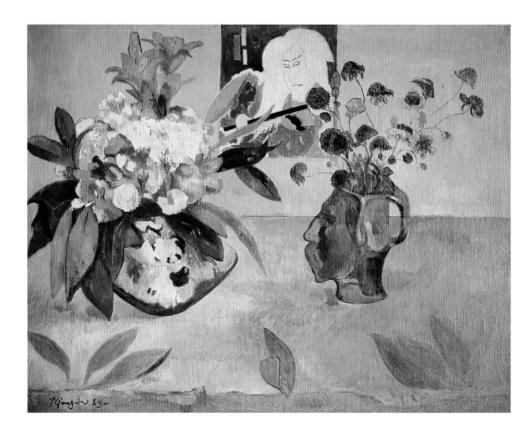

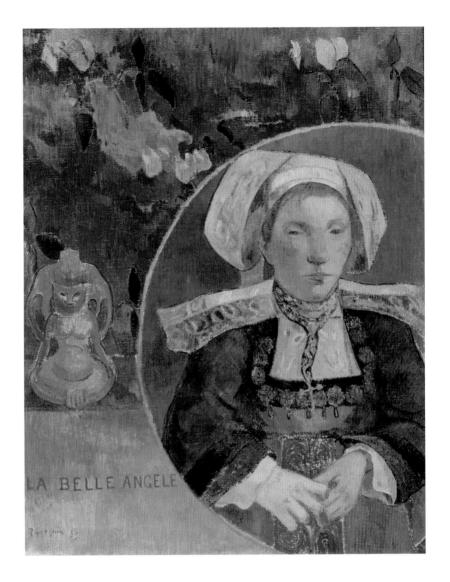

⁷⁴ OPPOSITE TOP LEFT Vase autoportrait, 1889

⁷⁵ OPPOSITE TOP RIGHT Peruvian mummy from the northern Andes, 1100–1400

⁷⁶ OPPOSITE BOTTOM Nature morte à l'estampe japonaise, 1889

⁷⁷ La Belle Angèle. Portrait de Mme Satre, 1889

the artist was still expected to produce a recognizable likeness. and not take too many liberties. Gauguin's interest in portraiture had been greatly stimulated by the example of Van Gogh, for whom it was unquestionably the noblest genre, but it was the composition of Degas's *Bellelli family* portrait that surely inspired him when he turned to the new problem of a group portrait of the Schuffenecker family, early in 1889, perhaps as a gesture of recompense for their generous hospitality. He did not hesitate to inject it with his own personal feelings and meanings, with the result that he was in danger of alienating the sitters. He had frequently referred to Mme Schuffenecker as a shrew, and he represented her here as a threatening, almost predatory figure with a claw-like hand, her bulky presence accentuating the cringing, self-effacing stance of Schuffenecker himself. Although we have no record of the latter's reaction. in his anxiety to make a name as a serious painter he cannot have been too pleased to see the tribulations of his private life demonstrated in this way. We only know that the painting was not exhibited publicly during Gauguin's lifetime. On the other hand, we do know something about Mme Satre's reaction when faced with Gauguin's highly stylized portrayal, Reputed in Pont-Aven as a beauty, she was so insulted by the somewhat cow-like rendering that she threw the portrait back in Gauguin's face. It remained unsold until 1891 when Degas acquired it for 450 francs. Henceforth Gauguin's more extravagant experiments in symbolic portraiture were confined to his own self-image.

For Gauguin, 1889 was to be a year for testing the public's response to the important advances he had made. He knew that only a public success would prove him in the eyes of his wife. with whom he had had strained and infrequent contact over the previous year. She continued, nevertheless, to dominate his thoughts and to provide a spur to his ambitions. Seven of his recent works went on show in February at the exhibition of the Vingt group in Brussels, an occasion on which several of the paintings received their full poetic titles, among them La Vision du Sermon. La lutte de Jacob avec l'Ange and Vendanges à Arles. *Misères humaines*. The critical response was disappointing, perhaps because the critics, only just attuned to the Neo-Impressionists, were unprepared for Gauguin's 'abstractions' from nature and his un-naturalistic colours. For the most part, they treated his Symbolist pretensions with derision and La Vision in particular was much mocked. In the Paris weekly La Cravache, however, Gauguin was congratulated

58

61

⁷⁸ OPPOSITE TOP La Famille Schuffenecker, 1889
79 OPPOSITE BOTTOM Autoportrait au Christ jaune, 1890–1

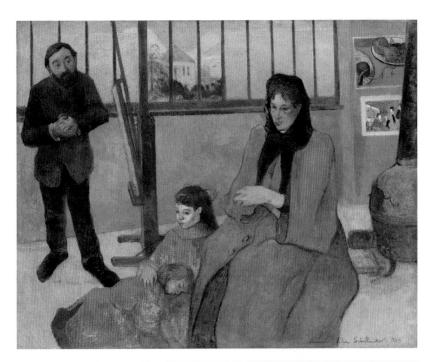

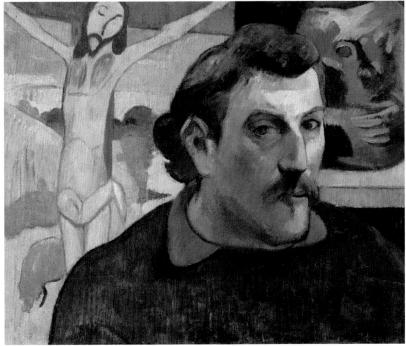

by Octave Maus, secretary to the Vingt group, on the 'primitive character of his paintings' and on the charm and refinement of his colour harmonies; Maus applauded Gauguin for leaving behind his debt to the landscape Impressionists and deemed the admiration of Degas ample compensation for the incomprehension of the public.

Gauguin's absence from any group exhibition in Paris since 1886 made him very conscious of the need to be seen there again, preferably in the context of works by other artists working along parallel lines with himself. Although 1889 had opened with a slump on the stock market, Paris was in a fever of preparation for the grandest Universal Exhibition yet, which would celebrate the centenary of the French Revolution in an orgy of commercialism from May to October, Art would of course have its place in the exhibition, next to France's technological achievements, and a huge Palais des Beaux-Arts was erected on the Champ de Mars site, under the shadow of the newly constructed Eiffel Tower. But as was to be expected. only officially sanctioned artists were to participate. The 'Decennial Exhibition', which was intended to give foreign visitors an insight into French art of the last decade, was dominated by the stars of the Salon, such as Bouguereau. Carolus-Duran, Bastien-Lepage and Dagnan-Bouveret. A few of the earliest examples of Impressionism were allowed into the 'Centennial' but the Monets, Renoirs and Pissarros occupied a very small enclave amid the rooms full of French history painting. Seurat and his Neo-Impressionist group would make their presence felt at the annual show of the Indépendants in September, which, with the influx of tourists, was fairly certain to increase its audience.

Both Gauguin and Schuffenecker saw the Universal Exhibition as an opportunity to make a big noise for themselves; it would be a sensational *coup* to get their works shown inside the designated exhibition ground. They achieved their end by persuading M. Volpini, the director of one of the larger exhibition cafés, the Café des Arts, to hang their pictures on his walls. Theo Van Gogh was not in favour of this plan, seeing it as a vulgar backstage manoeuvre, and he advised Vincent not to have any part in the show. Guillaumin also turned down the invitation to participate. A group of a hundred or more works was eventually mustered, by Gauguin, Bernard, Schuffenecker, Laval, Anguetin and some younger, lesser-known artists, among them Daniel de Monfreid (a friend of Schuffenecker's, who was later a devoted correspondent and mediator when Gauguin was in Tahiti). The exhibition of the self-styled 'Groupe impressionniste et synthétiste' opened

on 10 June and lasted until at least September; a small, handprinted catalogue was produced by the artists.

Hoping to make some fast money through the sale of lithographs, Gauguin and Bernard had compiled albums of Bretonneries using bold, simplified designs, printing them from zinc, which was a cheaper surface than stone. For this first venture into printmaking, Gauguin mainly used subjects from his Breton and Martinique paintings of the previous two years. His growing appetite for suggesting oblique and mysterious meanings led to his retrospectively loading some of the images with literary titles and, as in the case of some of his paintings, there was a danger of these sounding pretentious or superfluous. Without its title, the image in Les Cigales et les fourmis can be read on a straightforward level as an observation of daily life in Martinique. With its reference to La Fontaine's fable, the title adds a second level of literary meaning, or perhaps of ambiguity: which are the grasshoppers, which the ants? The paintings Gauguin showed included most of those already exhibited in Brussels, with the notable exception of La Vision, and a few new works such as Eve and Dans les Vagues

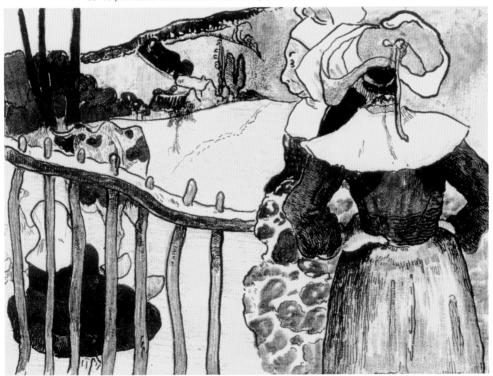

82

81

83,70

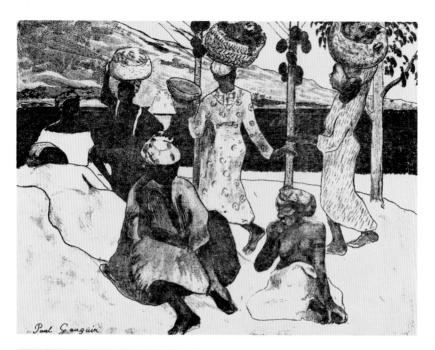

Paul Gauguin Charles Ladal Léon Fauché

E. Schuffenecker Louis Anquetin Georges Daniel

EXPOSANTS

Emile Bernard Louis Roy Ludovic Nemo

81 TOP Volpini Suite: Les Cigales et les fourmis, 1889 82 BOTTOM Aux Roches noires, frontispiece of the Volpini exhibition catalogue, 1889 (*Ondine*). Gauguin combined the two latter images in *Aux Roches noires*, the frontispiece to the catalogue.

82

Gauguin's hope, as he candidly explained to Theo Van Gogh, was that this show would demonstrate to the older Impressionists and to Seurat that he was now a free artist, able to summon support from other quarters than theirs and able to command public and critical attention in his own right. One critic whose support Gauguin actively cultivated was the young Symbolist poet Albert Aurier, a friend of Emile Bernard's. In April 1889 Aurier launched a new, light-hearted and risqué weekly journal, Le Moderniste, addressed to an urbane male readership. This publication featured not only the Volpini exhibition at the Café des Arts, illustrating some of the works on show there, but it also gave Bernard and Gauguin space to try their hand at art criticism. As a result, almost all the summer issues of the short-lived periodical sounded the drum for the new Pont-Aven Synthetist style, thus making the declared editorial policy of eclecticism and impartiality sound rather hollow. Other reviewers were less comprehending. Jules Antoine in Art et Critique complained of the 'barbarousness' of the works on show and of the difficulty of telling which artists were Impressionists and which Synthetists. Of much greater weight was the review in La Cravache by Félix Fénéon, who argued that Gauguin, in this exhibition, had shown himself to be, like Seurat, a defector from Impressionism. All along. but by different means, so Fénéon argued, Gauguin had been working towards a similar goal to Seurat, an art of 'synthesis and premeditation'. As though arming himself against future attacks. Gauguin copied and treasured the opening paragraph of this review, in which his most recent canvases were said to crown and confirm the consistent tendency of his paintings, sculptures and ceramics towards archaism and exoticism. He was less enamoured of Fénéon's suggestion that Anguetin, whom both he and Fénéon considered an artist of inferior talent, might have had some influence on his style. However, Gauguin's protestation that he did not know Anquetin was scarcely proof that there had been no cross-fertilization: Bernard had effectively acted as mediator between the two artists. Possibly Gauguin sensed the double-edged nature of Fénéon's observation that both Bernard and Laval would need to free themselves from the stamp of Gauguin, whose work was 'too arbitrary or at least results from a state of mind that is too peculiar for newcomers usefully to be able to take him as their starting point'. Fénéon clearly did not think that Gauguin had the potential to lead others, as Seurat had done, or had established a style on which others could build.

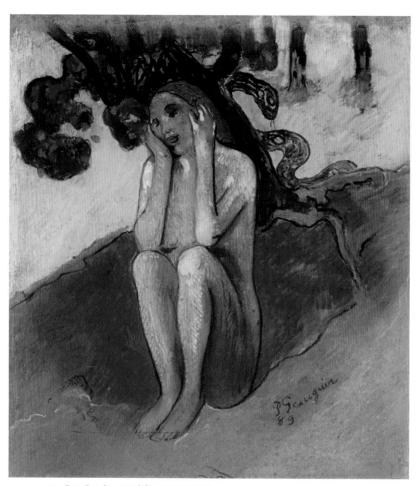

83 Eve. Pas écouter li li menteur, 1889

Although to our eyes the paintings exhibited at the Volpini Café des Arts scarcely form a coherent, homogeneous group, there was some consensus of critical opinion about their appearance. Whether damning or praising the fact that the new pictures were quirky, arbitrary and personal, most critics commented on the daringly simple, childlike and caricatural drawing and the flagrantly flat, anti-illusionistic colour application. These innovations had the effect of exciting and intriguing a whole section of disaffected young art students, already rebelling against the outworn academic dictates of their teachers (whose sole ideal seemed to be illusionistic trickery bolstered by photography), but who had been unsure

how to proceed towards a more 'honest' form of art. Isolated individuals such as the southerner Aristide Maillol and the Dutchman Ian Verkade were fired by what they saw at the Volpini exhibition, but the key figures in this band of potential disciples were the students at the Académie Julian, well-educated young artists of a more intellectual bent than Gauguin, notably Paul Sérusier and Maurice Denis. With a group of like-minded friends, these students had already formed a secret artistic fraternity within the art school, halfjokingly calling themselves the 'Nabis'. Hebrew for prophets. By visiting Theo Van Gogh's gallery they had familiarized themselves with the recent Synthetist works of Gauguin, the raw elements of which Sérusier had gleaned in Pont-Aven in October 1888. On returning to Paris at the beginning of the new term, Sérusier had brought with him Le Talisman, le bois d'amour, an embryonic abstract landscape done under Gauguin's instructions. Gauguin, and Sérusier in his wake, used it as an object lesson in how to paint with pure colour, straight from the tube, without adhering too closely to the details or local colour of the scene to be represented. The idea of disseminating revolution in one of the strongholds of artistic conservatism greatly amused Gauguin and as a politician he could also see its practical advantages. So when Sérusier

84 Paul Sérusier, Le Talisman, le bois d'amour, 1888

wrote to Gauguin, after seeing the Volpini show, 'I am one of yours', and announced his intention of coming to join Gauguin in Brittany, he was warmly welcomed. The practical efforts Sérusier and Denis made to support Gauguin over the next year or so, for example by publishing a combative article entitled 'Définition du Néo-Traditionnisme' in August 1890, penned by Denis but in many ways a joint undertaking, also received the artist's appreciative approval.

Gauguin was a firm believer in artists taking up their own defence, arguing their case. In July 1889, in two consecutive articles in Le Moderniste, he aired his own observations about the Universal Exhibition. He complained of the paucity of modern design to be seen there, and pointed out the need for a new kind of ornament to suit iron, the building material of the age. He contrasted the wonderful design and craftsmanship of the middle ages with the lifelessness of present-day furniture and sculpture. His cry for authenticity, truth to materials, had a particular bearing on his own work as a wood-carver and ceramicist but also showed that he was in tune with the growing European-wide movement promoting the traditional arts and crafts. He singled out from the mass of Sevres and other manufactured pots on show the exceptional work of Chaplet and Delaherche. (Lest any readers of the article should fail to make the connection, Aurier appended a note demanding to know why Gauguin's own remarkable pots and statuettes were nowhere to be seen at the Exhibition!) Gauguin had few words of praise for the fine art on show, apart from Manet, pointing out that the absence of a representative work by Manet in a public collection was a public disgrace. Here also he joined his voice to a contemporary campaign, launched by Monet earlier in the year, to get Manet's Olympia bought for the nation and installed in the state's collection of modern art. the Luxembourg.

For most people the Universal Exhibition provided an array of ephemeral distractions but for some it offered more lasting food for thought. Although drawn to the coloured fountains and the Javanese dancers, Camille Pissarro was repelled by the underlying French ideology, with all its nationalistic, materialistic and imperialistic fervour. Gauguin was a less critical visitor. He went repeatedly to watch the stunts of Buffalo Bill, a reflection of the unashamedly macho side of his character, which also emerged in his enjoyment of fencing and boxing. He was a curious and assiduous visitor of the Colonial Exhibition too, which demonstrated aspects of the life and culture of French-held territories such as Madagascar, Martinique, Tahiti and Tonkin (now Vietnam).

85 The Palais des Colonies at the Universal Exhibition 1889, Paris

Gauguin's apparently naïve acceptance and Pissarro's criticism of the interests behind the Exhibition are a fair indication of the divergent political views of the two artists. Certainly, reactionary political concerns had governed the organization of the Exhibition. If an especially important place was given to the delegation from Tonkin, annexed from China in a recent and bloody conflict, it was undoubtedly to persuade the government's critics of the worthy gain that had been made and to attract potential colonists. The message of the Exhibition was directed not only at the French voters, so recently and dangerously swayed by the absolutist claims of General Boulanger; it was also aimed at those new and far-flung subjects, chosen to come to Paris for a few months as living exhibits of their native countries. Indeed, E. Monod, reckoning up the score at the end of this exhibition year, confidently reassured his readers that the message had been got across: 'our natives took away the impression that France is a rich and powerful country, whose moral superiority they recognize and whose authority they will be less and less tempted to contest.'

Although Gauguin would scarcely have endorsed these sentiments, his appetite for the colonial life was unquestionably reawakened at the Universal Exhibition by the spectacle of the colourful native costumes, dwellings and exotic artefacts –

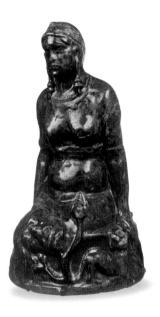

86 LEFT Étude de personnages annamites à l'Exposition Universelle, 1889 87 RIGHT Vénus noire, 1889

a huge Tonkinese Buddha, for example – and encounters with different racial groups, some of whom he sketched. His ideas, repeated over the coming months, of how easily life could be lived in, say, Madagascar or Tahiti, reflected the information provided in the official handouts. At first, his plans for returning to the tropics focused on Tonkin. Perhaps, like the gossip journalists, he was disappointed by the delegation of Tahitian women, whose legendary beauty had been praised so evocatively by Pierre Loti a decade earlier in his novel Rarahu or Le Marriage de Loti. Evidently, the colonial functionary responsible for selecting them had been more concerned with their morals than their looks, the two reputedly never going together in Tahiti. Like the gossip columnists, Gauguin became obsessed by the dream of tropical idylls, and he was prompted to formulate his artistic image of primitive beauty, a new ideal to set against the lifeless ideal woman of Europe. In Black Venus, for instance, a ceramic sculpture probably modelled in May 1889, the image of the black woman was calculated to disturb spectators. He was particularly keen for Theo Van Gogh

86

to put it on show in July, on its completion, before the Universal Exhibition closed.

So it was with his thoughts firmly set on the tropics that Gauguin returned once more to Brittany in June. No sooner had he arrived than he complained of how crowded and spoilt Pont-Aven had become. He decided to move some twenty kilometres away to the more remote hamlet of Le Pouldu, where he had worked briefly the previous year. Set on a rocky peninsula, Le Pouldu was characterized by scattered farms, windswept dunes and sandy beaches. Gauguin was joined at the Hôtel Destais by two new disciples, Paul Sérusier and a wealthy Dutchman, Meijer de Haan, to whom he had been introduced by Theo Van Gogh. At first, Sérusier feared that Gauguin was just a joker, not the serious philosophical artist for whom he was searching. Both Sérusier and De Haan had a strong philosophical bent, to which Gauguin made reference in his symbolic portrait of De Haan entitled Nirvana. They no doubt helped to keep Gauguin abreast of the latest anti-positivist thinking that was becoming fashionable in intellectual circles in Paris. If De Haan's reading included Milton and Carlyle, as another of Gauguin's paintings indicates, Sérusier was reading Edmond Schuré's

88 Nirvana. Portrait de Meijer de Haan, 1889

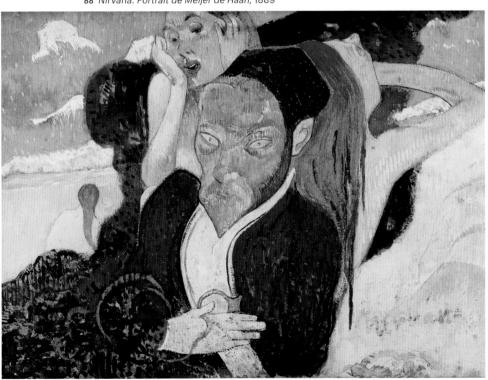

Les Grands Initiés, a comparative study of world religions, in which Christianity was given a logical but by no means more prominent place beside Buddhism and the Indian Vedic religions. A number of Gauguin's more abstruse images from this date onwards suggest at least a passing familiarity with these esoteric strands of Symbolist discourse.

On a more practical level, Sérusier, working under Gauguin's tutelage, quickly overcame his initial mistrust but was perplexed by the problem of whether or not to paint from nature, how much art depended on observation, how much on memory and imagination. One senses that he was impatient

89 The Red Cow. 1889

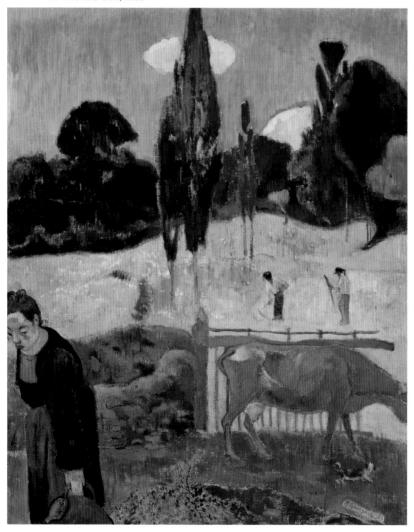

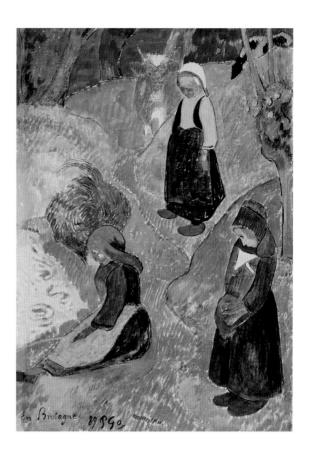

90 En Bretagne, 1889

to throw off, there and then, the academic yoke of copying, but nervous about doing so, whereas Gauguin, who had the capacity and experience to take a longer look at his artistic progress, was aware that a period spent in fairly straightforward contact with nature was a necessary prelude if he was to launch and sustain another concerted effort at symbolic abstraction. After the experience of Arles, Gauguin felt especially drawn to the harsher, more primitive aspects of the Breton landscape. In a letter of October to Vincent Van Gogh he wrote that the very costumes of the peasants seemed to express the sadness and god-fearing rigour of their lives. He contented himself with fairly naturalistic renderings of landscape motifs in the immediate vicinity, often working with De Haan or Sérusier, paying a new attention to agricultural activities, perhaps another sign of Vincent's influence.

Working on landscapes or still lives had the advantage of allowing them to concentrate on technical problems, in

89, 90

Leader of the Symbolists (1889-1891)

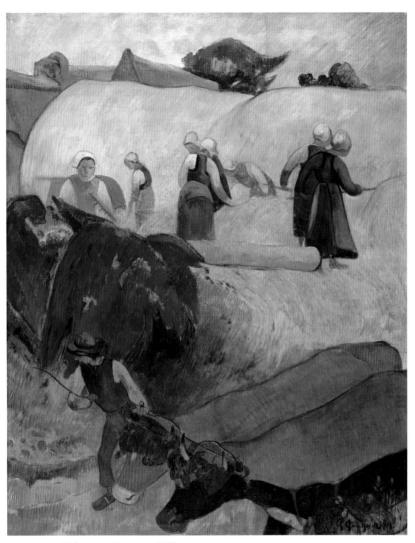

91 Moisson en Bretagne, 1889

Gauguin's case, how best to achieve the even, matt, rustic and primitive appearance he wanted in his pictures. Works such as *Misères humaines* had shown him how extremely coarse canvas could be used to absorb much of the greasy base of oil paint, leaving only a thin opaque coat of colour. He also experimented with a technique involving wet newspaper, paste and the application of hot irons – a technique learnt from a picture restorer – to produce an unvariegated matt surface.

Gauguin later described the general goals he had been working towards: 'I scrutinized the horizons, seeking that harmony of human life with animal and vegetable life through compositions in which I allowed the great voice of the earth to play an important part.' In works such as Moisson en Bretagne, it is the strength of the underlying design rather than the colour or brushwork that establishes harmony: lines are smoothed and simplified and strong rhythms established through repeated shapes (the tree and the shaggy green bush echo the shape of the heads of the oxen in the foreground); colour is applied flatly and in an unemphatic way. Much the same technique was used in the large composition Ramasseuses de varech, also painted at Le Pouldu. Seaweed had regularly been gathered there for use by farmers as a fertilizer, but in the nineteenth century it was also an important source of iodine. Gauguin, in common with many of his contemporaries, seems to have been struck by the melancholy aspect of this strange form of harvest.

Although these works were by no means naturalistic transcriptions of the surrounding landscape, with *Le Christ*

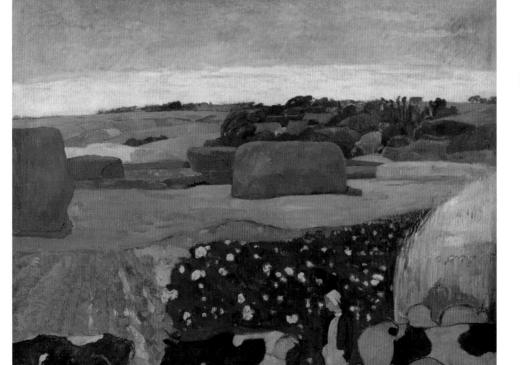

92 Haystacks in Brittany, 1890

91

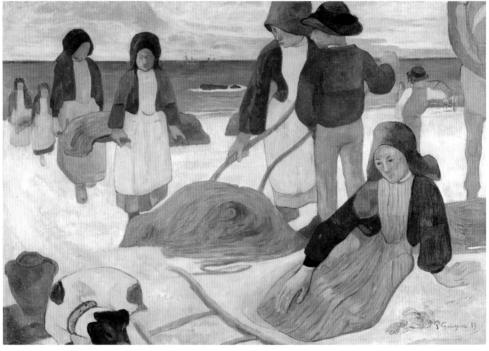

93 TOP Rentrée des vaches à Pont-Aven, 1889? 94 BOTTOM Ramasseuses de varech, 1889 jaune Gauguin consciously embarked on a more imaginative and ambitious series of works, once again inspired by Breton piety. The figure of Christ was based on Gauguin's simplified sketch of a wooden crucifix in the ancient chapel of Trémalo near Pont-Aven. The synthetic interpretation of the original carving was carried through into the painting. The flat, unmodelled and unvariegated vellow, Gauguin later explained, was intended to express the feelings he had about the desolate isolation and medieval quality of Breton life. though in all probability the yellowish stain of the crucifix itself first suggested the use of this colour. He evidently used the technique of blotting the surface with wet newspaper as the print is still visible on the paint surface, perhaps to dull the glossiness of the oil pigment and give an aged appearance to that strident yellow. Quite possibly the idea behind this subject. and Le Christ vert. Le Calvaire Breton which followed, can be traced to a poem by Marie Krysinska, Le Calvaire, published in La Revue Indépendante in June 1889. Written in free verse by one of the alleged pioneers of this revolutionary form in Symbolist poetry, the poem describes a simple stone calvary representing the Christ of sorrows which seems to the poet to link symbolically the desolate heath and its earthbound penitents with the 'glorious golden sky' above.

97

96

95

100

98

The visual source for *Le Christ vert* was the carved stone pieta in the village of Nizon near Pont-Aven. The calvaries were notable and distinct features of the Breton scene for the visitor and it is surprising that until then Gauguin, with his

95 Crucifix from the chapel at Le Trémalo, near Pont-Aven

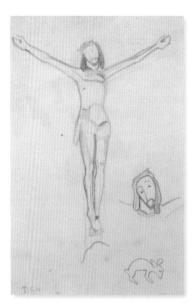

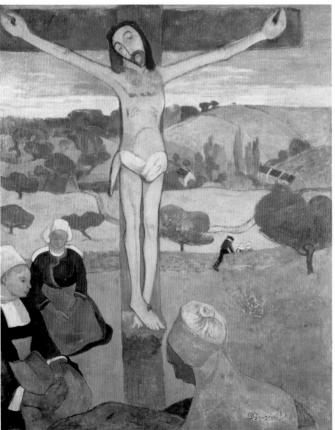

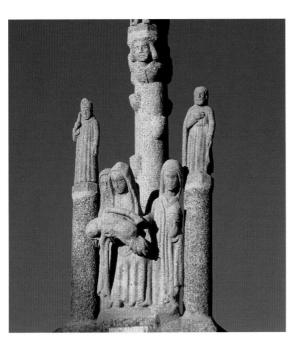

sculptural interests, had made no reference to them. His desire to avoid the well-established conventions for painting Brittany, conventions exemplified by the slightly later calvary painting of the Breton Salon artist Yann D'Argent, *Le Calvaire de Quillinen près de Quimper* (1893), may have blinded him to their expressive potential. Although essentially the local inspiration and message of workaday piety of the two paintings were the same, where D'Argent gave a realistic sense of scale and location, Gauguin deliberately distorted the various elements, severing the deposition motif from the rest of the calvary, making the carved figures life-size and merging them with the landscape, using not the close setting of Nizon but instead the dune-scape of Le Pouldu, more dramatic and expressive of the mood of sadness he wished to convey.

From 1888 onwards Gauguin's responsiveness to local Breton art, in the form of sculpture and traditional carved furniture, bore fruit in a number of projects. There was a carved 'armoire' along traditional Breton lines on which he worked with Emile Bernard, incorporating his own signature motifs of geese,

103

⁹⁶ OPPOSITE TOP Study for Le Christ jaune, 1889

⁹⁷ OPPOSITE BOTTOM Le Christ jaune, 1889

⁹⁸ ABOVE LEFT Deposition from the calvary at Nizon, near Pont-Aven

⁹⁹ ABOVE RIGHT Yann D'Argent, Le Calvaire de Quillinen près de Quimper, 1893

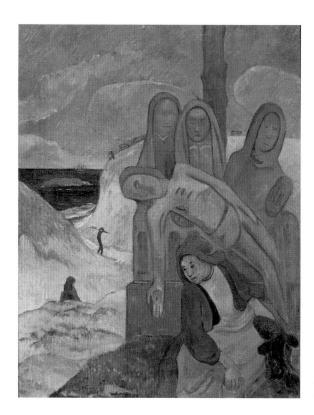

100 Le Christ vert. Le Calvaire Breton, 1889

Martiniquais and Breton women. In the autumn of 1889. after first modelling the design in clay, he embarked on his most ambitious wood carving to date, Soyez amoureuses vous serez heureuses, using a panel of fine linden wood, especially ordered through Schuffenecker from Paris. Wooden panels. sometimes carved with figures and inscriptions, were used as sliding doors in the traditional Breton box beds and although Gauguin's panel seems not to have been intended for such a function, it may owe part of its inspiration and imagery to such indigenous carvings. Indeed, the Trémalo chapel where Gauguin found the crucifix for *Le Christ jaune* boasted beams and lintels carved with painted human and animal heads. Some of the details in his complex design bear a resemblance to such grotesques. The male figure attempting to seduce the naked woman to lower left, whose wedding ring is emphasized, is yet another self-portrait. What personal experience, if any, this conjunction may refer to has never emerged from the wealth of speculation about Gauguin's private life. For all its deliberately primitive appearance, the message Gauguin

101

102

evidently wanted his carving to convey was a modern, secular and cynical one, an ironic reflection on the hollowness of the motto 'Be in love and you will be happy'. Soyez amoureuses was in a sense a labour of love, carved over many weeks during spare intervals from painting, the contours of the woman's body painstakingly smoothed, stained and polished in contrast to the more roughly hewn areas where the cuts of the chisel were deliberately left visible.

101 Soyez amoureuses vous serez heureuses, 1889

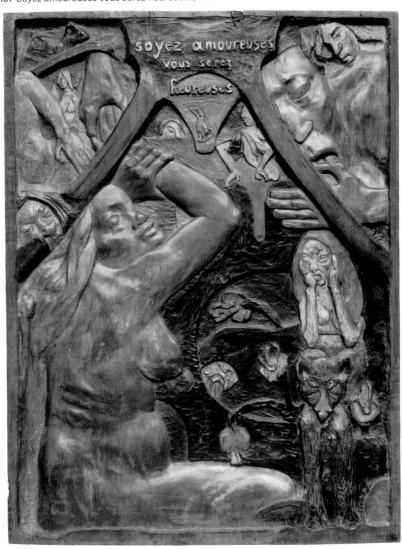

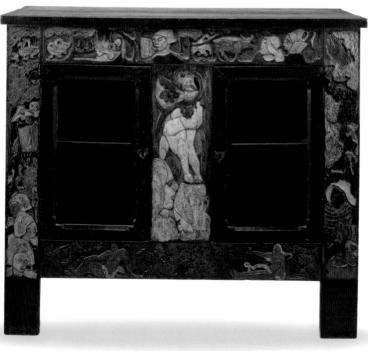

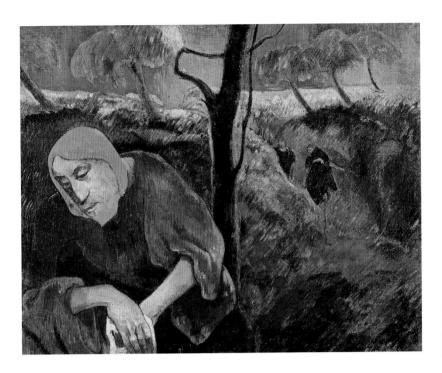

Gauguin had invested much time and energy in this carving and in his new religious canvases and was clearly upset when reports of their negative reception filtered back from Paris. To assist Theo Van Gogh, he wrote elaborate, though still open-ended explanations of their meanings, but he expressed his impatience with people's desire to pin him down: 'either it's good or it's not artistic'. Ironically, Gauguin's feelings were echoed two years later by the critic P. M. Olin, reviewing *Soyez amoureuses* at the Vingt show in Brussels. He found fault with the inscription on the grounds of its over-precise fixing of meaning which, he felt, removed the suggestive quality of the imagery and made the work into a sort of rebus or picture puzzle.

In view of the consternation his works were evidently causing in Paris in the late autumn of 1889, Gauguin decided to hold back the one picture that he was certain would be misconstrued, *Le Christ au Jardin des Olives*, though he sent a sketch and description of it to Vincent Van Gogh. Much has been made of the blasphemous implications of Gauguin's

104 106

102 OPPOSITE TOP Breton lit clos (box bed)
103 OPPOSITE BOTTOM Paul Gauguin and Emile Bernard, carved and polychromed cabinet known as Paradis terrestre, 1888
104 ABOVE Le Christ au Jardin des Olives, 1889

identification with Christ, for it is fairly clear, despite the brilliant red hair, that he used his own features for the face; moreover, Gauguin at this time frequently compared his own trials with those of Christ. Vincent was distressed by the work, and strongly disapproved of the entirely imaginary turn Gauguin's and Bernard's imagery seemed to be taking, arguing that if *he* were to attempt to convey the message of Christ's sorrow, he would make a painting of olive groves, something he could actually see.

It is worth noting that Gauguin and Bernard were not alone in using the image of the calvary or of Christ's agony in an autobiographical way. In 1886 Octave Mirbeau had published his novel Le Calvaire, transparently based on the author's sufferings at the hands of a faithless mistress, and Albert Aurier's poem *La Montagne du Doute*, first published in 1889 and well known to Bernard and Gauguin, equated the burden borne by Christ with that of the poet, endowed with the dubious gift of genius. Much of the responsibility for enabling such parallels to be made lay with Ernest Renan, whose Vie de *Jésus* of 1863 had brought a modern, positivist and psychological approach to bear on the known facts of Jesus's life on earth, effectively explaining Christ's sufferings as though he were an ordinary mortal. After falling out with Gauguin in 1891, Bernard condemned his former comrade's shallow understanding of Christianity: 'Look at Gauguin's Christs, they are human, they are of this world.... Christ did not shed stupid tears onto beautiful veined hands. All that has to do with Gauguin, that's to say with self-adoration, with the purely profane, with Renan.'

105 Marc-Antoine Verdier, Le Christ couronné d'épines. Portrait d'Alfred Bruyas, c. 1850

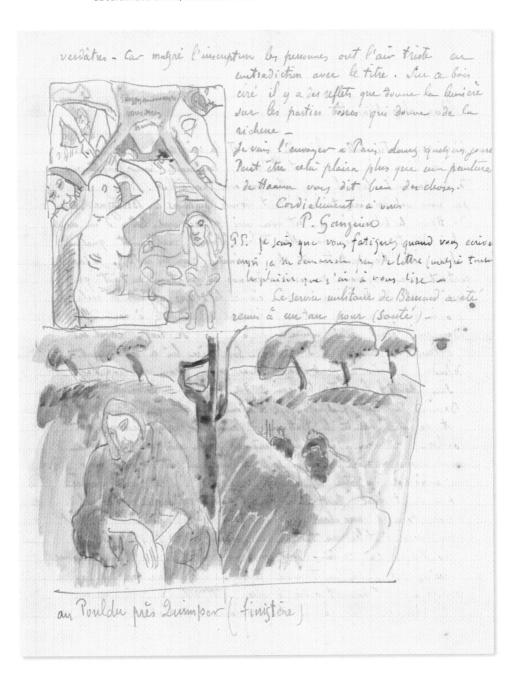

Gauguin might well have had a visual precedent in mind when he embarked on this symbolic self-portrait. On his visit to Montpellier with Vincent Van Gogh, both artists had been struck by the many portraits made by notable contemporary artists of Alfred Bruyas, the enlightened but somewhat narcissistic patron whose collection dominated the Musée Fabre there. One of these, by Marc-Antoine Verdier, portrayed him as *Le Christ couronné d'épines*, whose colouring and general disposition has similarities with Gauguin's.

Among the decorations Gauguin and his friends painted onto the walls and doors of the dining room in Marie Henry's inn at Le Pouldu, were two further highly contrived selfportraits by Gauguin. In one of them, essentially a caricature. he used a totally flat, linear style, as on a playing card, to present himself symbolically as the Fallen Angel. In the second. Boniour M. Gauguin. Gauguin alluded to the title at least of Courbet's Bonjour M. Courbet, which represents Bruyas in a landscape setting greeting his celebrated artistic protégé Courbet, who is dressed in the guise of the Wandering Jew. Although Courbet too had drawn the analogy between the artist and the outcast, he nevertheless represented himself as boldly squaring up to his patron, whereas Gauguin's depiction of a chance encounter with a Breton peasant woman merely reinforced his isolation and alienation. In all these paintings, Gauguin seems to have been concerned to convey a predominant mood of depression and suffering, tinged by a world-weary cynicism; in a long letter to Theo Van Gogh, he asserted that in his recent works he had sought to suggest the idea of suffering without explaining what sort of suffering. This claim in itself demands some explanation, for Gauguin's aims sometimes appear contradictory. At one level he was undoubtedly wary of being judged a 'literary' painter and sought to dissociate himself from the notion of producing works of art that had to be 'read' to be understood. Yet at another he deliberately cultivated complex, ambiguous and autobiographical meaning, almost as a gesture of defiance: if the critics were so woefully unable to appreciate him, then he would make sure they could not understand him either. In June 1890 he wrote to Vincent Van Gogh, for the last time as it turned out, 'Alas I see myself condemned to be less and less understood, and I must resign myself to following my path alone, dragging out an existence without family, like a pariah.... The savage will return to the wilderness.'

In the context of Symbolism, which demanded that artists should touch the spectator's feelings through the combination of forms and colours, not through sentimental stories, and

105

108

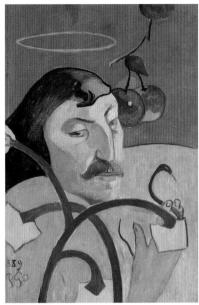

107 Reconstruction of the interior of the dining room at the inn of Marie Henry at Le Pouldu, with murals by Gauguin and Meijer de Haan 108 Portrait charge de Gauguin, 1889

should suggest and evoke abstract ideas rather than explain and document reality. Gauguin's confused aspirations find some sort of rationale. Increasingly, he was directing his creative products at a select Symbolist audience, accepting that the masses would have to be rebuffed along the way. Because his recent works had met with only muted enthusiasm from Theo Van Gogh, at the end of 1889 Gauguin's confidence needed bolstering and he appealed to Schuffenecker and Bernard for their opinions. Evidently he received satisfaction from those quarters but the flattering exchanges between him and Bernard during the first half of 1890 soon began to sound somewhat hollow. Bernard's own progress had been far from straightforward since 1888, and their artistic paths were beginning to diverge. Like Gauguin, he had spent time in Brittany in 1889 and had worked on religious motifs inspired by primitive woodcuts, but since visiting various exhibitions and museums in Paris self-doubts had set in, and he was flung hither and thither by uncertainties as to his talents and direction as an artist. In addition, he was suffering from family difficulties and an unhappy love affair so that, by the summer of 1890, he was ready to abandon the attempt to make ends meet as an artist in Europe and to take up Gauguin's

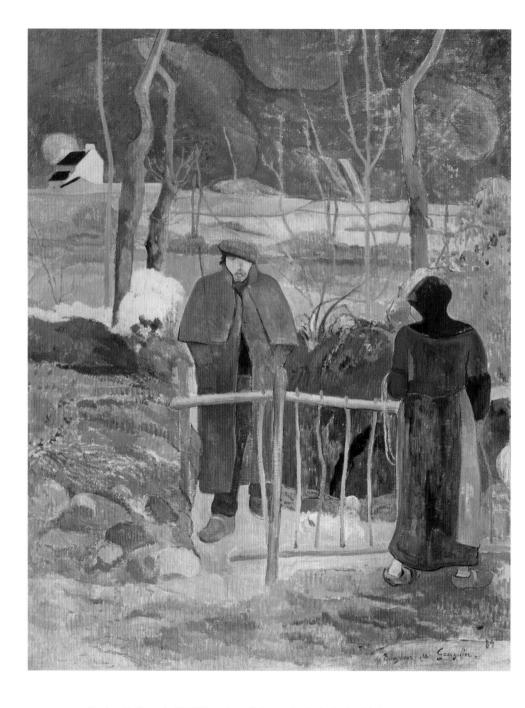

109 Bonjour M. Gauguin (I), 1889, variant of the version in the Le Pouldu inn

invitation to accompany him to his current tropical destination, Madagascar. But Bernard's resolve in this or any such undertaking was shaky, as Gauguin was well aware. For one thing, it hinged on the outcome of a proposed business deal worth 5000 francs with a wealthy inventor, a certain Docteur Charlopin. For this investment Charlopin would receive a bulk consignment of pictures by each artist at bargain prices which he would then retail.

If Bernard's loyalty was an unknown quantity, Gauguin now had, in addition to De Haan and Sérusier, a growing number of new disciples in Brittany, including Séguin, Filiger, the Danes Ballin and Willumsen, the Dutchman Verkade and the Pole Slewinski. Many of these artists had come to Paris for the Universal Exhibition and been drawn to Brittany by the revelation of seeing the works at the Volpini show. Their contact with Gauguin himself was often of short duration, but the Pont-Aven aesthetic had now taken root and could be expected to survive without him. The flattering distraction of so many younger talents looking to him as a figurehead undoubtedly swelled Gauguin's ego, but it did nothing to alleviate the difficulties of finding buyers for his recent work.

The fact that he was principally occupied by the ways and means of earning his passage overseas and securing a post in the colonies meant that Gauguin's output of paintings, normally substantial, fell off sharply in 1890. In anticipation of the work to come, which, he promised Theo Van Gogh, would be grander and more complete than anything he had yet done, Gauguin allowed himself to abandon his canvases, seeking to conserve his resources and energies. A few landscapes done 'mechanically' from nature at Le Pouldu date from this year and an unusually direct, solidly modelled portrait of an unknown, probably Parisian woman, in which the figure is set against the background of the Cézanne Nature morte, compotier, verre et pommes, which Gauguin still owned. The presence and purpose of so obvious a homage to Cézanne at this juncture in Gauguin's career is curious. Perhaps the prospect of his imminent departure from Europe, coupled with his evident disinclination to work on more taxing. imaginative compositions, sent Gauguin back to studying his earliest artistic mentors once more. Returning to Paris for the winter of 1890-1, Gauguin set himself the task of copying Manet's Olympia which, in November 1890, had at last taken its place in the Luxembourg. It seems to have been the drawing and the composition that chiefly interested him, for he made little attempt to parallel the extraordinary richness and drama of Manet's blacks and whites, nor was he bothered

113

111

112

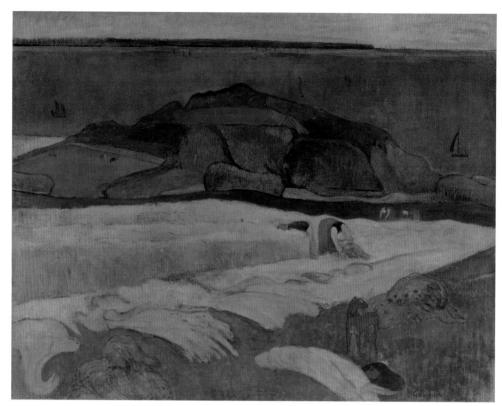

110 La Moisson au bord de la mer. 1890

with the niceties of detail in the setting. According to Jean de Rotonchamp, Gauguin's first biographer, he spent only a week or so working in front of the Manet and completed the copy from a photograph.

The exercise seems to have sparked off Gauguin's creative energies once more: in the early months of 1891 he painted a large, gravely symbolic picture of a nude in a Breton landscape, *La Perte de pucelage*. The scale of the work was identical to his copy of *Olympia*, both being slightly smaller than Manet's original. He used as his model a young Parisienne named Juliette Huet, whom he temporarily made his mistress. As with the Manet, the stark pallor of the woman's body is contrasted with a darker-toned setting, in this case a reworking of the view from Le Pouldu over the promontory towards the Ile de Groix,

111 OPPOSITE TOP Portrait de femme à la nature morte de Cézanne, 1890 112 OPPOSITE BOTTOM Paul Cézanne, Nature morte, compotier, verre et pommes, c. 1880

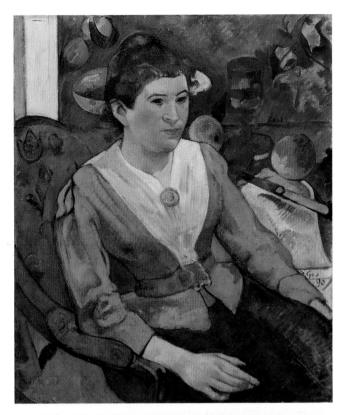

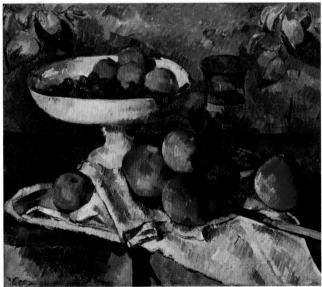

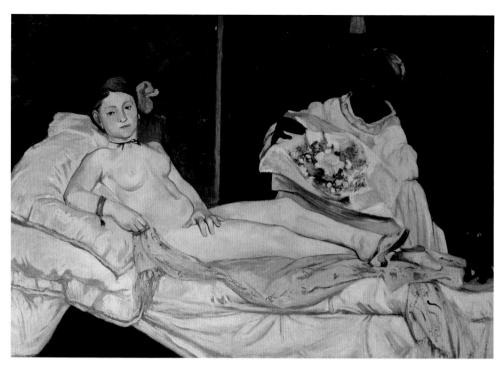

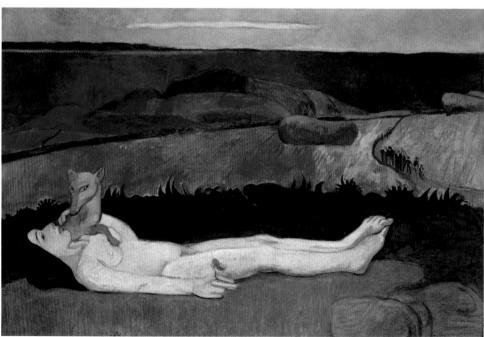

which Gauguin had already painted in *La Moisson au bord de la mer* in 1890. Exceptionally, we have no written account by Gauguin to help throw light on the obvious symbolic intentions of *La Perte de pucelage*. The fox, an animal used in *Soyez amoureuses* as 'symbol of perversity', reappears here, and the girl's defloration is alluded to in the cyclamen she holds. The painting seems charged with such punning references and has plausibly been interpreted as a picture aimed at, and possibly suggested by, the literati in Paris with whom Gauguin was mixing. Octave Mirbeau was the first owner of the preparatory drawing of the girl's head and fox, presumably a present in gratitude for the articles he wrote about Gauguin at a crucial moment in February 1891. A few years later, thanks to the good offices of Schuffenecker, the painting was bought by the rich patron of the Symbolists, Count Antoine de La Rochefoucauld.

The explanation for the absence of discussion of this picture in the Gauguin correspondence is simple. By early 1891 Gauguin had virtually no one left with whom to correspond. Vincent Van Gogh had taken his own life in July 1890. Gauguin received the news without shock or great emotion. Although his letter of condolence to Theo Van Gogh and his failure to attend the funeral have been seen as unfeeling, there is no reason to doubt Gauguin's sincerity when he wrote that Vincent's life had been a painful struggle and he saw this death as a release. However, his motives for opposing Bernard's plan to organize a retrospective Van Gogh exhibition in the autumn of 1890 were undisguisedly selfish, as was his reaction to the news that Theo Van Gogh himself had suffered a complete nervous collapse. Gauguin judged that fate had dealt him, personally, yet another blow. The demise of support from the Goupil gallery came on top of the news that the Charlopin affair had aborted. Now he would have to revise his plans for selling his works and it would fall to him alone to organize the finance for his departure and existence in the tropics.

In a ruthless bid for freedom, Gauguin did not hesitate to abandon those who he felt had failed him. He had progressively alienated Schuffenecker by relentlessly mocking his caution in financial affairs – in short, his reluctance to sink capital in Gauguin's escapade to the tropics – and his acceptance of the yoke of teaching (he was drawing master in a Paris lycée). In January 1891 Gauguin had so abused Schuffenecker's hospitality and friendship that he had finally been shown the door. As for Bernard, already annoyed by Gauguin's disloyalty to their old

113 OPPOSITE TOP Olympia (copie d'après Manet), 1891 114 OPPOSITE BOTTOM La Perte de pucelage, 1890 comrade Vincent, he came to see himself systematically written out of Gauguin's history and plans.

There is no doubt that Gauguin was alert to his potential for publicity. At a time when there was much squabbling in Paris over who deserved the greatest honours for the recent Symbolist revolution in poetry (press banquets were making overnight heroes of formerly obscure poets), Gauguin decided to capitalize on the sympathies and admiration of the young Symbolist writers and 'get himself elected', as Pissarro was scathingly to observe, a 'man of genius'. Pissarro was referring to certain machinations that preceded the sale of Gauguin's pictures at the Hôtel Drouot in February 1891 (a sale which raised 9985 francs), the banquet held in Gauguin's honour at the Café Voltaire on 23 March, and the benefit concert staged at the Vaudeville on 21 May, after Gauguin's departure for Tahiti. These manoeuvres included the unashamed traffic in favours, complimentary portraits and begging letters larded with flattery, the courting of influential figures from literature (Mirbeau, Mallarmé and Rachilde), art (Pissarro himself, Monet, Odilon Redon and Eugène Carrière) and public life (Antonin Proust and Ary Renan), and the promotion of Gauguin by turns as a sound investment or a charitable cause. All these moves were familiar and effective short-cuts up the ladder to fame and glory but they nevertheless provoked jealousy. distaste and cynicism in those whose susceptibilities had been trampled underfoot in the process.

Pissarro had assisted in Gauguin's rise in spite of himself, by recommending him to the critic and fellow anarchist Octave Mirbeau. The latter, known as a proponent of advanced art, found highflown words with which to describe Gauguin's art: 'This [man's] work is made up of a disquieting and spicy mélange of barbaric splendour, Catholic liturgy, Hindu reverie, gothic imagery and obscure and subtle symbolism; it combines uncompromising realism with wild poetic flights of fancy.' Writing in this vein in the Paris daily newspapers *L'Echo de Paris* and *Le Voltaire*, Mirbeau did much to publicize Gauguin's forthcoming sale and boost his reputation. In battening onto the story of Gauguin's 'tormented life' to illustrate the plight of genius in corrupt Western democracy, Mirbeau painted a heart-rending picture but paid scant attention to the details.

Bernard was also caught up in the campaign to promote Gauguin. In a letter to Aurier of mid-1890, he had impressed on him that now would be the opportune moment to bring out his promised article on Gauguin. Sure enough, in March 1891 the article appeared, in the newly relaunched periodical *Le Mercure de France*, under the portentous title 'Le Symbolisme

115 Portrait de Stéphane Mallarmé, 1891

en peinture – Paul Gauguin'. Bernard was dismayed to find his own contribution to Gauguin's evolution was not once mentioned, despite the fact that Aurier used *La Vision* as the foundation for his elaborate argument. Gauguin was presented as the figurehead of Symbolism, the founder of a new and exciting form of art that could no longer go under the ubiquitous name of Impressionism, an art of Ideas that was essentially, Aurier claimed, Subjective, Synthetic, Symbolist and Decorative.

The claims made for the uniqueness of Gauguin's art and for Gauguin himself as a thinker and visionary were judged by many to be inflated. Pissarro had difficulty in recognizing the man he had known from Aurier's and Mirbeau's descriptions. Fénéon, writing in May in Le Chat Noir, spared Gauguin none of his irony, pointing out that such lofty claims led one to expect rather more of his art than it had yet delivered. Gauguin's derivation from the Japanese, from Cézanne, from Van Gogh and from Monet were still all too readily apparent. Gauguin himself seems to have had no qualms about accepting the mantle of genius. He forwarded cuttings of the relevant articles to his wife Mette, whose natural scepticism was quashed by this evidence of the impact her husband had made in Paris. When in triumph he came to take his farewell of her and the children in Copenhagen, she evidently greeted him with more warmth than their sometimes curt exchanges over the previous years had led

116 Paul Gauguin photographed with his children Emil and Aline in 1891 in Copenhagen

him to expect. If the success of his sale had boosted his hopes of a more secure financial future, his greatest satisfaction came from being able to impress his wife and family with the news that in Paris his was now a name to conjure with. Promising to return from the colonies a rich man, to make a fresh start and live out his old age surrounded by his loved ones, Gauguin left Mette in early March and set sail for Tahiti on 1 April 1891.

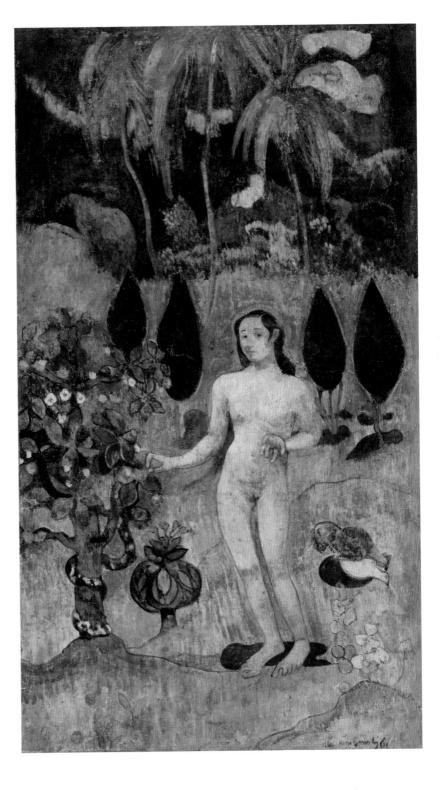

Chapter 5 **The Search for the Primitive (1891–1893)**

When Gauguin embarked from Marseilles he was at last alone. All the younger artists who had been thinking of going with him - Bernard, De Haan and Sérusier - were left behind. The fact was that neither they, nor many of Gauguin's relatives and acquaintances, had been convinced of the soundness of the venture. His wife, indeed, feared that he was courting disaster. Ironically, only Vincent Van Gogh and Bernard had fully seen the point of going so far afield. Vincent had argued that it would be logical for the studio of the south to lead on to the studio of the tropics. Once the studio of the south had opened artists' eyes to the intensity of colour juxtapositions produced by Mediterranean light, they would want to pursue their discoveries further afield. He predicted that colour would play a more important role in modern painting. Gauguin would be the right man to lead such a movement, since he had already proved his capacity to respond to tropical light and colour in the works he had brought back from Martinique. Bernard, for whom travelling with Gauguin was no longer possible, later sought his own artistic fortunes in Egypt.

The search for colour no doubt played a part in Gauguin's thinking, though less of a part than it might have done four years before, when he went to Martinique and was still working in a more or less naturalistic vein. His most recent Breton works, after all, had demonstrated that he could achieve a high intensity of colour with little prompting from nature. A more important consideration was surely that he wanted the stimulus of new, exotic motifs to revive the flagging interests of the 'stupid buying public'. He had fixed on Tahiti relatively late in his planning. When a merchant seaman, he had touched in at various South American ports on the Pacific, and he clearly cherished the sailor's enchanted view of the islands of the

118 Henri Lemasson, Street in Papeete, 1897-8

South Seas where life was reputed to be easy, with food and women always available.

As he did not leave on impulse, nor had he thrown over civilized life (despite having made protestations to the Symbolist artist Odilon Redon which suggested just such a renunciation), he had taken the trouble to prepare himself with up-to-date information from the colonial office, and immediately before his departure had written to the Minister of Public Instruction, requesting support for his artistic mission. His official letter stated: 'I wish to go to Tahiti in order to carry out a series of paintings there of the country whose character and light I aim to capture.' He was successful in being granted a letter of official sanction, help with his passage out and a loose commitment to the Ministry's acquiring 3000 francs worth of paintings on his return.

Evidently, the officially received version of Gauguin's reasons for leaving France differed substantially from the stories offered in the press by such writers as Mirbeau. Not all critics, however, had been as emotionally swept up by Gauguin's plight as had Mirbeau. The Belgian critic Emile Verhaeren, in the anarchist journal *La Société Nouvelle*, had offered more

measured and circumspect observations, usefully placing Gauguin's enterprise within a historical context. 'Another artist who has been drafted into child art is M. Gauguin. Whereas M. Minne [a contemporary Belgian Symbolist artist] looks exclusively at the naïve art of his own race and is drawn towards the cradle of the European ideal, M. Gauguin expatriates his dream to the Indies and even to yet more remote islands. He is off in search of his aesthetic origins. Also in search of total isolation, exile beyond all art that has hitherto been conceived and practised, complete virginity and, ultimately, of that year in, year out life, far from everyone and everything, which rinses the eyes clean of the impurities of decaying civilizations.... Ten vears ago. it was argued that the artist should devote himself to the art of his own region, study that alone, imprint himself with his native locality, not look beyond the garden wall. Well, doesn't the example of this painter setting off for the remotest unknown spots point up the vanity of all advice!' So in the opinion of this astute contemporary commentator on art, Gauguin was sticking his neck out by leaving France, but he was not alone in setting himself against the grain of naturalism.

On board ship, Gauguin found himself surrounded by respectably dressed petty bourgeois, all on government missions. In a letter home posted in Sydney, Australia, he stressed his intolerance of such dreary people, and delighted in his physical otherness (he had let his hair grow long) and sense of superiority. These, however, were the very expatriate bureaucrats he came across in his day-to-day life in Tahiti, colonials against whom he set himself with increasing determination and provocation during the course of his selfimposed exile in Oceania. But was Gauguin as different as he liked to think from his compatriots? His ambition, after all, was to revitalize his mode of production with untapped resources, and as a businessman he sensed that there was a demand in Europe for the kind of images of a forgotten culture he intended to produce - with its mystery, legend, religion and magic – images that could be contrasted with the over-evolved decadence of the West. Circumstances, French foreign policy, the blossoming of Symbolism with its hatred of the everyday and thirst for the unknown and the primitive - all combined to present a promising picture of the possible outcome of his commercial risk.

If Gauguin was convinced that he was the first painter to exploit the Oceanic as opposed to the well-worked Oriental terrain, he was mistaken. A fellow countryman, Charles Giraud, had worked in Tahiti some forty years before, turning out Tahitian scenes for the Salon throughout the 1850s. Artists,

119

indeed, were not new to the Tahitians, for they had encountered such men as William Hodges and Sydney Parkinson among the crews of the very first European ships to reach their islands in the late eighteenth century. By Gauguin's day, at least one other artist, an American by the name of John La Farge, as well as Charles Spitz, a photographer, were busy recording their impressions of the life of Tahiti, no doubt aware, like Gauguin, and as James Cook himself had been in 1769, that it was a way of life threatened with extinction.

In his first letter home to Sérusier, posted in November 1891, some five months after his arrival, Gauguin reported on his artistic progress to date. He was working hard but as to the quality of the work, he could not yet judge, 'for it's a lot and it's nothing. No finished painting vet - but a load of research which may be fruitful, many documents which will serve me for a long time. I hope, in France.' Later, he admitted that it would only be back in Paris, when he could see his pictures framed, that he would know whether they were good or not. From the detailed chronology of Gauguin's output during his first stay in Tahiti, worked out by the art historian Richard Field, it is clear that he took time to settle down and produce a painting of any size or complexity. He proceeded relatively cautiously at first, as he had done in Brittany, making small-scale figure sketches and studying the tropical terrain and vegetation before attempting to integrate significant figures into this setting. Such paintings as Montagnes Tahitiennes might almost have been produced

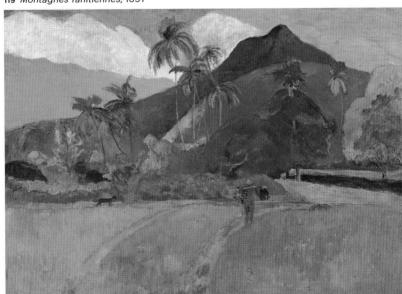

with a view to discharging the promises he had made to the Ministry. But it was ultimately the Tahitians themselves Gauguin had come to paint, and finding models to pose for him in his studio was a delicate business. Gauguin made something of a false start by spending the first three months in the capital Papeete, which had been much Europeanized by the 1890s, where his 'official' sanction may have hindered him as much as it opened doors for him; for if it gave him a certain immediate status in colonial circles, it also raised expectations which he was in no position to fulfil. In one of his first letters home to Mette, he boasted that he was being courted by the social élite, the royal family and French government officials. and entertained hopes of making money from portraiture. After a few weeks setting up home in Papeete and finding his way through its relatively rigid social structure (he even donned the appropriate linen suit), he soon showed once again that when it came to producing a fair likeness of a socially prominent sitter. he was not prepared to make artistic concessions, vide his portrait of Suzanne Bambridge, a woman of mixed English, Irish and Tahitian parentage.

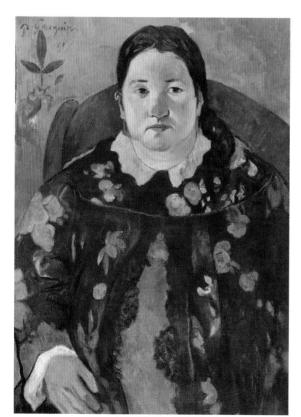

120 Suzanne Bambridge, 1891

118

The reality of colonial life in Tahiti was undoubtedly a disappointment to Gauguin. Although he only occasionally admitted as much in passing remarks, other witness accounts and contemporary photographs make clear that this paradise on earth had been severely altered since the first glowing descriptions brought back by European visitors. Indeed, in Gauguin's terms, Tahiti must have appeared almost completely tainted by commerce with Europeans. Gauguin was looking for a primitive idyll, free from vice and baseness of all kinds, in contrast to the money-grubbing rancour he associated with Europe, and some of his first letters home might lead one to think he had found it. To Mette he wrote enthusiastically, after just three weeks in Tahiti, about the silence and stillness of the tropical nights, the gentle, hospitable ways and physical beauty of the natives. He was waiting, in a new receptive frame of mind, for the expected return of creative energy: 'I understand why these people can remain hours and days sitting immobile and gazing sadly at the sky. I apprehend all the things that are going to invade my being and feel most amazingly at peace at this moment.' In the account he later wrote of his Tahitian experience, Noa Noa, he elaborated on this feeling of having his over-civilized soul cleansed and rejuvenated in contact with the innocence of the 'savage', his bad feelings towards his fellow men being replaced by good ones. Such claims have become so vulgarized today by holiday brochures that it is hard to believe Gauguin could make them in all seriousness. Yet, in the same letter to his wife, Gauguin revealed that Tahiti was not all he had hoped for, lamenting that together with Western diseases and culture a large measure of that essentially European vice of hypocrisy had been introduced by Protestant missionaries! This sounds like a deliberate taunt at his Danish wife, for elsewhere he argued that the Catholics' influence had been equally harmful. In effect, the traditional native beliefs had been destroyed and all but lost from memory in the process of the island's conversion to Christianity by English and French missionaries.

Bengt Daniellson, an anthropologist who lived for many years in Tahiti and tried the experience of 'going native' for himself, has unveiled much of the reality of Gauguin's existence in the South Seas. After a matter of weeks, living high on the hog in Papeete, those money-grubbing concerns Gauguin had hoped to leave behind him returned with a vengeance. His thoughts were to become ever more desperately fixated on the monthly arrival of the mail-boat, with its possibility of letters and money from France. His own letters home became increasingly querulous in tone as his savings dwindled and

the desired funds failed to materialize. He did not hesitate to reproach friends, such as the young poet Charles Morice, whose promises of financial support seemed to have been forgotten. His business concerns were uppermost in these letters, as he chided dealers for their inefficiency, demanded from his wife and from friends that they run errands on his behalf in Paris and give him specific, up-to-date news of his picture sales and critical standing. As had been the case when he first went to Brittany in 1886, the decision he took in September 1891 to leave Papeete for the remoter settlements further round the coast was prompted as much by the necessity of living more cheaply as by any artistic considerations.

Gauguin decided to settle in Mataiea, some forty-five kilometres from Papeete, probably on the advice of a Tahitian chief whom he had befriended. There he rented a native-style oval bamboo hut, roofed with pandanus leaves. Once settled, he was in a position to begin work in earnest and to tackle serious figure studies. It was probably soon after this that he painted Vahine no te tiare, his first portrait of a Tahitian model. He later recorded how the girl, having understood what he required of her, disappeared, leaving him in agonies lest she should have taken flight, only to return dressed in her lace-trimmed Sunday best. To a large extent, full-length European-style smocks, like the one she is shown wearing, had replaced the traditional Tahitian pareos. The women now spent as much time plaiting straw hats which had to be worn to chapel on Sundays (they had been introduced in 1840 by an opportunistic missionary named Pritchard) as they did weaving garlands of flowers. (Incidentally, Gauguin recorded this typical activity in *Deux* femmes sur la plage.) Gauguin felt he had to work quickly on the portrait lest the model change her mind. If we can believe his account, which certainly has the ring of authenticity, painting these much-vaunted Tahitian beauties fully clothed, let alone naked, was not going to be as easy an undertaking as he had persuaded his painter friends to believe.

By the late summer of 1892 the completed canvas was back in Paris, hanging in the Goupil gallery. (Theo Van Gogh's place had been filled by Maurice Joyant, a poor substitute in Gauguin's view.) From the many subsequent references to this image in his correspondence, it is clear that Gauguin set considerable store by his 'Tahitienne' and, by sending her on ahead to Paris, wanted her to serve as an ambassadress for the further images of Tahitian women he would be bringing

122

¹²¹ OPPOSITE TOP Deux femmes sur la plage, 1891
122 OPPOSITE BOTTOM Vahine no te tiare (Woman with a Flower), 1891

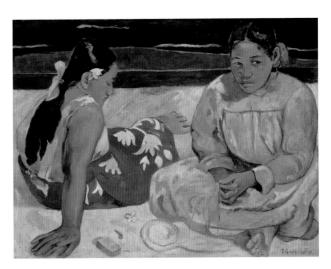

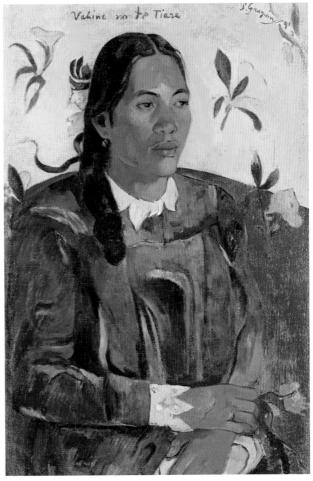

back with him on his return. He pressed his male friends for their reactions to the girl, rather than to the picture, anxious to know whether they, like him, would be responsive to the beauty of her face: 'And her forehead', he later wrote, 'with the majesty of upsweeping lines, reminded me of that saving of Poe's, "There is no perfect beauty without a certain singularity in the proportions." No one, it seems, was quite attuned to his emotional perception: while Aurier was enthusiastic, excited by the picture's rarity value, Schuffenecker was somewhat taken aback by the painting's lack of Symbolist character. Indeed, apart from the imaginary floral background which harked back to Gauguin's 1888 *Autoportrait*, the image is a relatively straightforward one. Recent anthropological work, backed by the use of photography, had 'scientifically' characterized the physical distinctions between the different races, albeit misguidedly hardening these distinctions into fixed typologies. Artists since the time of Captain Cook had represented

123 Le Repas, 1891

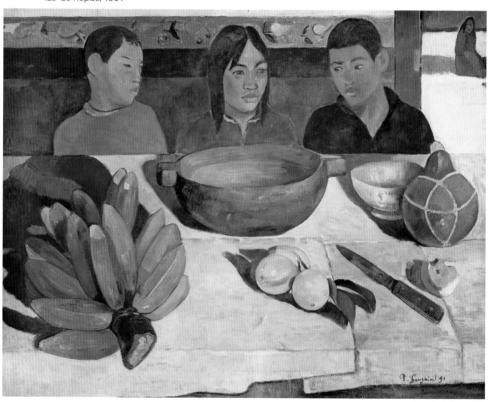

Tahitians in idealized ways, adjusting their features and proportions to accord with European tastes, but the more recent portraits by Charles Giraud of Queen Pomare (1851–2) gave his model a powerful and singular Polynesian presence despite her Westernized dress. Similarly, this first image by Gauguin suggests a desire to portray the Tahitian physiognomy naturalistically, without the blinkers of preconceived rules of beauty laid down by a classical culture. Naturalism as an artistic creed, though, was anathema to Gauguin; it made the artist a lackey of science and knowledge rather than a god-like creator. He wanted to go beyond empirical observation of this kind, to find a way of painting Tahiti that would accord with his Symbolist aspirations, that would embody the feelings he had about the place and the poetic image he carried with him of the island's mysterious past.

125. 126

121

114

121

The preparation for achieving this synthesis was to concentrate once again on drawing, not just drawing from nature but 'searching deep within himself, as he explained to Daniel de Monfreid in a letter of November 1891. An instance of what this approach may have involved is provided by Deux femmes sur la plage, one of the few Tahitian paintings to be dated 1891. In searching for an appropriate pose for the lefthand figure, Gauguin seems to have resurrected and reversed the foreshortened pose of the young Breton shepherdess that he had already used in a variety of guises in earlier works. The generalized landscape setting, which has the effect of pushing the bulky figures up to the surface, has much the same broad sweeping horizontals and arbitrary changes of colour as his recent La Perte de pucelage. It is not yet recognizably Tahitian. Gauguin seems to have been intrigued by this combination of two female figures engaged in silent dialogue and not only painted a near replica of the composition to send back to Europe (the first version, exceptionally, found a buyer in Tahiti: a certain Captain Arnaud acquired it for 400 francs), but explored the idea in a number of later canvases, complicating the interrelationship on both the formal and the psychological level.

124

Te faaturuma, which Gauguin translated as La Boudeuse (The Brooding Woman), must be one of the earliest works from the first Tahitian trip to receive a Tahitian title, although the title was clearly an afterthought, written on the canvas not by Gauguin but by Daniel de Monfreid under Gauguin's instructions. While the gesture of head on hand is the traditional emblem of melancholy and harks back to Dürer, the pose and physiognomy relate closely to the right-hand figure of Deux femmes sur la plage, expressing that typically Tahitian

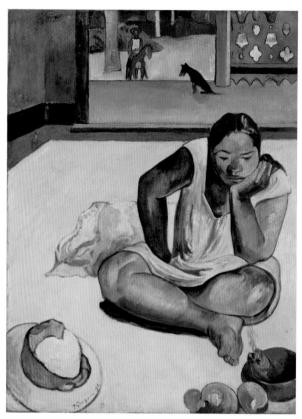

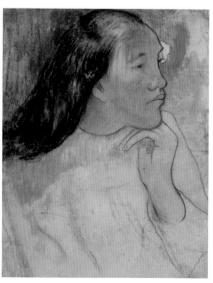

124 TOP Te faaturuma (The Brooding Woman), 1891 125 BOTTOMLEFT A Tahitian Woman with a Flower in her Hair, c. 1891–2 126 BOTTOM RIGHT Tahitian Woman, 1891

impassivity Gauguin had remarked on to his wife. Here the setting is more specific and contemporary, with its colonial-style room opening onto a verandah, raised above the brilliant green of the landscape beyond. The compact containment of the figure, her asymmetrical positioning and the introduction of strong diagonals, carving up this otherwise flat space, might suggest that Gauguin was once more thinking of Degas or looking to Japanese prints for compositional ideas.

One can suggest such visual parallels with some confidence, given that Gauguin had not left Paris empty-handed: on the contrary, he had armed himself with a collection of visual stimuli, the selection of which must have involved a great deal of heart searching. Several months before leaving France, in fact, he had assured Odilon Redon that he would be taking with him in his baggage a 'whole little world of friends' who would converse with him every day: friends, that is, in the form of photographs, drawings and prints, including the more transportable items in his personal collection, such as Redon's lithograph *La Mort*. The task of identifying the images in this visual library and their influence on Gauguin's Tahitian work has occupied several scholars, and their researches reveal Gauguin to have remained far more dependent on Western sources than might at first appear.

Ia Orana Maria offers one of the clearest instances of the use Gauguin made of this collection of source material and reveals

127 Odilon Redon, La Mort, mon ironie dépasse toutes les autres, 1889

127

the complex fusion of observation and artifice that made up his working method. This large canvas was the most highly wrought composition he produced in his first year in Tahiti, and the first where he departed entirely from an observable subject to enter the realm of fantasy. Gauguin considered it a significant and broadly successful work. In its expression of naïve, superstitious faith and its fusion of the supernatural with the everyday, it is comparable to the religious works he had painted in Brittany. Indeed, it was still a motif based on Catholic tradition, for all its exotic, luxuriant setting and Tahitian figures. Gauguin was not yet in a position to essay a subject relating to the island's ancient religious beliefs. The two praying figures, with their hieratic, primitive poses, were direct borrowings from figures on the stone-carved relief of the temple of Borobudur in Java, of which Gauguin owned a photograph, and this long admired example of primitive religious art also provided him with the stylized foliage that forms a decorative band above their heads, masking the more naturalistically treated mountains. The somewhat disparate elements of the painting were collated from a series of drawings and as such the painting perhaps lacks the simplicity and clarity of statement in his earlier religious images. There are signs of indecision on the canvas, such as the late blocking out of the globular-shaped fruit in the foreground still life, and the awkward insertion of the angelic messenger, whose hovering presence is easily overlooked in the restless floral patterning, particularly when set against the monumental strength of the Virgin and child. In itself, there was nothing particularly novel about Gauguin's iconography. Angelic salutations were standard Catholic themes, cropping up regularly in the work of the more devout of Gauguin's followers, Charles Filiger and

128 Relief from the temple of Borobudur, Java

129 TOP Jules Bastien-Lepage, Jeanne écoutant les voix, 1879 130 RIGHT Luc-Olivier Merson, Je vous salue, Marie, c. 1885

130

129

131

Maurice Denis, and in the work of Salon artists. Although the inclusion of the Christ child seated on his mother's shoulder was unorthodox, Luc-Olivier Merson's Je vous salue, Marie had used the same device, setting the encounter with Mary in the banal context of the French countryside, with peasant and child returning from the fields; while Bastien-Lepage's famous Jeanne écoutant les voix (1879) had made a somewhat similar appeal to sentiment and attempted the same difficult fusion of an other-worldly presence with an earthly setting. There was some discernment in the judgment of the critic who, when he saw Gauguin's painting hanging in Paris in 1893, condemned it for being 'nothing but a Bastien-Lepage done Tahitian style – all it needed was musical accompaniment by a Tahitian Gounod!' Probably, Gauguin was wise to decide against sending this work on ahead to be exhibited in Copenhagen, when the opportunity arose, perhaps aware that he would need to justify and explain it to the critics in person. It was a work whose complexity was calculated to please the Symbolists but whose conservative iconography could well be expected to lay Gauguin open to further attack from his political opponents.

The meaning of *Ia Orana Maria* is still a puzzle in view of Gauguin's known opposition to the work of the Christian

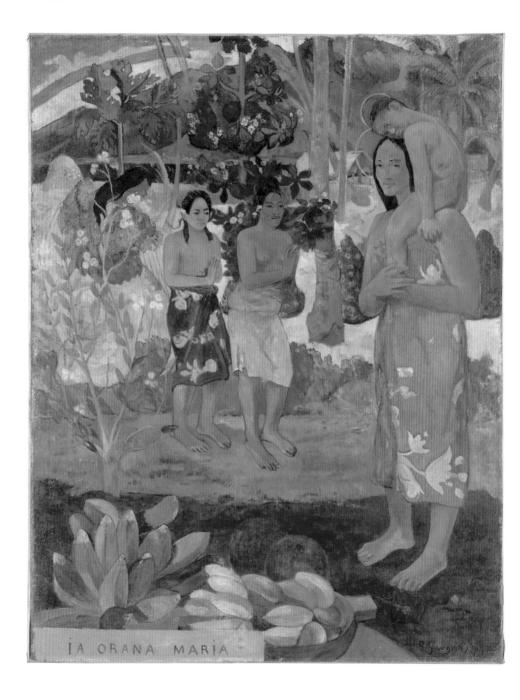

131 la Orana Maria (Hail Mary), 1891

missionaries. Was he making an ironic comment on the way in which Catholicism had been altered and mollified in the process of being assimilated into the lives of the Tahitians, its message understood only in terms of simple, positive images that were in any case part of their daily experience - motherhood and childbirth, for instance? If so, his later painting of 1896 Te tamari no atua, or Naissance du Christ, could be said to make a parallel point. Certainly, the introduction of the Christian concept of sin, which anthropologists agreed was absent from traditional native beliefs, particularly sin relating to matters of sexual and material possession, was widely recognized as one of the most traumatic aspects of Tahiti's colonization by Europeans, and Gauguin was surely making an oblique comment on this when he gave his pictures such titles as What, are you jealous? and When will you marry?

L'Homme à la hâche was also painted during this productive period at Mataiea, although according to Gauguin's account in Noa Noa it recorded an incident he had witnessed at Paea. He used a similar vertical format and tripartite configuration to Ia Orana Maria, with a combination of a single, simplified monumental figure in the right foreground and a smaller, stooping figure in the middle distance and a glimpse of a more naturalistically treated seascape at the top of the canvas. Here,

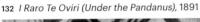

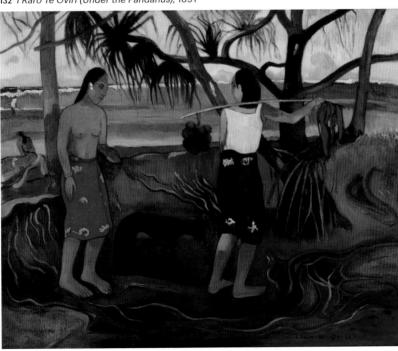

139. 142

134

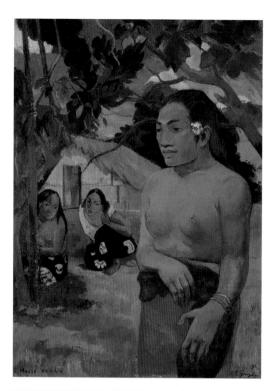

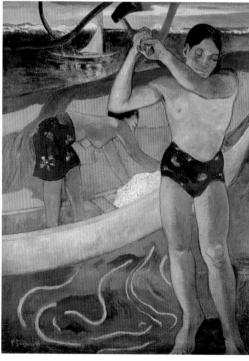

the simplification of colour into broad areas, broken up by seemingly arbitrary arabesques, which Gauguin likened to the characters of an 'unknown, mysterious language', makes the image a more abstract one. Gauguin used discreet, cloisonnist contours to give elegant strength to his woodcutter, who seems to epitomize the legendary image, current since the Enlightenment, of the 'noble savage'.

Because this work stands out as such a rare instance of Gauguin's representing an active, working male figure, one is reminded of the fact that it was images of women on which he concentrated throughout his career. Gauguin was, after all, a male artist working for a male consumer market and he was not ashamed to pander openly to that market at times, in spite of his avowed hatred of the base tastes of the decadent European bourgeois. *Vahine no te vi*, for instance, seems calculated to appeal; a straightforward, if somewhat clichéd, image of a Tahitian girl with a mango, Gauguin has given it a decidely baroque dynamism in the twist of the girl's body and the emphatic folds of drapery, at odds with the frozen rigidity of pose he consciously cultivated in more 'primitive' works, such as the contemporaneous *Ta Matete*. The explanation for this, as Field has suggested, again lies in a borrowing. This striking

143

¹³³ OPPOSITE TOP E Haere oe i hia? (Where are you going?), 1892

¹³⁴ OPPOSITE BOTTOM L'Homme à la hâche, 1891

¹³⁵ ABOVE Man with an Axe, 1891-3

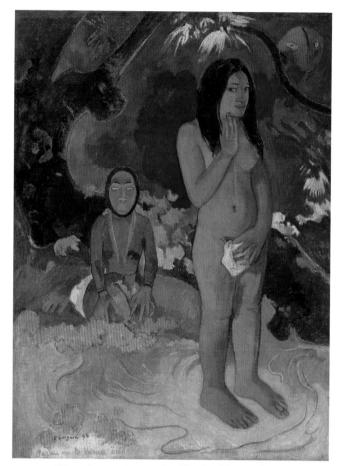

136 LEFT Parau na te varua ino (Words of the Devil), 1892 137 RIGHT Une fille (study for Parau), 1892?

contrapposto pose was used by the Neo-classical artist Prud'hon in his *Joseph et la femme de Potiphar*, a drawing of which had belonged to Arosa and a photograph of which formed part of Gauguin's portable personal collection. In fact, on his second trip to Tahiti Gauguin made a painted copy of the Prud'hon.

In *Ta Matete*, which has loosely been translated as 'We shall not go to market today', Gauguin represented the women who frequented the public square and market of Papeete, the nearest Tahitian equivalent to the night-life district of Pigalle. It was from the ranks of these women that Gauguin had taken

138 орроsіте тор Te poipoi (Morning Ablutions), 1892 139 орроsіте воттом Aha oe feii? (What, are you jealous?), 1892

145

144

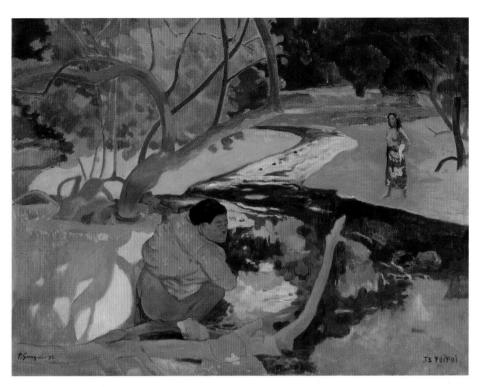

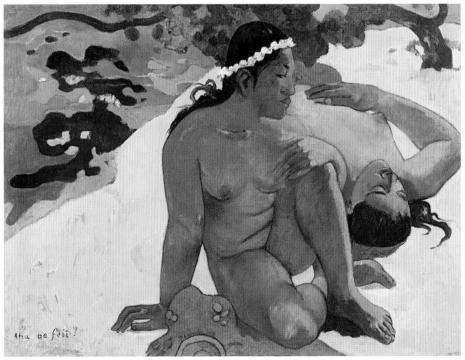

140 TOP Aha oe feii? (What, are you jealous?), 1894
141 BOTTOM Study for Nafea faa ipoipo?, 1891–3
142 OPPOSITE Nafea faa ipoipo? (When will you marry?), 1892

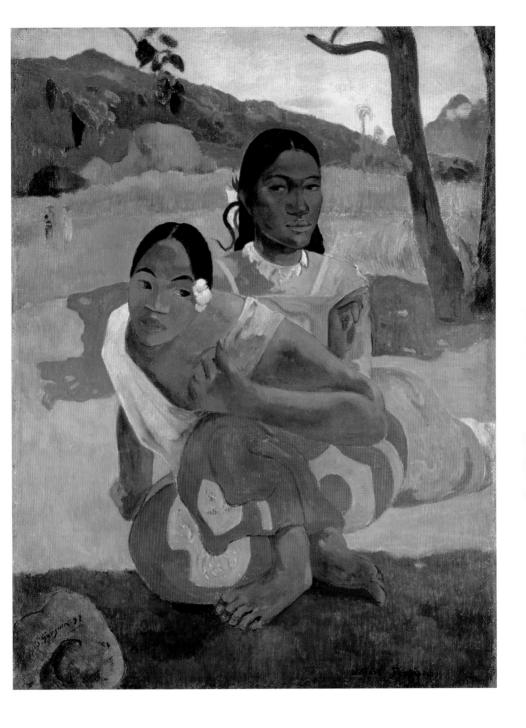

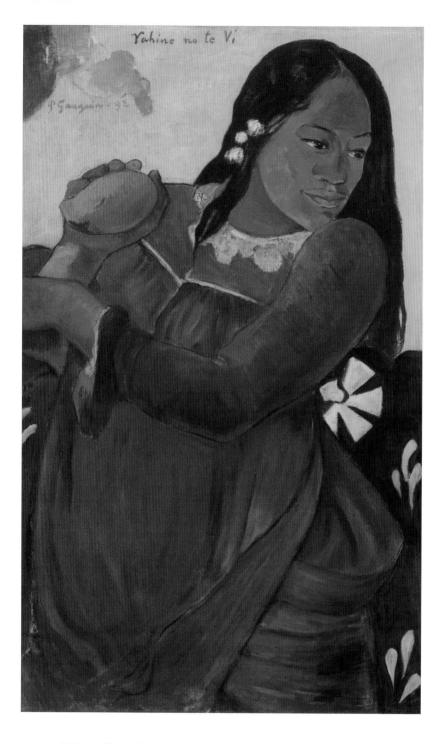

143 OPPOSITE Vahine no te vi (Woman with a Mango), 1892

144 TOP Joseph et la femme de Potiphar, 1894

145 BOTTOM Pierre-Paul Prud'hon, Joseph et la femme de Potiphar, c. 1820

his first Tahitian mistress. Titi, of mixed heritage, but he quickly found her too demanding and financially draining a companion, unable or unwilling to adapt to the 'life of nature' that he tried to lead in Mataiea. Gauguin's adoption of the artifice of the Egyptian frieze configuration for this painting. closely based on a photograph of a Theban tomb painting in the British Museum he had brought with him, indicates the difficulties he was having in finding any vernacular artistic tradition on which to build. He perhaps intended to pass some sort of comment on these town women, who had become used to luxury from constant interaction with European settlers. (In this land where sexual favours had been offered freely and fearlessly to the first European visitors, the development of a more Western style of prostitution was an inevitable but tragic aspect of the encroachment of Western civilization, as Gauguin was surely aware.) Alternatively, the deliberate fusion of Egyptian with Oceanic cultures may have been Gauguin's way of acknowledging those contemporary anthropological theories which traced the mysterious ethnic origins of the Polynesians back to 'the most ancient race of mankind', the 'red-skinned race' whose civilization had supposedly reached its peak in ancient Egypt. Such theories were cited by Schuré in Les Grands *Initiés*, and we know that Gauguin was interested in the cultural and ethnic origins of the people among whom he had chosen to live. For all its artfully primitive flatness, Ta Matete was one of the few pictures in which Gauguin obliquely referred to some

146 Egyptian fresco from a tomb at Thebes of the XVIIIth Dynasty

of the social realities of Tahitian life. For the most part, he carefully averted his gaze, turned his back on the spectacle

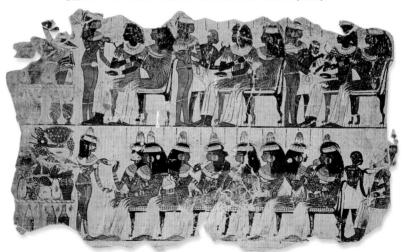

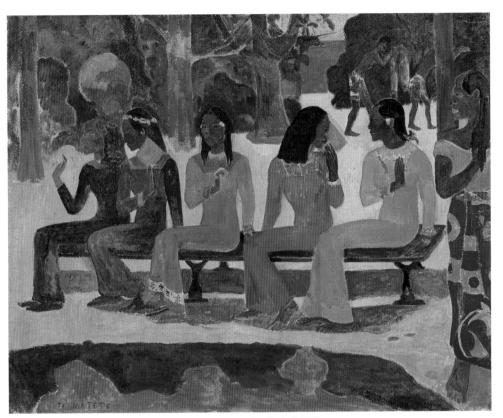

147 Ta Matete (We shall not go to Market Today), 1892

of the changes taking place around him and looked to the past for his inspiration.

143

Ta Matete and Vahine no te vi were painted in the spring of 1892, a period when Gauguin was working steadily and well by his own lights. 'I am in the midst of work', he told Mette in April 1892, 'now that I have got to know the soil and its odour, and the Tahitians, whom I draw in a very enigmatic manner, are very much Maoris for all that and not Orientals from the Batignolles.' (The Batignolles was the area of Paris where artists traditionally went in search of exotic models.) Paradoxically, this productive period followed an ominous setback to his health and a spell in hospital in Papeete. He had suffered some sort of seizure and coughed up blood for several days. Having come through relatively unscathed, his optimism was restored and he was grateful for the chance to continue the work he had begun. By taking each day as it came, conserving his energies and organizing his painting programme so that one day's task

followed on logically from that of the previous day, he achieved a steady output of paintings, many of them the stunningly beautiful, major works on which his reputation is founded.

At the end of his first year in Tahiti, Gauguin felt that his achievements were already sufficient to prove to the fainthearted that it had been no folly to leave Europe. He was merely frustrated, as ever, by the lack of funds for, and uncertainty over the possible date of, his return to France. By the summer of 1892 Mette, for her part, seemed disposed to believe in him at last, now that she could see some hope of reward for the years of deprivation she and her children had endured. Her new confidence resulted from a series of successes. She had managed to sell Gauguin's important early Etude de nu. Suzanne cousant for a good price to Theodor Philipsen, a Danish artist, and was being courted by him and Johann Rohde, the joint organizers of Copenhagen's Frie Udstillung, the annual Free Exhibition, for some recent pictures by her husband to hang. By chance, she had come across an important article on 'Les Symbolistes' by Albert Aurier, published in the April edition of La Revue Encyclopédique, which hailed Gauguin as the incontestable initiator of the new movement. She had been to Paris and met a number of Gauguin's friends and for the first time been recognized and treated as somebody worthy of consideration on the strength of her husband's reputation. Charles Morice was evidently extremely gallant. She also met the artist Eugène Carrière with Morice and reclaimed the portrait of Gauguin he had painted just before the latter's departure for Tahiti. On the same occasion she possibly approached the esteemed republican politican Georges Clémenceau on her husband's behalf to request his official support for Gauguin's free repatriation. Unbeknownst to him, Gauguin had no grounds for continually chiding his wife for her supposed indifference to his fate. When he eventually heard how active she had been on his behalf, he began to speak once more of patching up their twenty-year-old marriage and resuming life together in Europe.

This was a hopelessly, even callously, unrealistic promise to hold out given the circumstances in which Gauguin then found himself. But Gauguin had an extravagant capacity for self-delusion, for fixing his sights on illusory goals, as he wryly admitted. He and Mette had been estranged for seven years. At the time of writing to her, he was living with a thirteen-year old Tahitian, Teha'amana, whom, according to his own account in *Noa Noa*, he had recently taken as a bride with the full blessing of her two sets of parents, biological and adoptive. Then there was the problem to be faced in Paris of Juliette Huet, who

148 Eugène Carrière, Portrait de Paul Gauguin, 1891

had borne Gauguin a daughter in his absence and who was undoubtedly in need of financial support. Gauguin clearly considered such human casualties as necessary to the cause of his art; in any case, they were common enough baggage for a man of his class to carry around. Fortunately, Mette Gauguin was no romantic, even if she was temporarily lulled into an optimistic frame of mind by her husband's talk; later, she summed up his attitude to life as one of 'ferocious egotism'.

The main reason Gauguin's work had been proceeding so well was that in the course of his research into the Tahiti of the past, he had made a crucial discovery. In March 1892 he had been lent a book by a French colonial, Goupil, a twovolume study of Oceanic life by a Belgian, J. A. Moerenhout. Voyages aux Iles du Grand Océan, first published in Paris in 1837, contained a full account of the forgotten religious beliefs and customs of Tahiti, as well as information about its language and literature, and political and social affairs. The importance of this document for Gauguin, which ironically he could have studied in Paris, as the romantic poet Lecomte de Lisle had done before him, lay in the fact that it opened the door to the mysterious Tahiti of legend, giving him access to those pagan rituals which he had imagined from afar. He first hinted at this discovery in a letter to Sérusier dated 25 March. He concluded with a postscript, 'What a religion the ancient oceanic religion is! What a marvel! My brain is buzzing with it and all the ideas it suggests to me are really going to scare people off. If people were worried about my old works in a domestic setting, what will they say about the new ones?' It seems probable that Gauguin was in the process of copying

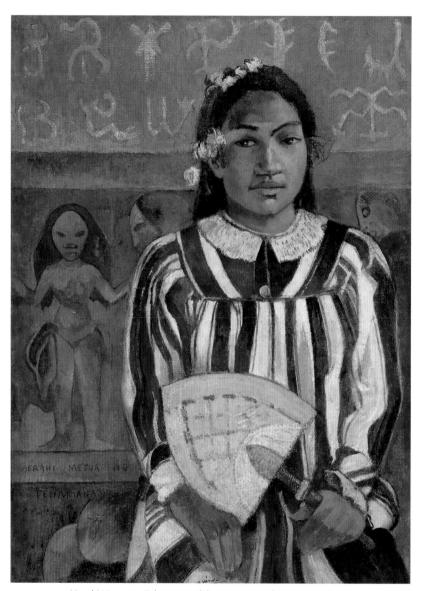

149 Merahi Metua no Teha'amana (The Ancestors of Teha'amana), 1893

sections from Moerenhout's account into his notebook and interspersing them with watercolour sketches. Entitled *Ancien Culte Maorie*, the notebook is now safely lodged in the Louvre. It remained with Gauguin until his death and although probably not intended for publication, it furnished him with the source

material for a number of pictures and was used as the basis for *Noa Noa*.

One of the first paintings to emerge from this period of study, and possibly Gauguin's first attempt at a Tahitian nude, was *Vairaoumati tei oa*, which he roughly sketched in the same letter to Sérusier, describing it as 'truly ugly, truly mad'. According to ancient Tahitian legend, Vairaoumati was the beautiful mortal chosen by the supreme god Oro to be his love and bear his child. She thus became the progenitress of the divine race of the Areoi, a kind of religious order who formed an élite within Tahitian society and lived their lives according to the rules of free love. Gauguin shared the fascination of many Europeans with this concept of unlimited sexual freedom, which had long been associated with the Tahitians. In the painting, a kind of pagan Annunciation, he represents Vairaoumati naked, seated in the same frozen Egyptian profile that he had used in Ta Matete, although the position of her legs and the cloth on which she sits recall Puvis de Chavannes' allegorical figure of Hope. Instead of using the horizontal frieze design, he chose a vertical format which involved a steep perspective and overlapping motifs. When he sketched the composition for Sérusier, Gauguin had not vet inserted the rather awkward figure of the divine seducer Oro into the composition, who looks down on Vairaoumati from the top right-hand corner, much as Gauguin's own face looks down on the naked woman in Soyez amoureuses. Their union is symbolized by the idol placed on the stone altar in the middle distance.

Just as the nude figure of Vairaoumati was based on artistic sources rather than on a Tahitian model, so too his carved and painted idols were inventions or reconstructions of Gauguin's own. They had to be, since almost all traces of indigenous Tahitian religious imagery had been lost or destroyed. In Ancien Culte Maorie, Gauguin had made a watercolour sketch of the conjoined figures of the Tahitian gods Hina and Tefatou, evidently inspired by the decorative details and stylized figural forms on a Marquesan oar handle. Like so many of his ideas once they had taken visual form, this one was reused time and again. For instance, it reappears in a woodcut, a ceramic vase and a carved statue that, like Idole à la perle, probably dates from 1892 (Gauguin mentioned in a letter to De Monfreid datable to around September that year that he was busy carving 'bibelots sauvages' from tree trunks). The imaginary idol also reappears in the background of a number of other paintings, notably Arearea, Nave nave moe and a landscape that he entitled Parahi te marae, meaning There is the Temple. The sacred hill

174 155

153.

152

150

151

147

200

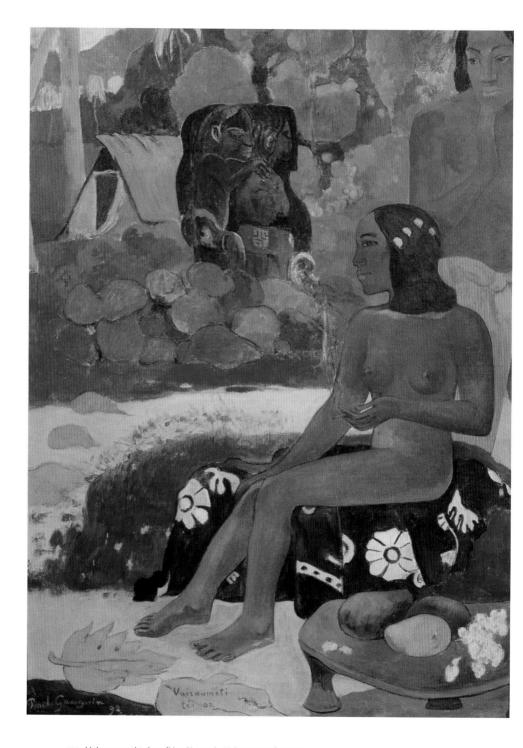

151 Letter to Sérusier, 25 March 1892, with sketch of Vairaoumati

with its surrounding fence was first schematically sketched in *Ancien Culte Maorie*, following Moerenhout's description, and then elaborated in stunning colour, both in watercolour and oil, with the fence now fancifully interspersed with death heads.

Perhaps because of the possibility of tying down his borrowings so precisely in this way (at times they are remarkably direct), Gauguin's integrity as an original artist has occasionally been called into question, as though there were something shameful about an artist's pillaging the past, or such a thing as innovation without tradition, creativity without source material. Surely the interest for the historian in identifying Gauguin's borrowings, whether from Moerenhout or from other art, is not to downgrade his achievements but rather to understand his artistic practices. His sometimes repetitive elaboration and recombination of successful pictorial ideas was not essentially different from the methods used by notable contemporaries working in France, Degas, for instance, or Cézanne. In the absence of original Polynesian artefacts to work from, with the rare exceptions of the Marquesan oars and carvings which Gauguin exploited fully, it was hardly surprising that for knowledge of Tahiti's past he should turn to a reliable published account and make heavy use of the portable collection

152 Idole à la perle, 1892-3153 Idole à la coquille, 1892-3

he had brought with him from Europe. Despite Gauguin's claims, it is in a sense reassuring to discover that the experience of severing himself from his culture did not in fact mean working from a *tabula rasa*; rather, it threw Gauguin more forcibly back on the enduring monuments of that rejected culture. The identification and study of his sources enables us to understand better to what extent the studio of the tropics was necessary to fire Gauguin's imagination and to what extent the appearance of the works he brought back to Paris was predetermined by the cultural baggage he had taken out with him.

154 TOP Study for Parahi te marae, c. 1892 155 BOTTOM Parahi te marae (There is the Temple), 1892

Chapter 6 Confronting the Public (1893–1895)

Late in 1892 Gauguin packed off a consignment of eight pictures to De Monfreid for exhibition in Copenhagen. When describing to his wife the works he had sent, he explained that in order to cater for all tastes (the Danes were presumably likely to be more conservative than the Parisians), he had selected a mixture of relatively 'doux' or mild, accessible paintings – mainly landscapes and genre figures – and some that he considered to be 'raide' or hard, inaccessible. It is interesting that even in Tahiti Gauguin continued to think of his work in these practical commercial terms; indeed, this obvious concern to provide enough variety to suit all corners of the market helps to rationalize what can otherwise seem a somewhat inconsistently diverse oeuvre.

To aid Mette in handling the critics' questions, Gauguin provided a gloss on the meaning of the works he acknowledged were more difficult, including the important nude Manao tupapau (The Spirit of the Dead keeps watch), which he valued highly but which he was certain would be misunderstood, and Parahi te marae. He explained, for instance, that the temple in the latter was used for prayers and human sacrifices, relishing, one suspects, the idea of the shudder of horror this would give his European audience. In the case of Manao tupapau, he explained that the fear on the girl's face was due to her terror of the Spirit of the Dead. 'I had to explain this fear with as few literary means as possible,' he wrote, 'as was done in the past. So I proceeded thus. General harmony, sombre, sad, fearful. intoning in the eye like a death-knell: violet, dark blue and orangey yellow. I painted the linen a greenish yellow, firstly, because the linen of the native is different from ours (made from the beaten bark of trees); secondly, because it creates. or suggests artificial light (the savage woman never sleeps

156

in the dark) and yet I don't want any lamplight effects (they're common); thirdly, this yellow links the orangey yellow to the blue and completes the musical harmony.'

Manao tupapau is unquestionably one of Gauguin's most beautiful and fully resolved paintings. The flowing lines of the girl's body and the decorative details give it the sensual quality of an Ingres Odalisque, yet the dark, velvety colour range, set off by the jangling yellows of the foreground, and the dramatic tension of the girl's face produce a powerful aura of mystery. Fear of evil spirits and ghosts was common among the Tahitians, the spirit taking the form of the person when alive, hence the strange, brooding figure in the background.

According to Noa Noa, the model Gauguin used was his young bride Teha'amana, something he judiciously omitted to mention to Mette, who knew only that he had a young Tahitian girl to keep house for him. One imagines he had entered into this arrangement essentially to further his artistic ambitions and be able to tackle the nude subjects he had planned. He clearly looked on this 'wife' as a dispensable resource, since he planned to leave her behind after a matter of months and move on to the Marquesas islands which, being more remote and more difficult of access than Tahiti, were reputed to be less altered. Such shameless exploitation of the indigenous people was commonplace in the colonies. Manao tupapau exposed her youthful body in a pose that he admitted would be considered indecent had he painted a European model, and he used Teha'amana's very real fears and superstitions about ghosts in order to give his painting its symbolic, mysterious aura. Two years later, having lost all hope of a reunion with his true wife, he wrote about his experience of this strange, shortlived marriage of unequals. The account he produced in Noa Noa was no doubt intended to titillate his male readership: to some extent fictionalized, it was written in a flowery manner reminiscent of Pierre Loti's popular novel about his own Tahitian marriage, Rarahu (Le Marriage de Loti), first published in 1879. It is possible that part of the description was in the hand of Charles Morice, the Symbolist poet who collaborated on the text of Noa Noa. When the first edition in book form was published in 1901, Morice felt under a moral obligation to excuse Gauguin's actions in taking such a young bride, adding that a thirteen-year-old Maori was equivalent in maturity to an eighteen- or twenty-year-old European. Gauguin, who did not hesitate to accuse his fellow colonialists of hypocrisy, was scarcely immune from such a charge himself.

Gauguin needed all his confidence and optimism to see him through the long wait for permission to travel home at

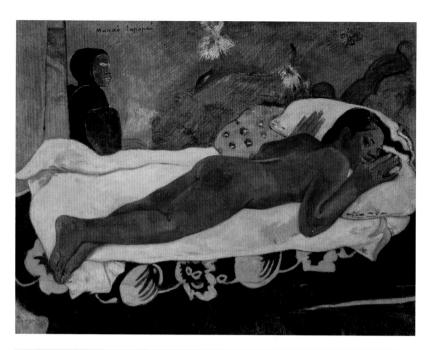

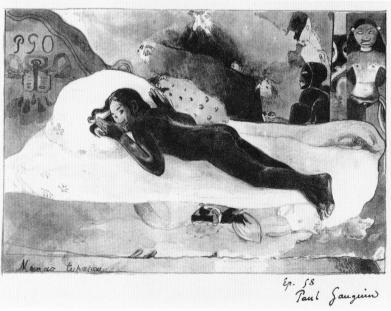

156 TOP Manao tupapau (The Spirit of the Dead keeps watch), 1892 $\,$ 157 $\,$ BOTTOM Manao tupapau, 1894

French government expense. He had first pleaded penury at the end of eleven months in Tahiti. The bureaucratic delays seemed endless but he was finally granted free repatriation by the Ministry and set sail for France on 14 June 1893. The voyage used up the few remaining savings he had, particularly as he opted to pay extra to travel second class. On arriving some two months later in Marseilles, he was furious to find himself stranded for lack of funds and obliged to await a money order from Paris.

As he had explained to Sérusier from Tahiti, he was impatient to get back to Paris so that he could 'stir things up a bit'. After the enforced idleness of the sea voyage, the autumn of 1893 was an incredibly hectic period in Gauguin's career. Having agreed terms with Durand-Ruel, who thanks to Degas's intervention had for the first time offered to hold a one-man show for Gauguin, not only did he have to stretch and frame the forty-odd canvases he planned to exhibit in a matter of two months, but he needed to ensure full press coverage and court the right sort of audience. To achieve this, having been out of town for over two years, he needed to catch up on all the gossip, find out what had been happening in the art world and see where his reputation now stood.

He sent a series of haranguing letters to his wife, believing her to have failed him in his hour of need at the port-side and demanding news of the exhibition in Copenhagen, which had taken place at the end of March that year. He particularly wanted to hear about the critics' reactions and any sales. since on such information hinged his chances of making this second show in Paris a success. He planned to take the city by storm with the complete novelty of the works he had brought with him. He soon learned that only one Tahitian painting had been sold at the Copenhagen exhibition, a variant of Femmes de Tahiti, to Mette's brother-in-law, the newspaper editor and politician Edvard Brandes. (Incidentally, Brandes had already played quite an important financial role for Mette during Gauguin's absence, buying several of the Impressionist pictures that had formerly made up her husband's collection. Gauguin seems to have resented this interference and later tried unsuccessfully to buy back the Cézannes and Pissarros.) As for the critical reactions, Gauguin may have taken heart that not all the Danish reviews had been unfavourable: the diversity of his talents had been signalled by the press. Whether or not Mette reported fully on the reviews is hard to say. Gauguin may well have been anxious about the inevitable comparisons of his works with those of the 'madman' Vincent Van Gogh, since in Copenhagen, for the first but by no means the last time, the

two artists' works were shown alongside one another. His worst fears might have been confirmed if word had reached him of the comments made by certain journalists; beside the intensity of life found in Van Gogh's works, his own were variously deemed 'pale and weak' and 'routine stuff'. This was hardly surprising given that only ten of Gauguin's recent Tahitian works had been seen in Copenhagen out of a selection of some fifty works, and a high proportion of them had been early canvases.

Another possible reason for Gauguin's jumpiness at this time may have been the publication, during the period of the Frie Udstillung, of extracts from Van Gogh's letters to Emile Bernard, many of them directly pertinent to himself. These extracts had been appearing in the Danish press as well as in the Mercure de France, and although the names of the living artists were obscured, for anyone in the know there was no mistaking Gauguin's identity; the role he had played in Van Gogh's tragic life had no doubt been the topic of much speculative gossip in the Paris cafés during his absence. Emile Bernard, moreover, who had been editing these letters and publishing art criticism in Gauguin's absence, had no desire to spare Gauguin's blushes. Was it perhaps to distance, and by implication to exonerate, himself that Gauguin suddenly decided to draft his own recollections of Van Gogh? His short ironic article, which was published in January 1894 in Les Essais d'Art Libre, is notable chiefly for the stress it lays on Van Gogh's 'madness', on his early missionary zeal and acts of Christian charity, on his belief in and apparent ability to work miracles, and his obsession with the colour yellow.

In other respects it must have looked to Gauguin as though circumstances in Paris were favourable to the understanding and appreciation of his new Tahitian works. During his twoyear absence Symbolist ideas had gained a wider currency and the standing of his young followers the Nabis had markedly increased. Apart from Paul Sérusier and Maurice Denis, this group included such talented members as Edouard Vuillard. Pierre Bonnard, Paul Ranson and Ker-Xavier Roussel. The Nabis or Symbolists had been exhibiting their flat, decorative and innovatory works regularly in the gallery of Le Barc de Boutteville, the latest dealer to take up the cause of new art, and were being much written about in the Symbolist press. Their names were also associated with the emergence of the first experiments in Symbolist theatre pioneered by their actor friend Aurélien Lugné-Poe. His new Théâtre de l'Oeuvre launched its first season of Scandinavian plays in October 1893. The opening of Ibsen's Un Ennemi du Peuple, with a programme and décor designed by Vuillard, coincided with the opening of Gauguin's one-man show in November, and the two artistic events were judged to be of equal importance by Charles Morice. Certainly, they were destined to appeal to similar sorts of audience and both playwright and painter, at different levels, could be said to be concerned with the individual's struggle to free himself from stifling bourgeois conventions. However, whereas Ibsen dramatized that struggle within a realistic domestic context, Gauguin's brilliantly coloured primitive idylls set forth the goals to work towards, the rewards of achieving that liberation.

Perhaps of greater relevance to Gauguin and to the way in which his works would be seen and interpreted was the fact that just a year and a half before his show opened, the Durand-Ruel gallery had been the venue for the first Salon of the Rose + Croix group, under the leadership of the self-styled Sâr Péladan. who had recruited adherents from among Gauguin's own former associates. Emile Bernard, for instance, and Charles Filiger, Exclusively concentrating on mystical, religious and allegorical art, the exhibition had proved a fashionable success. However distasteful Gauguin may have found the naturalistic, academic styles of many of the exhibitors, their success was unmistakably a sign of the times and he must have hoped his own show would awaken the same degree of public interest. He was intrigued and envious to learn that his friend Filiger now enjoyed the patronage of Count Antoine de La Rochefoucauld, the aristocratic Maecenas and amateur painter and poet who had initially sponsored the Rosicrucian movement. Gauguin was not slow to court the Count's sympathies himself, dedicating a drawing of his own most Rosicrucian work *Ia Orana Maria* to La Rochefoucauld for reproduction in Le Coeur Illustré, a new esoteric Symbolist journal the latter was financing. Roger Marx and Octave Mirbeau were critics from whom

Gauguin could reasonably expect continuing support, having been favourably reviewed by them both in the year of his departure. But the untimely death of Albert Aurier in October 1892 had deprived him of an eloquent champion whose philosophical articles carried considerable weight. It was to Charles Morice that Gauguin entrusted the task of writing an introduction to his exhibition catalogue, perhaps exacting recompense for Morice's failure to send out the money raised by the Théâtre d'Art benefit performance two years before.

Whatever irritation Gauguin may have felt while in Tahiti for his young acolyte was rapidly put aside in Paris.

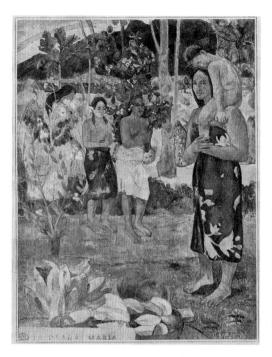

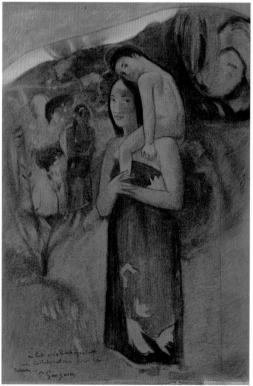

158 TOP LEFT la Orana Maria (Hail Mary), 1891
159 TOP RIGHT la Orana Maria, 1894
160 LEFT la Orana Maria (inscribed 'Au Comte de La Rochefoucauld'), c. 1893-5

By the time Gauguin's exhibition opened there had already been a flurry of excited press speculation about his return with his Tahitian 'negresses', almost as though the artist were bringing back live human specimens from an expedition! (Possibly the journalists were thinking of the indigenous village enclaves in the 1889 Colonial Exhibition). However inappropriate such responses, in the sense that he was still enough of a celebrity for his show immediately to attract considerable attention in the press, Gauguin could congratulate himself that he had timed his return from the South Seas nicely. In their anticipation, such critics aired the clichéd views of what Tahiti meant in the public imagination, views formed by reading travel literature and Pierre Loti.

It is not difficult to imagine the extraordinary effect this roomful of canvases must have had on those first visitors stepping in from the cold, November city streets. The consistency of the brightly coloured, flat and decorative style was more apparent than in any previous Gauguin exhibition, but more noticeable still, in almost every painting the visitor was confronted with Gauguin's ideal, his 'natural', unselfconscious, primitive Eve. Whether her presence denoted an animal litheness as in the stunningly simple *Otahi* (the colour and the disposition of the feet cunningly disguising the debt to Degas), or a dark and brooding mystery as in *Manao tupapau* and *Hina Tefatou*, or the sheer physical delight and abandonment of *Fatata te miti*, elegant Parisiennes with their consorts were bound to be taken aback by this confident projection of a new rule of beauty.

From the insistent use of an unfamiliar language for his titles and the decision to decorate the catalogue with what he doubtless considered a particularly barbarous black and white image. Gauguin sought to underline the distance that now separated him from the essentially urbane cultural expectations and blinkered perspective of his audience. Morice's preface, in all likelihood written under Gauguin's direct supervision, evoked Tahitian legends and presented Gauguin's paintings very much in the terms of Aurier's earlier definition of Symbolism, thereby urging viewers not to expect a documentary or realistic approach to the Tahitian subject-matter. It also gave brief explanations of a few of the more abstruse images in the exhibition, *Hina Tefatou*, for example, and *Manao tupapau*. Somewhat dubiously, it argued that Gauguin had not gone to Tahiti in search of novel motifs, but because his spirit had strained under the fetters of European ways of seeing. By staying for a lengthy period and living, so Morice claimed, 'as a native', Gauguin had penetrated deep into the hinterland

156 163

161

162

and essence of Tahiti, indeed, was instinctively in tune with its primitive character by virtue of his own Inca ancestry. Evasive and misleading as much of this introduction now seems, Morice did at least make clear that Gauguin's compositions were an attempt to revive the paradise lost, 'the Tahiti from before our terrible sailors and the perfumed confections of M. Pierre Loti', and that he had alternated or even fused with images of Tahiti today images of its former glory – this had been the intention behind *Ia Orana Maria*, for example.

It is not surprising that, for those who disliked Gauguin's art, Morice's preface could be dismissed also as 'moderniste' and 'décadent'. Seemingly by extension, Morice himself was wrongly described as an 'israelite' in the right-wing journal La Libre Parole, an indication of the irrational anti-Semitism already rampant in France on the eve of the Dreyfus affair. Many reviewers, however, took their cue to approaching and interpreting Gauguin's work from Morice's words: Octave Mirbeau, in L'Echo de Paris, used Gauguin's show as an excuse to heap further abuse on Pierre Loti and to pen another decidedly romanticized portrait of Gauguin's 'return to savagery', and of his intuitive understanding of the mysteries of Tahiti. As we have seen, Mirbeau was committed to the cause of anarchism and admired Gauguin above all for his rebellious stand against society. Such political affiliations had considerable significance given that in the very month in which most of the reviews of Gauguin's show appeared, the latest in a series of violent anarchist attacks on bourgeois institutions was perpetrated: a bomb was planted in the Chambre des Députés. Félix Fénéon was another critic practically as well as intellectually involved with anarchism, for which he stood trial and faced imprisonment the following year. Although he had virtually abandoned art criticism at this time, he found time to look at Gauguin's show and to give it a mention in La Revue Anarchiste: 'At Durand-Ruel's, the decorative canvases that Paul Gauguin has brought back from Tahiti - barbarous, opulent and taciturn in character'.

Gauguin's attitudes towards anarchism are difficult to pin down. He appears to have shared many of the basic tenets of the anarchist philosophy – belief in the freedom of the individual, opposition to many forms of state authority, the Church, and so on – although he claimed to be uninterested in and ignorant of politics. But Gauguin was nothing if not opportunistic and for the moment it probably suited and amused him to posture as an anarchist. The anti-hero was a pose he had cultivated in his

¹⁶¹ OPPOSITE TOP Fatata te miti (Near the Sea), 1892 162 OPPOSITE BOTTOM Otahi (Alone), 1893

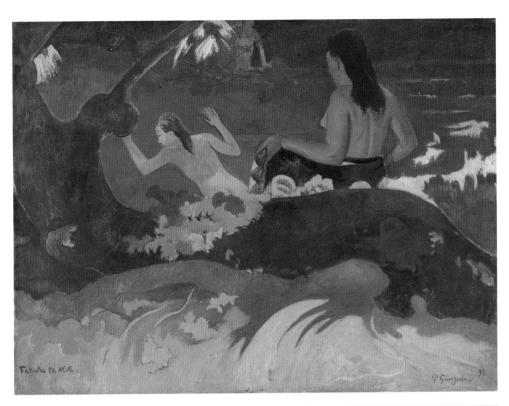

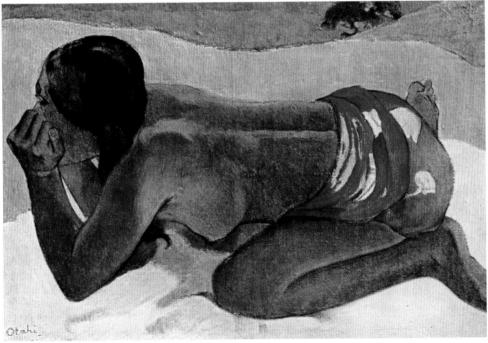

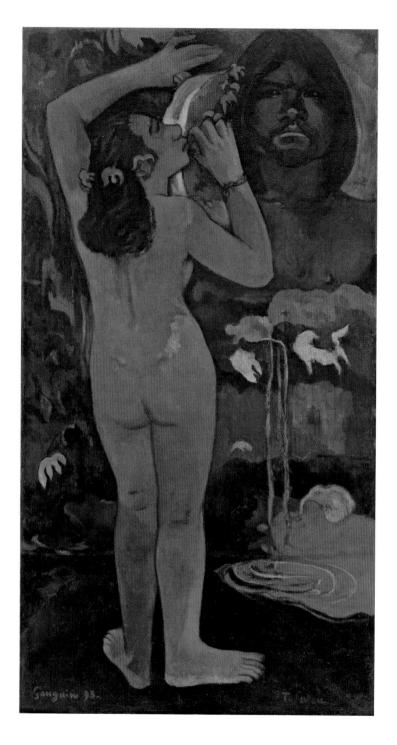

163 Hina Tefatou (The Moon and the Earth), 1893

164

self-portraits, after all, and the extravagant attire he sported on his return to 'civilization', to judge from the amusing gouache painted by Manzana Pissarro in memory of Gauguin's one-man show, was calculated to shock and amaze. Yet, in the eyes of committed anarchists like Pissarro and Paul Signac, Gauguin's lifestyle and now his choice of subject-matter evaded present-day ignominies and represented a 'sell-out' to the bourgeoisie, a pandering to a growing reactionary sentiment. Certainly, Gauguin's work had its admirers among a group of conservative patrons of the arts, such as Denys Cochin and Henri Lerolle, and even the support of Degas and Denis may have rendered him suspect in the eyes of more radical artists.

Political considerations aside, Gauguin was no longer a young man and could not afford to be rebuffed by the critics as he had been at earlier stages in his career. It seems that most critics were disposed to take his pictures seriously in 1893 and 1894. Even if they were irritated by the Tahitian titles and inclined to pass over the relevance of the subject-matter, they paid attention to and some were genuinely intrigued by the formal and colouristic daring of his canvases. Only the most conservative critics were still so disconcerted by the synthetic distortions of Gauguin's style, much as they were by other innovative painters working in this vein in Paris, that they failed to *see* the subjects at all.

Thadée Natanson, in *La Revue Blanche*, was unusual in having the perception to see through the exotic novelty of subject to the numerous references to more traditional Western art, and indeed he criticized Gauguin for relying too heavily on

164 Georges Manzana Pissarro, Portrait de Gauguin en pied, c. 1906. Manzana Pissarro drew this from memory: behind Gauguin some works done after the 1893 one-man show can be identified.

this apparel of novelty to dispense him from attempting any real innovation in style. In substance, these were the grounds on which certain fellow artists continued to carp at Gauguin's success, notably Pissarro, in whose view Gauguin was now 'stealing from the savages of Oceania'. A somewhat more typical review, probably written by Roger Marx, made purely formal, pictorial points, which were reiterated some twenty years later by the influential English critic Roger Fry. Discussing Manao tupapau with exceptional frankness, the reviewer argued that title and gloss here were completely unnecessary, 'perhaps indeed we would be hampered by the author's hidden intentions, if we were obliged to pay heed to them. A young Tahitian girl lies stretched out on her stomach on a sort of bed.... Is it a Polynesian Olympia that Gauguin has represented here, or is the chosen subject purely picturesque and pictorial, or again should we suppose it to be a precise symbol? I could not say, but this bronze body, so firm and unified, with its matt flesh, reposing from all activity, is so finely drawn, so broadly painted, so well set off by a décor that is both very brilliant and very simple, that I praise such a work with joy.'

That Gauguin was pleased to be spoken of in these formal, painterly terms is indicated by the fact that this was one of numerous cuttings he collected and pasted into a notebook. He dedicated the notebook to his daughter Aline, surely in itself a clear expression of his need for self-justification and acceptance

165 Pape moe (Mysterious Water), 1893-4

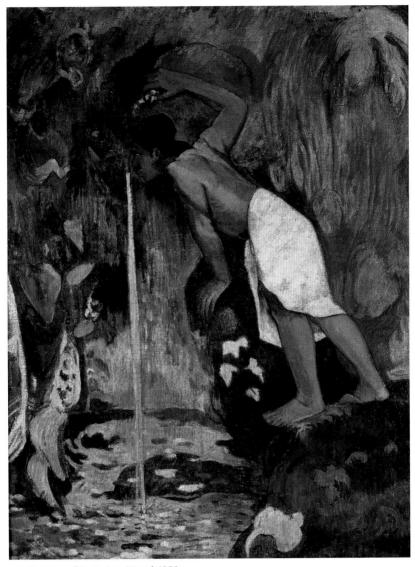

166 Pape moe (Mysterious Water), 1893

in the eyes of the child he held most dear, yet a poignant gesture given that his daughter did not live long enough to receive it. He would, perhaps, have been happier still with the comprehensive praise of Fabien Viellard, writing appropriately in *L'Art Littéraire*, who admired with equal force Gauguin the painter and Gauguin the thinker. He began by enthusing about

Gauguin's successful rendering of the enveloping and brilliant sunlight of the tropics, almost as though Gauguin were still working under the banner of Impressionism, and went on to praise his intellectual understanding of the Tahitian people, which he judged comparable to his empathy with the Bretons. But it was Achille Delaroche, writing in L'Ermitage, whose philosophical interpretation most fully satisfied Gauguin and came closest to understanding what he felt he had set out to do. Taking his cue from the approach of Albert Aurier, Delaroche set aside all questions as to the real or faked novelty of Gauguin's subject or to the technical and historical origins of his style, and allowed himself to respond to the works on a more purely subjective level, at the level of their 'suggestive decoration'. He was struck by the way in which 'the serenity of these natives overwhelms the vanity of our insipid elegances, our childish agitations! All the mystery of the infinite moves behind the naïve perversity of these eyes of theirs, opened to the freshness of things. It makes little difference to me whether or not there is in these paintings any exact reproduction of the exotic reality.' For Delaroche, Gauguin's art had the mysterious power to resolve the conflict between the conscious and the unconscious. Here at last, in Gauguin's view, was a critic who had shown himself receptive to the magical inner core of mystery he believed his works possessed.

From a critical point of view, Gauguin counted his one-man show a success and, coupled with the flattering comments of contemporaries such as Degas, Mallarmé and even, grudgingly, Pissarro, it helped to buoy up his confidence. Although certain commentators, including Charles Morice, have claimed that the Gauguin one-man show was a disastrous venture. there seems no justification for writing it off in this way. The disappointment lay solely in the material outcome. Only eleven of the forty-four pictures were sold. Gauguin justified his lack of sales to his wife, blaming the high prices he had been obliged to ask (2000 to 3000 francs each) in keeping with Durand-Ruel's standards. Neither despondent nor complacent, he judged it necessary and opportune to keep up the momentum of publicity, and he set to work to write a series of articles as well as the partly factual, partly fictional account of his Tahitian experiences that he entitled *Noa Noa*, an expression meaning 'very fragrant', believing this would serve to extend the public's knowledge and understanding of his Tahitian work. For practical and artistic reasons, as a way of highlighting the dichotomy between the outlook of a Parisian sophisticate and his own one of primitive simplicity, he agreed to collaborate with Charles Morice on the text. (For Gauguin to pose as the

167, 170

167 Noa Noa, 1894

possessor of a raw, primitive sensibility was disingenuous. of course, as Nicholas Wadley has pointed out.) With Noa Noa in mind, Gauguin produced a series of ten woodcuts, his first experiments in a medium he quickly made very much his own. In subject the prints explored themes already treated in his paintings and represent stages in the cycle of life. The chapters of Noa Noa essentially describe Gauguin's feelings and experiences on settling to work as a painter in Tahiti, his limited exchanges with the islanders, followed by his marriage. These personal recollections are interspersed with sections of Tahitian legend, supposedly heard from the mouth of his young bride but in fact copied from Ancien Culte Maorie and thus directly from Moerenhout. It is from these legends that the woodcuts derive their themes. Gauguin cut them up and pasted them into the pages of his own copy of the manuscript, often beside watercolours or photographs, thereby creating interesting collages of imagery and meaning.

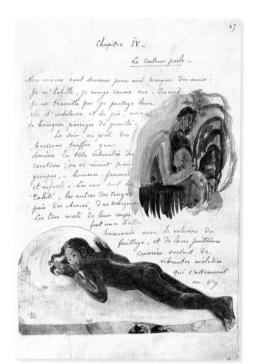

168 TOP LEFT Page 57 from the Louvre manuscript of Noa Noa, with woodcut of Hina and Tefatou from Te Atua, photograph of a Tahitian girl and watercolour of Hiro, the god of thieves, freeing a virgin from her enchanted captivity

169, 170 TOP RIGHT AND BOTTOM LEFT Pages 67 and 75 from the Louvre manuscript of *Noa Noa*, with woodcuts and watercolours

Noa Noa gave a purpose to Gauguin's print-making in 1894, but he cannot have failed to observe the growing importance of print-making in general, particularly colour lithography, within the Parisian avant-garde and no doubt felt an urge to keep up on this front. His competitiveness in technical matters and his readiness to experiment and innovate in different media were constant factors of Gauguin's career. The woodcut was a somewhat neglected technique, despite its long tradition. and Gauguin became one of the pioneers of its revival, with such artists as Auguste Lepère and Félix Vallotton. If the consciously crude primitivism of Gauguin's woodcut style was somewhat out of step in the 1890s, it proved an inspiration in the next decade to the German Expressionists. His woodcuts were in a sense simply reversals of his carved wood panels, worked with an ordinary carpenter's chisel and richly inked, creating sometimes suggestively diffuse, sometimes crisp and bold, primitive shapes, touched with colour to increase their decorative appeal.

At about this time Gauguin also produced two more important oil paintings of Tahitian subjects, demonstrating that the imagery was lodged in his memory and could be called up at will. Mahana no atua (Day of God) was a fantasy of an ancient Tahitian religious ritual, but the pyramidal design, with the worshippers arranged symmetrically round the central idol, is oddly reminiscent of Ingres's archly classical decoration for the Louvre, The Apotheosis of Homer. A similar religious ritual is enacted in the background of Nave nave moe, and early in 1894, shortly after its completion. Gauguin exhibited the canvas next to the works of the Nabis, at one of the group shows organized by the dealer Le Barc de Boutteville. In both these paintings and in the bold, full-length portrait of his new model Anna (of mixed Indian and Malay origin who passed as Javanese), Gauguin achieved a new level of decorative abstraction and colouristic simplicity, setting off his favourite harmony of pinks and blues with smaller patches of vermilion and chrome yellow.

In a rented studio in the rue Vercingétorix, Montparnasse, the winter and spring of 1893 and 1894 was also for Gauguin a time of socializing, living up to his reputation as the celebrated artist from Tahiti. He painted the walls chrome yellow and his own highly coloured works and carvings created a powerfully exotic ambience, as several of his callers remembered. Through his neighbours the Molards, he met a cultured and lively circle of Scandinavians. He also attended openings in Paris – he was seen at the Salon du Champ de Mars for example – and travelled to Brussels to see the first exhibition of the newly formed Salon de la Libre Esthétique (the successor to the Vingt group), which

173

174

172

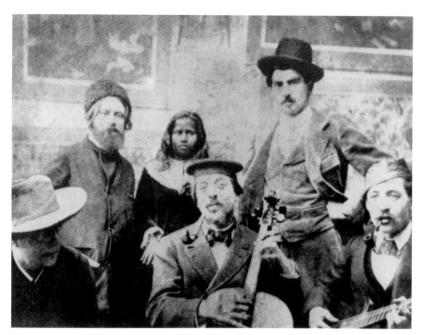

171 Gauguin's studio at 6 rue Vercingétorix, 1894, with (from left) ?Gauguin in Buffalo Bill hat, Paul Sérusier, Anna la Javanaise, Fritz Schneklud with cello, Georges Lacombe, and the musician G. Larrivel

he reviewed. One characteristically provocative gesture made at this time was his offer to donate to the Luxembourg Museum his most prized Tahitian painting, *Ia Orana Maria*, an offer that was unceremoniously turned down, thus confirming and reinforcing Gauguin's hatred of officialdom.

Quite how Gauguin envisaged his long-term future is hard to say. Both he and Mette, in their letters before December 1893, were evidently discussing the possibility of a family reunion, perhaps in a fisherman's cottage on the Norwegian coast. Some time in the opening months of 1894, however, things came to a complete impasse and Mette finally broke off communications. The final straw seems to have been her fury that Gauguin appeared to have no intention of sharing the legacy of 13,000 francs that, fortuitously, had just come his way from his paternal uncle in Orléans.

Certainly, Gauguin's decision to return to Pont-Aven in April 1894 must have been prompted more by nostalgia and a desire to see old friends than by any real intention of producing further Breton paintings. In truth, he had nowhere else to go where he might feel at home. One has the impression that Gauguin relished his notoriety and enjoyed cutting a dash in

his strange, exotic attire, with Anna and her monkey in tow. Thanks to the inheritance, he could afford to live more lavishly than before, and there were plenty of young painters, new as well as former recruits to the Pont-Aven school, to whom he could hold court about his experiences in Tahiti. From what

172 Aita Tamari Vahine Judith Te Parari (Anna the Javanese), 1893-4

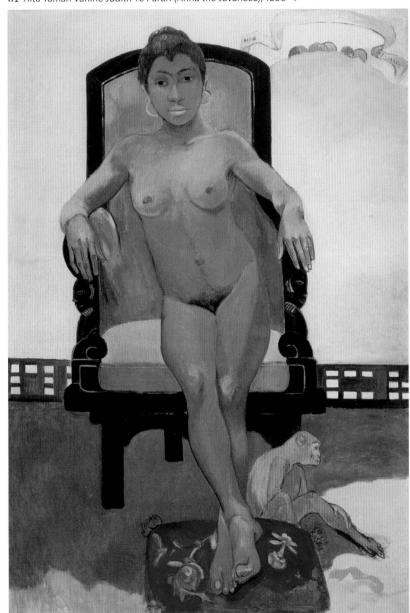

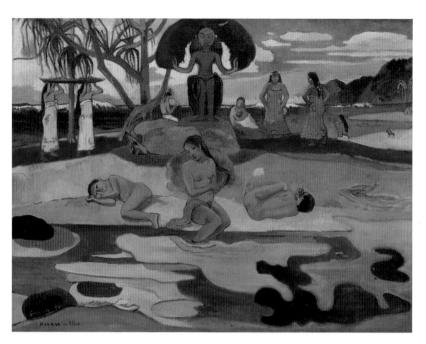

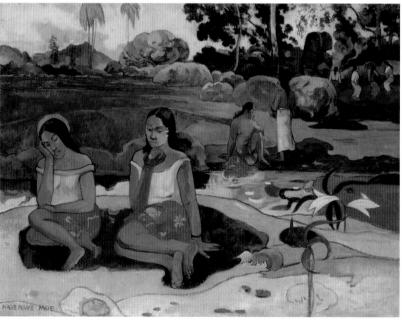

173 тор Mahana no atua (Day of God), 1894 174 воттом Nave nave moe (Delicious Water), 1894

175 Two standing Tahitian women, 1894, dedicated 'à l'ami Baven [sic]' (Robert Bevan)

we know of his behaviour on this occasion, bragging about sexual exploits, getting involved in a brawl with sailors at Concarneau in which he suffered a broken ankle, and then engaging in legal wrangles with the local authorities, he appears to have accepted that henceforth he would live up to the role of the dissolute in which his wife, among others, had cast him. He no longer maintained the pretence of being seen as a respectable family man. The image impressed on the young British artists he befriended, Robert Bevan and Roderic O'Conor, was one of hard-drinking extravagance and cynical disillusion.

On returning to Paris after a prolonged period of immobility, during which he had completed very few paintings, he found his belongings had been ransacked by the faithless Anna (she had left his work intact, however). Gauguin opened his studio from 2 to 9 December, inviting critics to come and admire his newly completed sets of woodcuts and monotypes. An account in the *Mercure de France* by Julien Leclerq made much of the technical strength of Gauguin's prints and described as 'revolutionary' his new method of making watercolour monotypes. In fact it was not an untried method: Degas had similarly cultivated the art of the monotype. And as in that case, this admirable keenness to try new media was an indication both of Gauguin's reluctance to tackle new subjects and of his satisfaction with the range of motifs he now had at his fingertips and could rework at will.

140, 175

Chapter 7 **Definitive Exile**(1895–1903)

On 18 February 1895, before leaving Europe for good, Gauguin once again put all his current stock of work up for sale. Unhappily, his attempt to repeat his success of four years earlier foundered and most of the items failed to meet the asking price. Degas, who had already bailed Gauguin out on previous occasions, bought several works, including *Vahine no te vi* and the *Olympia* (copy after Manet). This continued expression of faith must have reassured Gauguin that he had not completely missed his direction, even though he was bitterly disappointed by the general outcome.

In seeking to publicize his sale, as before Gauguin had enlisted the services of a prominent literary figure, inviting August Strindberg, the Swedish dramatist (whose plays were currently being discovered by Parisian audiences), to write a preface to the sale catalogue. Strindberg wrote back declining the invitation, giving his reasons for feeling unequal to the task and trying to explain what it was he found so disconcerting about Gauguin's 'barbarous' work. This unease of the highly civilized European was, of course, grist to Gauguin's mill and he published the letter as it stood, with his own reply, which sought to answer some of Strindberg's doubts. 'The Eve of your civilized imagination makes you and almost all of us misogynists; the Eve of primitive times who, in my studio, startles you now, may one day smile on you less bitterly.... The Eve I have painted – and she alone – can remain naturally naked before us. Yours, in this simple state, could not move without a feeling of shame, and too beautiful, perhaps, would provoke misfortune and suffering.' He extended the argument by drawing a linguistic analogy, comparing the 'crude', simple language spoken by his Eve with the polished, inflected languages of Europe.

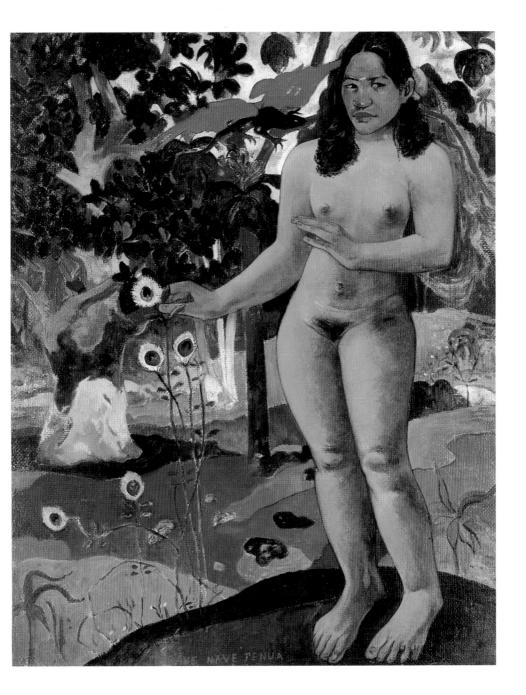

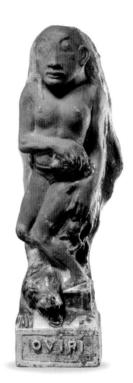

177 Oviri, 1894-5 178 Oviri, 1894-5

Gauguin was in no mood to heed the advice or warnings of others; he felt he had nothing to gain by staying any longer in Europe, no hope of a reunion with his family, and no will to continue the struggle for existence in a hostile environment, a struggle that was so much more bearable in the gentle climate and friendly atmosphere of Tahiti. In deciding to return there a second time, he was no longer thinking of a future triumphant return to Paris, nor was he thinking of the important work he still had to do. What he had already achieved would suffice to carry his name into posterity. Indeed, his latest creation in stoneware ceramic, the sculpture Oviri, hints at Gauguin's disillusioned state of mind: an extraordinary embodiment of an idea of the 'savage' with which he self-identified, merging male and female elements and ideas of birth and cruel death. In effect, Gauguin's motives for leaving a second time were essentially negative ones: a renunciation of Europe's decadence, an evasion of personal responsibilities, as well as an inability to

back down from the elaborately constructed image of himself as rebel, outsider and primitive, an image that had ensured him a cult following on the streets of Paris or Brittany, but had effectively closed off the possibility of resuming serious, private working habits in France. Not least among the reasons for his deep disillusionment with the Paris art scene was the fact that in the *Mercure de France* of June 1895 his own integrity had been called into question by Emile Bernard in a swingeing attack. An acrimonious exchange of correspondence ensued in which the validity of his reputation was the chief bone of contention. For once, rather than entering the fray, Gauguin allowed others to speak for him and took a gentlemanly way out by quitting the scene.

With Gauguin, calculation only went so far and then impulse took over. He had explained to his wife back in 1889. 'You know me, either I calculate, (and I calculate well) or I don't calculate at all, heart in hand, eyes front, I take up the fight bare-breasted.' Had he planned things more judiciously, so his first biographer Jean de Rotonchamp was to claim, Gauguin could have ensured himself a regular income for the remaining years of his life. Ambroise Vollard, who was just on the point of seriously launching himself as dealer for the work of Cézanne and the Nabis, had made a few modest purchases from Gauguin's sale and would have been prepared to support Gauguin with a steady retainer in return for a regular submission of work. Instead, when he left Paris Gauguin had struck up only the slimmest of financial deals with a café proprietor named Lévy and Georges Chaudet, a minor artist, agreements that were quickly reneged on. He tried subsequently to launch a syndicate of fifteen patrons who would each invest in him to the tune of 150 francs a year, but from a distance and with no precedent to point to, this arrangement failed to get off the ground. Back in Tahiti, extravagant spending soon exhausted Gauguin's savings. On arrival in September 1895 he had set about having a spacious, purpose-built dwelling constructed at Punaauia, sparing no expense on the installation of a studio. Already by November 1895, the begging letters to De Monfreid had resumed and Gauguin was once more complaining of his health.

The reason the two-year-old injury to his ankle refused to heal was not just the tropical climate, as Gauguin thought, but the advancement of syphilis, diagnosed in 1895, which is thought to have hastened his death in 1903. In his last years, Gauguin's mobility was severely restricted and he endured considerable pain and stretches of time in hospital; but his enforced confinement to a studio-based practice merely exaggerated

an already established working pattern. Earlier ideas were harnessed, developed and recycled as Gauguin's imaginative reconstruction of a Tahitian past turned more and more in on itself. However, the necessary revitalizing periods of contact with nature were lacking in these later years. For intellectual stimulus Gauguin relied heavily on the Mercure de France, sent out to him regularly and free of charge from Paris. He had taken shares in the *Mercure* shortly before his final departure in 1895, and there is no doubt that he devoured its contents: it was one of his few means of keeping abreast of happenings in the art scene and in the wider world. But the gap left on the Mercure staff by the untimely death of Aurier had been filled by a young and pretentious poet. Camille Mauclair, whose art criticism was decidedly unfriendly towards Gauguin. As a shareholder. Gauguin did not hesitate to voice his grievances about this inconsistency to the Mercure's editor, Alfred Vallette. In truth. by the mid-1890s the Mercure occupied a central establishment position and was no longer the foremost mouthpiece for avantgarde ideas. It had been superseded in that role by La Revue Blanche, an altogether more eclectic, anarchic review which championed the Nabis and the new star of Paris. Henri de Toulouse-Lautrec, It was in La Revue Blanche that Morice published a first edition of *Noa Noa*, without illustrations, in November and December 1897, a move that annoved Gauguin.

180

No painting was done during those last few months of 1895, but the wooden cylinder with Christ on the Cross dates from this period. It is a strange combination of the most traditional of Christian symbols with patterns taken from a Marquesan war-club. Its general shape and elaborate surface decoration probably reflect the fact that Gauguin had recently seen an excellent collection of Maori artefacts in the museum in Auckland, New Zealand, where he stopped on his journey out. The museum had on show examples of Maori dwellings. with their richly carved lintels and structural posts, as well as free-standing wooden statues of ancestral chiefs, at least one of which turns up in a later painting of Gauguin's. He made sketches of some of the abstract geometric motifs, and in adorning his own huts in Tahiti and later in the Marquesas. he followed some of the decorative precedents of the Maoris. The wooden cylinder stands half a metre high and was obviously worked on over a long period. In its use of hybrid religious motifs, it possibly indicates Gauguin's familiarity with similarly hybrid symbolic carvings from Brittany, where local craftsmen had incised their own Christian iconography into druidic menhirs. The carving can also be seen as an attempted synthesis of Gauguin's 'primitive' artistic sources.

179 The new room in the South Wing of the Museum at Auckland, New Zealand, opened in 1892, showing carved panels used in decorating Maori dwellings

Once again, the symbol of Christ's crucifixion had a probable autobiographical significance; Christopher Gray has pointed out that the carved hand and foot which appear on one side of the cylinder refer to the present source of Gauguin's physical suffering, his infected ankle.

The increasing complexity of idea and elaboration of surface decoration one finds in Gauguin's woodcuts and carvings also characterize the group of major paintings he produced between 1896 and 1898. One witnesses a certain progression in complexity if one compares the two large nudes of 1896 and 1897, Te arii vahine and Nevermore, O Taïti, and the two mural-like friezes D'Où venons-nous? Que sommes-nous? Où allons-nous? and Faa Iheihe of 1897 and 1898 respectively. Whereas Gauguin's first single-figure nude, Manao tupapau, had been sparked off by an observed moment of terror, these later nudes were more laboriously and artfully conceived. The first borrows a pose from one of the numerous Venuses of the German Renaissance artist Lucas Cranach, as well as loosely paying homage once again to Manet's Olympia. The idea behind the image seems equally convoluted: Gauguin explained that the reclining nude was a queen, and he had included 'two old men near the big tree, arguing about the

183.

187.

188,

193

156

tree of knowledge'. This commentary suggests that in painting his primitive nudes, so 'free from shame', Gauguin was nevertheless self-consciously aware of the great tradition of nude painting in the West, and such favourite themes of Renaissance artists as Susannah and the Elders. The motif

180 TOP LEFT AND MIDDLE Cylinder with Christ on the Cross, 1896
181 TOP RIGHT Menhir de Pleuven, Pleumeur-Bodou, Côtes du Nord
182 BOTTOM Lucas Cranach the Elder, Nymphe endormie, 1537
183 OPPOSITE TOP Te arii vahine (Woman with Mangos), 1896
184 OPPOSITE BOTTOM Te tamari no atua (The Birth of Christ), 1896

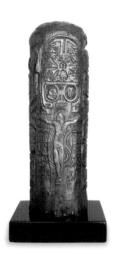

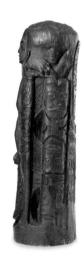

of the whispering, huddled figures was one of those Gauguin repeatedly recycled, in works of all media. They reappear in the shadowy middle plane of D'Où venons nous?, and the presence of another, somewhat sinister, brooding couple seems to torment the reclining nude in Nevermore, whose eyes express unease. More generally, the idea of two figures conjoined in conversation, which was extensively explored during Gauguin's first stay in Tahiti, crops up everywhere in his late work; one of the last, most beautiful mutations is the traced monotype of 1902, where the figures are reduced to heads and no longer appear sinister or conspiratorial, anxious or brooding, but serene and self-contained.

Gauguin congratulated himself on the rich and sonorous coloration he had achieved in *Te arii vahine*, which he repeated in *D'Où venons-nous?*, the dark blues and greens giving a jewellike prominence to the clusters of bright reds, oranges and pinks that are so characteristic of his late Tahitian palette. A more muted, sombre note pervades *Nevermore*, in keeping with its reference to the lugubrious refrain of the raven in Edgar Allan Poe's poem. Gauguin compensates for the elaborate background, where each decorative detail seems charged with significance, by the simple monumentality of the heavy-

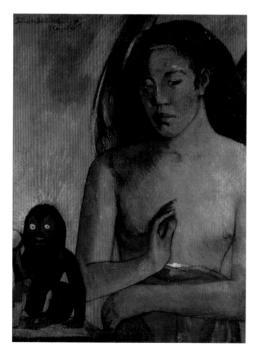

185 Poèmes Barbares, 1896

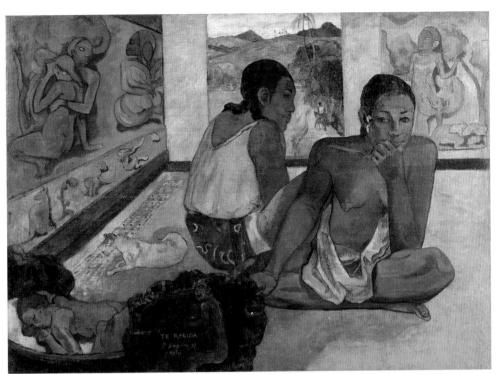

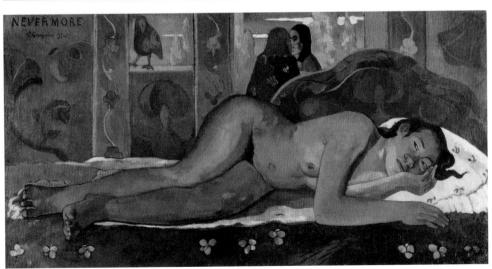

186 ТОР *Te Rerioa (The Dream),* 1897 187 ВОТТОМ *Nevermore, O Taïti,* 1897

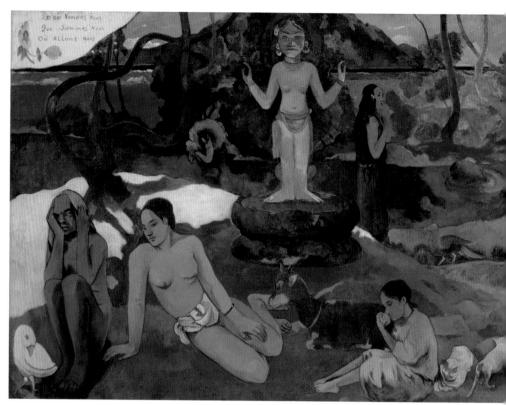

188 D'Où venons-nous? Que sommes-nous? Où allons-nous? 1897

limbed nude, whose powerful presence owes much to bold modelling. As a painter, Gauguin never altogether renounced three-dimensionality for flatness, despite Cézanne's complaint that he 'only painted Chinese images'. The colour range of *Faa Iheihe* departs still further from reality, with its rich yellows and golds harking back to the gilded backgrounds of early Italian paintings, much as its frieze arrangement echoes Botticelli's *Primavera*, a reproduction of which Gauguin had pinned to the wall of his hut. The progression towards an ever more cluttered surface reaches its extreme here; plants, fruit, foliage and animals seem to serve a purely decorative function.

Unquestionably the most important canvas of Gauguin's late career was *D'Où venons-nous? Que sommes-nous? Où allons-nous?* which he painted at the end of 1897. That year, financial worries and poor health, as well as the news of his daughter Aline's tragic death, brought him to the point of despair. He determined to commit suicide if nature did not do the job for

193

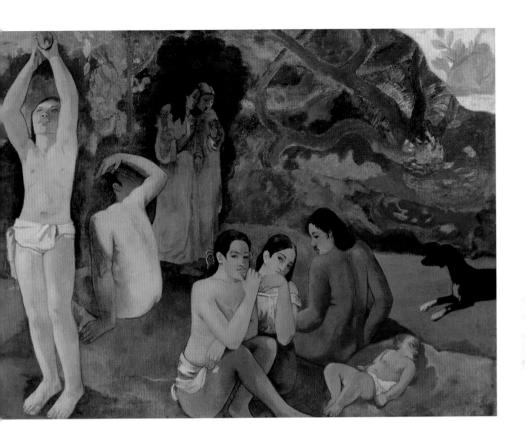

him. Paradoxically, the personal satisfaction he had gained from his most recent canvases had rekindled his ambitions as a mural painter, and he determined to produce one last masterpiece on a huge scale, a work that would serve as a fitting monument after his death. He ordered a quantity of paints and brushes from De Monfreid in Paris, and when they finally arrived he set to work on a canvas almost four metres wide, the largest he had ever tackled. He worked quickly, so he claimed, by day and night, using large brushes to cover the surface of the broad sacking, not bothering with sketches or a cartoon but painting by instinct in a state of heightened tension. After a month the canvas was completed to his satisfaction. Gauguin then took himself up into the mountains, swallowed a large quantity of arsenic and waited to die. The quantity was perhaps too great because his body rejected it and although he suffered terrible pains and cramps he escaped death once more. Returning to his studio, he remained for many days immobile

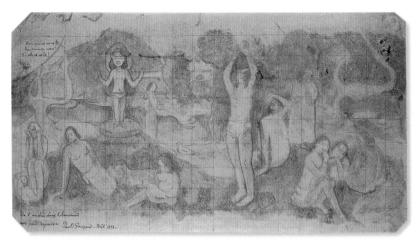

189 Squared-up study of D'Où venons-nous?, 1897-8

on his bed, contemplating the great work he had accomplished. It is quite possible that only at this stage did he paint in the portentous inscription; Gauguin later explained that it was intended as a signature, rather than a title, a philosophical reflection prompted by the picture. By July 1898, when he decided to send it to be exhibited and sold in France, curiosity about its future fate had helped to dispel his previous mood of morbid hopelessness.

Gauguin gave numerous lengthy accounts of the production and meaning of this painting, firstly to De Monfreid. Some of the claims he made about its execution do not stand up to scrutiny, such as his insistence on having produced the whole thing without forethought or preparatory sketches. He wished to distance himself from and avoid comparison with the elaborate preparatory procedures of the academically trained artist. One almost completely resolved, squared-up sketch survives, done in watercolour and sanguine on tracing paper. Moreover, several of the figures had their origin in earlier works. The largest standing central figure, plucking fruit from a tree, was derived from a small sketchbook copy he had made of a drawing in the Louvre then thought to be by Rembrandt. The arrangement of the numerous figures is in a broad frieze, some standing, some seated. All are self-contained, and apparently unconnected with one another by any coherent narrative. though four of them stare out at the spectator interrogatingly. As usual, Gauguin deliberately took liberties with anatomy and perspective, especially in the central seated figure seen from behind. His composition has many similarities, though, with

192

the murals of Pierre Puvis de Chavannes, whose large painting for the museum at Rouen, *Inter Artes et Naturam*, exhibited at the Salon in 1890, would have been familiar to him.

As early as 1891, Aurier had drawn attention to Gauguin's potential as a mural decorator, calling for someone to offer him the chance to paint walls. When Gauguin sought such

190 TOP Paul Sérusier, La Cueillette de Pommes, Pont-Aven Triptych, c. 1891 191 BOTTOM Paul Signac, Au Temps d'Harmonie, 1894-5

an official commission in 1894, with Degas's backing, he was rebuffed. Nevertheless, there was a vogue for decorative mural painting in the 1890s, involving artists as diverse as the Nabis Denis and Vuillard, the Neo-Impressionists Cross and Signac and the more conservative Salon painters Henry Lerolle and Albert Besnard. Gauguin cannot have failed to notice the growing importance of decorative schemes at the exhibitions he visited while in Europe, and among his own followers in Brittany; although on a much smaller scale, Sérusier's triptych of c. 1891 has important similarities in subject and coloration to Gauguin's later composition. For all these artists the example of Puvis de Chavannes had been an inspiration, his precedent almost inescapable. Taking their cue from Puvis's work, the themes most artists favoured tended towards the general and allegorical rather than the specific or realistic, in keeping with the anti-naturalistic mood of the times. This did not prevent a traditional, golden-age theme taking on a modern political significance in the hands of an artist like Signac: Au Temps d'Harmonie (1894-5) was a projection of an idyllic future when anarchy would reign supreme. In so far as Gauguin looked instead to an imagined past, to a primitive idyll where man and nature had existed in harmony, his painting could be said to express a more conservative, reactionary standpoint. There were numerous possible literary sources for the questions posed by Gauguin's composition. The Scottish philosopher Thomas Carlyle's Sartor Resartus had just been serialized in the Mercure de France and it gave prominence to very similar metaphysical problems.

Gauguin was extremely anxious that his great work should be presented to the right people under the most favourable circumstances, an organizing task as usual allotted to De Monfreid. Having travelled half way round the world rolled up, the canvas needed some attention before it was stretched and framed, finally going on view at Vollard's gallery from November to December 1898, with a dozen or so smaller Tahitian works, among them *Faa Iheihe* and *Vairaoumati*. Gauguin suggested the names of various influential people who he felt should be invited to see them, including previously supportive critics such as Roger Marx and Octave Mirbeau. Perhaps in deference to Gauguin's bitter complaints about Camille Mauclair, instead André Fontainas was sent along to review the show for the *Mercure*.

Fontainas devoted considerable space to Gauguin's exhibition. Admitting at the outset that he had formerly felt an antipathy for Gauguin's art, he explained how he had forced himself to make a serious appraisal of these new works. He set

190

191

193, 150

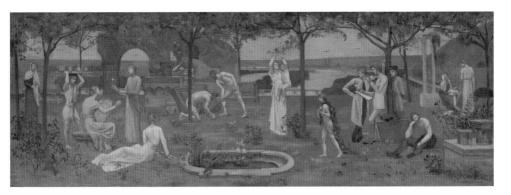

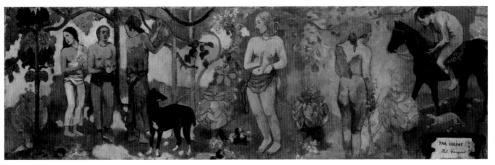

192 TOP Pierre Puvis de Chavannes, Inter Artes et Naturam, c. 1890 193 BOTTOM Faa Iheihe (Tahitian Pastoral), 1898

aside other people's objections to Gauguin's wilful drawing style, arguing that it was the artist's prerogative to express himself through line as he saw fit. Nor did he think it necessary to carp at Gauguin's choice of an exotic rather than a banal subject-matter; indeed, he congratulated him for having had the courage to leave behind the popular cult of ancient Brittany, whose charm he felt was beginning to pall. In stylistic terms, he was struck above all by Gauguin's emotive use of colour, but criticized him for his over-use of certain stark contrasts (a brilliant red against a vibrant green, for instance). He was captivated by what he took to be the more straightforward evocations of day-to-day Polynesian life, works such as Faa *Iheihe.* However, he remained unimpressed by the large panel D'Où venons-nous? with its loftier ambition to address general philosophical questions. Fontainas made the obvious comparison with Puvis de Chavannes (whose recent death had been widely lamented), but all in the latter's favour: 'To represent a philosophic ideal he [Puvis] conceived harmonious groupings whose attitudes were able to impose on us a dream

193

analogous to his own. In the large panel exhibited by M. Gauguin, nothing, not even the two supple and pensive figures who pass through it, so calm and so beautiful, nor the clever evocation of a mysterious idol, would be capable of revealing to us the meaning of the allegory, had he not taken the trouble to write in a corner at the top of the canvas: "Where do we come from? What are we? Where are we going?"

A similar verdict was reached by Thadée Natanson, reviewing the exhibition for *La Revue Blanche*. He praised Gauguin highly for his increasingly seductive and gracious decorative forms and for his vibrant colours, but suggested that his attempt to inject his works with literary and symbolic meanings did them a disservice, merely revealing how unhelpful in the long run his earlier flirtation with the Symbolist poets had been. We do not know whether Gauguin saw Natanson's review, but he was sufficiently upset by Fontainas's to feel the need to answer him in a long letter. To the charge that his choice and arrangement of forms failed to communicate his underlying idea, failed to signify, he gave a somewhat evasive response. He argued that mystery, ambiguity, an inability to seize the full meaning of the suggestive décor of Tahiti, were part of his intention. He also iustified the occasional monotony of his use of colour by means of an elaborate analogy with polyphonic music. But this questioning of his capacity to convey serious philosophical meaning in a grand-scale work clearly preoccupied Gauguin. When Charles Morice, two years later, tried to raise a subscription to buy the still unsold canvas for the French nation, Gauguin was even then anxious to defend himself against Fontainas's criticism and to arm Morice against possible future objections. He explained that the relation between the arrangement of the figures and the questions posed in the title was in fact very simple. On the left, the old woman facing death, and the idol indicating the beyond, raised the question 'Where are we going?' In the centre the figure plucking fruit raised the question of the meaning of day to day existence, while on the right, the newborn child corresponded to the question 'Where do we come from?' 'Behind a tree are two sinister figures, enveloped in garments of a sombre colour, recording near the tree of knowledge their note of suffering, the suffering that knowledge itself causes in contrast to the simple beings in a virgin nature, the human idea of paradise maybe, who give themselves up to the joy of living.' (One is tempted to identify these sinister figures with Gauguin himself, the wiser but sadder European forced to contemplate from outside the unspoilt primitive life made beautiful by his own creative fantasy.) Finally, not for the first or for the last time, Gauguin

194 First page of a letter to Daniel de Monfreid, February 1898, with sketch of *D'Où venons-nous?*

produced his ultimate self-justification – the blasphemous excuse that, like Christ, he spoke in parables; just as many of the listeners to Christ's teachings had been incapable of understanding His message, so most of Gauguin's audience would fail to penetrate his veiled meanings: 'Seeing they see not, hearing they hear not.'

In his last years, Gauguin's output of paintings dwindled, especially between 1899 and 1901 when he resorted to taking a desk job for the Office of Public Works and Surveys in Papeete to make ends meet, and also became involved in journalism for local satirical newspapers. He edited his own satirical journal Le Sourire and contributed lengthy polemical articles to another, Les Guêpes. He entered the fray of colonial politics with no particularly consistent axe to grind and at various times one finds him attacking the Protestant missionaries, pointing out the ineptitudes and corruption of the bureaucracy and legal system (he was incensed at the governor's refusal to investigate fully his own grievances about petty thefts committed by natives), or defending the interests of the French settlers against the increasing economic influence of the Chinese immigrants. He fulminated against war-mongering moves on the world stage, commending an example of judicious French diplomatic policy in the Sudan, for instance, because it had averted bloodshed. None of these later writings suggests he held the native Tahitian population in particularly high esteem, or that he had any misgivings about the morality or usefulness

196,

197

of colonization. Much as a tone of brooding pessimism underlies the superficially paradisical world he conjured up through his art, Gauguin's journalistic writings are pervaded by a world-weary irony which was evidently appreciated by a small, select audience among Tahiti's colonial population.

After 1901 a new arrangement with Vollard ensured Gauguin a steadier income, and at last he was able to move to the Marquesas islands, still further, so he hoped, from civilization. There is a loss of focus and vitality in much of the later painting, due in part, no doubt, to Gauguin's failing evesight and general health. However, the move to Hiva-Oa produced something of a renewal in his creative energies and in some paintings he equalled the ambition and stylistic force of his previous work. Contes barbares, for example, is a major achievement in which the metamorphosed features of Meijer de Haan reappear from the past, a sinister presence overlooking the two figures of Tahitian women, one in the pose of Buddha. Gauguin even embraced some entirely new subjects at this time: Cavaliers sur la plage, for example, with its undisguised debt to Degas; and he returned to painting landscapes and still lives, some inspired by the exotic flora and fauna of Polynesia, others, such as Nature morte avec 'L'Espérance' de Puvis, nostalgic evocations of the European culture he had supposedly left behind. Gauguin's last letters to France by no means lack optimism, nor had he lost interest in the progress of his works on the art markets of Europe. Moreover, he continued to experiment at the technical level, concentrating once again on the medium of monotype in which, with no false modesty, he felt himself to have made such revolutionary strides that his achievements would have to be noticed in Europe. The greatest advantage of monotype for Gauguin was that it avoided the need for a printing press. Perhaps in deference to the warnings of Fontainas and Natanson, he henceforth steered clear of deep metaphysical problems in his art, confining them instead to his copious writings. The imagery he explored in such prints as Femme Tahitienne accroupie vue de dos, another version of which the sculptor Maillol owned, was simpler, more archetypal and monumental, based round single figures and family groups.

One gets the feeling that in his last, lonely years Gauguin resorted to writing as a substitute for the companionship, conversation and exchange of ideas he lacked. Much of the autobiographical material had a propaganda purpose, a setting

201

204

200

199

¹⁹⁵ OPPOSITE TOP LEFT Etude de force, c. 1900

¹⁹⁶ OPPOSITE TOP RIGHT Le Sourire, 1899

¹⁹⁷ OPPOSITE BOTTOM Le Sourire, 1900

straight of the record, a getting back at the critics, a covering over of the tracks. He hoped to see his various writings collected together and published before his death, but it was probably just as well for his reputation that no such publication appeared. His recollections of his contemporaries are not always fair, affectionate or illuminating, but it is interesting to find his admission of indebtedness to Pissarro, whose importance, Gauguin argued, had been unjustly forgotten by so many of his followers. More often than not, Gauguin's ideas seem to have been sparked off by an article read in the *Mercure de France*, and the diversity of topics he touched on, from art and education to religion and politics, as well as the specific questions he discussed, correspond closely to matters dealt with in the relevant monthly issue of the journal. His pieces bear witness

198 OPPOSITE TOP Femme Tahitienne accroupie vue de dos, 1901–2 199 OPPOSITE BOTTOM The Pony, c. 1902 200 ABOVE Nature morte avec 'L'Espérance' de Puvis, 1901

201 Contes barbares, 1902202 OPPOSITE TOP Invocation, 1903203 OPPOSITE BOTTOM Christmas Night, 1902-3

204 Cavaliers sur la plage, 1902

to a restless, energetic intellect but they lack organization, coherence and consistency.

Gauguin died in 1903, in ignominious circumstances. In France there were even false reports that he had been stricken by leprosy. Having fallen out with the local Catholic bishop, he was given a hasty, low-key burial, and because some of his works were deemed indecent they were burned. The inventory of his remaining effects which were sold at auction reveals his colonial life to have been by no means as impoverished or primitive as he liked to maintain.

De Monfreid arranged a small exhibition of Gauguin's work in late 1903 in Paris, but the major retrospective was held in 1906 at the Salon d'Automne. Although Morice feared that the retrospective was held too soon for people to view Gauguin's work objectively, unclouded by the legends and rumours associated with his name, he need not have worried. For a whole new generation of young artists in Paris, such as Henri Matisse, André Derain and Raoul Dufy, this comprehensive survey of Gauguin's achievements could not have been better timed.

Their enthusiasm for his bold, unnaturalistic use of colour and decorative simplicity fully justified Gauguin's confident prediction that his work in itself was less important than its consequences would be: the liberation of the next generation from the trammels of naturalism. Gauguin's special contribution to the history of art was inseparable from his biography: the introduction of exotic, 'primitive' elements into the stylistic and iconographic repertoire. This has proved to be an equally enduring aspect of his legacy to the artists of the twentieth century. Did Gauguin but know it, even before his death a copy of the newly published, illustrated edition of *Noa Noa* had come into the hands of a young Spaniard exiled in Paris, Pablo Picasso, and was being carefully and productively annotated.

Conclusion

The extraordinary events of Gauguin's life made him a legend in his own time. Far from seeking oblivion in his island retreat. he lived out his last years as a focus of attention, albeit at a great distance from his native land. Though he died in unenviable circumstances, he congratulated himself on having lived his life in the way he had chosen rather than according to the dictates of society. For this he was condemned by Pissarro and others; in their view, not only had Gauguin evaded his responsibilities, he had failed to produce a social art that could be understood by ordinary people. We have seen that Gauguin by no means escaped the conditioning of the historical times in which he lived; indeed, his decision to exploit the tropics in the way that he did would have been virtually unthinkable at any other point in history. Then again, the problems he set himself as an artist, how to abstract from nature, how to get at the intangible idea through material form, how to convey meanings mysteriously, by means of parables, can only be understood in the light of his involvement with literary Symbolism. Gauguin owed an enormous debt to the support and endeavours of others, and the only reason he could make his claim on posterity with such certainty was because he had undertaken in union with others the enterprise of freeing art from its thraldom to nature. If at the formal level his example was of crucial importance to the coming generation of Fauves and Expressionists, so too were the examples of Van Gogh, Signac and Cézanne.

It was undoubtedly Gauguin's belief in the ultimate triumph of his supreme acts of individualism that sustained him through the bad times. This belief came about by degrees, by repeated failures to make a success of group ventures. It manifested itself in a suspicion of all joint enterprises, and

205 Two Tahitian Heads, c. 1902

eventually in scorn and rejection of democratic society as a whole. However much Gauguin tried to play down the literary aspects of his work, it was no coincidence that his appeal was always felt as keenly by writers as by painters. The romance of his life and the way it carried over into his art intrigued and inspired literary men from Huysmans to Mirbeau and to Maugham. Not for nothing did he enact the idle daydream of the Western businessman, an escapist dream that remains potent even though Gauguin's Tahiti, the Tahiti of legend, has been irretrievably sacrificed to the exigencies of a modern age.

Appendix to the New Edition: Gauguin research since 1987

In the three decades since the original publication of this title in 1987, Gauguin's life and oeuvre have attracted an exponential degree of attention from scholars, curators and collectors. Gauguin's work can now be found in most of the great museums of the world and exhibitions are mounted from Amsterdam to Graz, Auckland and San Francisco. In commercial terms an alltime high was surely reached in 2015 when his beautiful Tahitian canvas Nafea faa ipoipo? (When Will you Marry?) sold to a Qatari buyer for an eyewatering \$210 million. Film- and documentarymakers find Gauguin an irresistible subject. In this appendix I aim to give the reader an idea of recent shifts in Gauguin studies, major research developments and publications of note, together with some pointers for the future.

One reason for the enduring popularity of Gauguin has to be his turbulent life story and wide-ranging iconographic interests, resulting in work produced in many different locations that speaks to many different constituencies. He pre-empted today's appetite for global travel. Today few countries can fail to find a connection with Gauguin, be it through his presence on their shores for a week or several months, his interest in and validation of their cultures, or the challenges his work raises. As well as his sojourns in Peru, Denmark, Norway, Panama, Martinique, Tahiti and the Marquesas Islands, Gauguin explored his native France, producing images of Paris, Rouen, Dieppe and Provence and putting his stamp on southern Brittany. Criticized by certain contemporaries for his eclectic borrowings, he gleaned ideas, images and techniques from such disparate sources as Japan, Java, India, Greece, Egypt and New

Zealand. Of course Gauguin undertook journeys in a very different time and context, when tourism was in its infancy but colonial empirebuilding - with France rivalling Britain, Germany and America - at its height. Although there were efficient mail services and the telegraph existed there were as yet no aeroplanes. Gauguin criss-crossed the globe by sea, and experienced firsthand the progressive shift from sail to steam: the timescales involved in international travel need to be taken into account when we seek imaginatively to re-enter his world. His era. like ours, was one of intensive archaeological discovery; he made the most of the artefacts that could be seen in the museums and exhibitions of Paris, and transported with him photographic images of artefacts from different cultures. For although he deplored photography's baleful influence on Salon painting, as recent research has shown the camera served Gauguin well, not least as a means to record and repurpose his own works. Indeed, through his guardian Gustave Arosa he was connected to one of its early technical experiments, the collotype.

Another major factor in Gauguin's enduring appeal is the enigmatic, multilayered nature of his imagery, which can seem on the one hand to endorse, and on the other to challenge, the values of our multicultural world. Paradoxically, feminist art history has found in certain of his images and social attitudes an obvious target, yet in some of his writings Gauguin emerges as a surprise advocate of women's freedoms. The open-endedness of his representations, the androgynous character he found in Polynesians for instance, together with certain homoerotic allusions in his fictionalized journal Noa Noa, have prompted questions about Gauguin's sexuality, particularly with the recent rise of queer theory. His inventive working methods, built upon the foundations of strong drawing and encompassing a diverse range of media - oils, watercolours, pastels, ceramics, woodcarving, printmaking - have proved unstintingly rewarding to study. Gauguin's art taken as a whole repays careful looking and deeper inquiry: far from the one-dimensional eroticization of 'dusky maidens' that has conventionally been purveyed by unthinking marketing, it is now more widely recognized as the outcome of intelligent premeditation and craftsmanship.

New documentary sources

Since 1987 the ongoing complete edition of Gauguin's correspondence under the editorship

of Victor Merlhès has resulted in two new publications focused on Gauguin's exchanges, respectively, with fellow artists Vincent Van Gogh and Emile Schuffenecker. Wide-ranging in their references, these veer towards interpretative studies, as does the same author's 1994 facsimile publication of Racontars de Rapin, Gauguin's 1902 essay reflecting upon the art of his time, which offers dense commentary of great erudition. The completion of the correspondence for the years 1889-1903 is eagerly awaited. In the interim, this author's Gauguin by Himself, 1993, offered a selection of Gauguin's writings in French and English, ranging from correspondence to essays. Nancy Mowll Mathews' well-documented Paul Gauguin: An Erotic Life, 2001, beyond its contentious Freudian thesis, published an illuminating series of previously inaccessible letters from Gauguin's Danish wife Mette to Schuffenecker.

A different slant on Gauguin the man emerges from the new abundance of ancillary publications of correspondence from within his French circle. The Seguin/O'Conor correspondence appeared in 1989. The recent revised edition of Vincent van Gogh - The Letters edited by Leo Jansen, Hans Luijten and Nienke Bakker has become an essential online research resource since its launch in 2009. Edited by Neil McWilliam, Emile Bernard: Les Lettres d'un Artiste, 2012, allows a more balanced view of his contested relations with Gauguin. A clearer understanding of Gauguin's relations with Daniel de Monfreid, his loyal confident and factotum, or with the Dutch/Jewish artist Meijer de Haan, his fellow lodger at Marie Henry's inn in Le Pouldu, emerges from monographic exhibitions on those artists (Narbonne 2003, Amsterdam 2010).

The Wildenstein Foundation's two-volume Gauguin: Catalogue de l'oeuvre peint (1873-1888), 2001, whimsically entitled Premier itinéraire d'un sauvage, has vastly expanded our knowledge of the range of Gauguin's early painted work and brought together in one place much valuable contextual information. Going beyond the scope of a conventional listing, the entries detailing the works' subjects, style, exhibition history and provenance reveal the unconventional ways in which Gauguin approached the established genres of still life, landscape and portraiture. Its ample and wide-ranging chronology enriches our knowledge of his family history, early travels in the merchant marine and navy, followed by his chequered career in the world of finance, his places of residence and circles of contacts.

One anticipates that the appearance of the later volumes, under the smart editorship of Sylvie Crussard and Richard Brettell, will be equally revelatory.

New scholarship has enhanced our understanding of Gauguin's exhibition history, his involvement with exhibiting groups in France and overseas, notably at the Volpini café exhibition in 1889 and with Les XX and the Libre Esthétique group in Brussels; his place in posthumous exhibitions such as Roger Fry's Post-Impressionist exhibition in London in 1910. Valuable new light has been thrown on Gauguin's relations with his dealers (specifically Theo Van Gogh and Ambroise Vollard) and collectors, an area where more remains to be done.

New scholarly approaches and exhibitions

Following the appearance in 2000 of Technique and Meaning in the Paintings of Paul Gauguin by Vojtěch Jirat-Wasiutyński and H. Travers Newton Jr., there have been several studies of Gauguin's use of different media, particularly ceramics, sculpture and print, although none has replaced the standard catalogues of ceramics, sculpture and monotypes by Bodelsen, Gray and Field. Similarly work has opened up on Gauguin's use of words, both within his artistic output, where literary allusions or Tahitian phrases are frequent, and in his aspirations as a writer himself. While decrying anecdotal art, Gauguin was an artist attuned to the aesthetic possibilities of literature (and music). I have explored the parallels between Gauguin and Robert Louis Stevenson, and the conflicted place he accorded narrative in his own work. Philippe Verdier and Elizabeth Childs have written on the 1897 manuscript in which Gauguin attacks Catholicism. Isabelle Cahn has published a valuable commentary to accompany the CD-Rom of Noa Noa and Diverses Choses. Linda Goddard has made a considered study of Gauguin the writer, characterizing him as a knowing exponent of a number of different genres. Having published separate essays and chapters on the topic, her book on Gauguin's writings is forthcoming at time of press.

With the exception of the posthumous publication of Henri Dorra's *The Symbolism of Paul Gauguin*, 2007, there has been somewhat less concern in recent decades with the issues of primitivism in relation to Brittany or with Symbolism, more with Gauguin's broader cultural and colonial context. But *Paul Gauguin: The Mysterious Centre of Thought*, 2013, by Dario

Gamboni proposed a novel and more intricate exploration of Gauguin's imagery, underlining the knowingly playful ambiguity of his imagemaking and arguing for the artist's psychological openness to chance forms and double meanings.

The nature of Gauguin's Catholicism was explored by Debora Silverman in 2001 in contrast to the Protestantism of Van Gogh, while Gauguin's own surprising brushes with Protestantism fascinated Othon Printz in 2008. For as well as informing his subject-matter, Gauguin's religious formation had a clear bearing on his (mostly hostile) reactions to the missionary activity in Polynesia. There have been illuminating post-colonial studies of his dialogue with Maori culture from New Zealand. Gauguin occupies an honourable position within the growing scholarly interest in late nineteenthcentury science, Darwinism, spirituality and the occult. Routinely, recent Gauguin studies have critiqued the artist's seeming endorsement of the European fantasy of Edenic life, which has been associated since the Enlightenment with the islands of the South Seas, setting his mythmaking against the realities of French colonial politics and Tahitian sexuality, but authors have not always remained alert to his provocation or ironies.

Gauguin's travels have always held a special appeal for adventurous seafarers, beginning with Victor Segalen, whose life was rerouted by his near encounter in the Marquesas with Gauguin and whose writings and theorizing of the exotic are the topic of renewed scholarly interest. For today's art historians wishing to follow Gauguin to French Polynesia, the Paul Gauguin cruise ship has opened up an avenue. Benefiting from field work, recent American studies display considerable familiarity with the Polynesian terrain: Stephen Eisenman's Gauguin's Skirt, for instance, stood out against the modernist tendency to equate Gauguin with liberating masculinity, demonstrating the nuanced complexity of his treatment of Tahitians in art and life and arguing that he was both 'representative of imperialism at its apogee and anti-imperialism at its birth'; Elizabeth Childs developed an illuminating parallel between Gauguin and two well-documented contemporary American travellers to the Pacific, Henry Adams and John La Farge; Caroline Boyle-Turner and June Hargrove have paid more attentive respect to Gauguin's last burst of creativity on Hiva Oa in the Marquesas Islands than previous scholars, this one included. A recent scholarly anthology,

Gauguin's Challenge, edited by Norma Broude, brings together new essays by many of the aforementioned chiefly Anglo-Saxon scholars. But just as modern tourism capitalizes on Gauguin's artistic reputation, conversely the damage to his personal reputation caused by decades of de-mythologizing and by modern sensitivities around race and sex (Gauguin has been swept up in the general moral panic about sex tourism) has resulted in Tahitians being unwilling or unable to sustain a museum in his name.

Several recent monographic exhibitions have had a geographic focus, with Tahiti the most popular locale, others concentrating on the artist's briefer connections with Brittany, Panama, Martinique and New Zealand. While a comprehensive coverage of these is beyond the scope of this summary, some of the most important exhibition catalogues are listed in the Select Bibliography. Whereas the centenary of Gauguin's death in 1903 was marked by a major show on Gauguin in Tahiti and the decade that followed saw a series of focused exhibitions looking at discrete moments or phases in his career or at his relations with other artists. Gauguin's propensity for fashioning his image. forging his myth, adopting narrative strategies, has been the approach of exhibitions over the last decade, as reflected in their titles: 'Gauguin: Maker of Myth' (Tate Modern, 2010); 'Gauguin: Metamorphoses' (Museum of Modern Art, 2014); 'Gauguin: Artist as Alchemist' (Art Institute of Chicago, 2017). That self-fashioning impulse was intimately connected to his experimentation with different media. Recent exhibitions have tended to adopt a more holistic approach to his output, no longer privileging Gauguin the painter but emphasizing his protean craftsmanship.

The future

Exploiting today's digital technology, the latest permanent collection catalogues and their findings are increasingly being presented online. *Gauguin Paintings, Sculpture, and Graphic Works at the Art Institute of Chicago*, 2017, edited by Gloria Groom with input by many other scholars, is a pioneering example. Working with unparalleled holdings of the artist's works on paper, the new website uses enhanced details and analytical techniques from the conservation studio to reveal the complexity of Gauguin's working methods and explore his use and reuse of imagery. The online format has again been chosen for the systematic catalogue entries of the Gauguin paintings in the

National Gallery of Art, Washington, currently at the editing stage.

As with Impressionism as a whole, there remain many questions about Gauguin, specific and more general, to pose: as resources expand, scholarship will find new directions, in the areas of critical reception and literature, for example. Gauguin's relations with Van Gogh may be better understood, but his dealings with his more obscure contemporaries and his significance for, and influence upon, many later artists remain to be elucidated. Gauguin's portraits will be the focus of an exhibition curated by Cornelia Homburg in Toronto and London in 2019. But other topics have so far eluded scholars: his drawings, his scabrous humour. Questions of dating and authenticity abound: for instance, uncertainty remains about the status of certain woodcarvings such as the Head with Horns acquired by the Getty Museum. We have not exhausted the fascination of Gauguin yet.

Select Bibliography

The Gauguin bibliography is vast and the list that follows is by no means exhaustive. In addition to listing those publications I found immediately useful in preparing this book in 1987, in particular those from which I drew quotations, the bibliography has now been updated and augmented to include some of the significant publications that have appeared in the intervening period.

Correspondence

Gauguin's complete correspondence is in the process of being edited. For this book I was able to draw on the first published volume, Correspondance de Paul Gauguin, 1873-1888, ed. Victor Merlhès, Fondation Singer-Polignac, Paris 1984. This includes all the extant letters Gauguin wrote and most of those he received up to December 1888, as well as other relevant documents such as Huysmans's review of Gauguin at the Impressionist exhibition of 1881, originally published in L'Art Moderne in 1883 (see Chapter 1). All references in the text to letters of this period are taken from this volume and translated by myself. There have been two supplementary publications by the same author: Victor Merlhès (ed.), Paul Gauguin et Vincent van Gogh, 1887-1888, Lettres Retrouvées, Sources Ignorées, Avant & Après, Paris 1989; and Victor Merlhès (ed.), De Bretagne en Polynésie, Paul Gauguin, Pages Inédites, Avant & Après, Lannion 1995.

For later correspondence the main sources are still: *P. Gauguin: Letters to his Wife and Friends*, ed. M. Malingue, trans. H. Stenning, London n.d. (1948), although the datings should be treated with caution; P. Gauguin, *Lettres de Gauguin à Georges Daniel de Monfreid*, ed. V. Ségalen, Paris

1930 (updated edition 1950); and *Paul Gauguin:* 45 Lettres à Vincent, Theo et Jo Van Gogh, ed. D. Cooper, Rijksmuseum Vincent Van Gogh, Lausanne 1983.

Other writings by Gauguin

There is no complete edition of Gauguin's writings. Extracts from his writings are to be found in Gauguin, Oviri, écrits d'un sauvage, ed. D. Guérin, Paris 1974. References in the text to Gauguin's writings, both to his published articles and to the unpublished Notes Synthétiques of 1884–85 and Avant et Après of 1903, are taken from this source. A translation of Avant et Après by Van Wyck Brooks appeared as Paul Gauguin's Intimate Journals in 1923 (new edition New York and London 1949). The facsimile edition of Gauguin's Cahier pour Aline of 1893, Fondation Jacques Doucet, Société des Amis de la Bibliothèque d'Art et Archéologie de l'Université de Paris 1963, contains the cuttings from most of the critical reviews of Gauguin's one-man show of 1893 (see Chapter 6). A useful account of Noa Noa, its genesis, meaning and transformation through successive editions is Noa Noa: Gauguin's Tahiti, edited and with text by N. Wadley, Oxford 1985. For Gauguin's later journalism see B. Danielsson and P. O'Reilly, Gauguin: Journaliste à Tahiti et ses articles des 'Guêpes', Paris 1966. Belinda Thomson (ed.), Gauguin by Himself, Little, Brown, London 1993, is an anthology across the range of Gauguin's writings. For a facsimile and analysis of Gauguin's 1902 text Racontars de Rapin see the publication by Victor Merlhès (ed.), Taravao, Editions Avant & Après, Pampelona 1994. The same text is available in translation as Ramblings of a Wannabe Painter, ed. and trans. Donatien Grau, David Zwirner Books, New York, 2016. Isabelle Cahn (ed.), Gauguin Ecrivain, Noa Noa, Diverses Choses, Ancien culte mahorie, CD-Rom, offers facsimiles of these three texts in the collection of the Louvre with an accompanying booklet in English and French, Réunion des Musées Nationaux, Paris 2003. Linda Goddard, Savage Tales: The Writings of Paul Gauguin, Yale University Press, New Haven and London 2019.

Other documentary sources

On Gauguin's youth and family origins see U. Marks-Vandenbroucke, *Gazette des Beaux-Arts*, nos 1044–47, 1958. *Correspondence de Camille Pissarro, 1865–1903*, 5 vols, ed. Janine Bailly-Herzberg, editions Valhermeil, 1980–1991. Félix Fénéon, *Oeuvres plus que complètes*, 2 vols, Paris and Geneva 1970. Octave Mirbeau, *Des Artistes*,

Paris 1986. Une Vie de bohème, Lettres du peintre Armand Seguin à Roderic O'Conor, 1895–1903, Musée de Pont-Aven, Quimper 1989. Gauguin: Actes du colloque Gauguin, Musée d'Orsay, 11–13 janvier 1989, La Documentation française, Paris 1991. Emile Bernard: Les Lettres d'un artiste, Neil McWilliam (ed.), Les Presses du Réel, Monts 2012.

Monograph studies

B. Danielsson, Gauguin in the South Seas, London 1965. F. Cachin, Gauguin, Paris 1968. M. Roskill, Van Gogh, Gauguin and the Impressionist Circle, London 1970. A. Bowness, Gauguin, London 1971. W. Anderson, Gauguin's Paradise Lost, London 1972. R. Field, Paul Gauguin: The Paintings of the First Voyage to Tahiti, New York 1977. F. Orton and G. Pollock, 'Les Données Bretonnantes: la Prairie de Représentation', Art History, September 1980, reprinted in Modern Art and Modernism: A Critical Anthology, ed. F. Frascina and C. Harrison, London 1982. B. Thomson, Gauguin and 'Post-Impressionism', Block 111, Arts: A Third-Level Course, Modern Art and Modernism, The Open University 1983. J. Teilhet-Fisk, Paradise Reviewed: An Interpretation of Gauguin's Polynesian Symbolism, Michigan 1983. A useful introduction to the Europeanization of Tahiti is D. Howarth Tahiti: A Paradise Lost, London 1983. Griselda Pollock, Avant-Garde Gambits, 1888-1893, Gender and the Colour of Art History, Thames & Hudson, London 1992. David Sweetman, Paul Gauguin: A Complete Life, Hodder & Stoughton, London 1995. Stephen F. Eisenman, Gauguin's Skirt, Thames & Hudson, London 1997. Vojtěch Jirat-Wasiutyński and H. Travers Newton Jr., Technique and Meaning in the Paintings of Paul Gauguin, Cambridge University Press, Cambridge 2000. Nancy Mowll Mathews, The Erotic Life of Paul Gauguin, Yale University Press, New Haven 2001. Deborah Silverman, Van Gogh and Gauguin: The Search for Sacred Art, Farrar, Straus and Giroux, New York 2001. Henri Dorra, The Symbolism of Paul Gauguin, University of California Press, Berkeley, Los Angeles and London 2007. Elizabeth C. Childs, Vanishing Paradise: Art and Exoticism in Colonial Tahiti, University of California Press, Oakland 2013. Dario Gamboni, Paul Gauguin: The Mysterious Centre of Thought, Reaktion, London 2014. Caroline Boyle-Turner, Paul Gauguin & The Marquesas: Paradise Found? Editions Vagamundo, 2016. Peter Cooke and Nina Lübbren (eds), Painting and Narrative in France, from Poussin to Gauguin, Routledge, Abingdon and New York 2016. June Hargrove, Gauguin, Citadelles & Mazenod, Paris 2017. Norma Broude

(ed.), Gauguin's Challenge: New Perspectives after Postmodernism, Bloomsbury, London 2018.

Oeuvre catalogues

In anticipation of the publication of the complete revised catalogue raisonné (in preparation) by the Fondation Wildenstein, the painted oeuvre up to 1888 is well documented by the twovolume Gauguin, premier itinéraire d'un sauvage, Catalogue de l'oeuvre peint (1873-1888), compiled by Sylvie Crussard and Martine Heudron, Wildenstein Institute, Paris 2001. The most complete guide to Gauguin's post-1888 paintings remains G. Wildenstein and R. Cogniat, Paul Gauguin: 1, Catalogue, Paris 1964, although it has many flaws. The succinct Rizzoli publication, re-edited by Flammarion as Tout l'Oeuvre Peint de Gauguin, Paris 1981, is a useful alternative, despite its postage-stamp size reproductions. For Gauguin's works in other media see M. Bodelsen, Gauguin's Ceramics, London 1964; C. Gray, Sculpture and Ceramics of Paul Gauguin, Baltimore 1963; M. Guérin, L'Oeuvre gravé de Gauguin, 2 vols, Paris 1927; Richard S. Field, Paul Gauguin: Monotypes, Philadelphia Museum of Art 1973. The Fans of Paul Gauguin, presented by Jean-Pierre Zingg, Editions Avant & Après, Pamplona 2001.

Collection catalogues

Gloria Groom and Genevieve Westerby (eds), Gauguin Paintings, Sculpture, and Graphic Works at the Art Institute of Chicago, available online at: https://publications.artic.edu/gauguin/reader/ gauguinart/section/139805

Exhibition catalogues

Gauguin and the Pont-Aven School, Tate Gallery, London 1966. R. Field, Paul Gauguin Monotypes, Philadelphia Museum of Art, Philadelphia 1973. M. Bodelsen, Gauguin and Van Gogh in Copenhagen in 1893, Ordrupgaard, Copenhagen 1984. K. Varnedoe, 'Gauguin', Primitivism in Modern Art, Museum of Modern Art, New York 1984. Le Chemin de Gauguin: genèse et rayonnement, Musée du Prieuré, Saint Germainen-Lave 1985. Gauguin, National Gallery of Art, Washington; Art Institute of Chicago; Musée d'Orsay, Paris 1988-89. Paul Gauguin, Tahiti, Staatsgalerie, Stuttgart, 1998. Gauguin, Ronald Pickvance, Fondation Pierre Gianadda, Martigny 1998. P. Gauguin: Von der Bretagne nach Tahiti, Ein Aufbruch zur Moderne, Landesmuseum Janneum, Graz 2000, a multi-authored catalogue, in German only. Gauguin's Nirvana, Painters

at Le Pouldu, 1889-90, ed. Eric M. Zafran with essays by Victor Merlhès, Robert Welsh and Bogomila Welsh-Ovcharov, Wadsworth Atheneum Museum of Art, Connecticut 2001. Van Gogh and Gauguin, the Studio of the South, Douglas Druick and Peter Zegers, Art Institute of Chicago; Van Gogh Museum, Amsterdam 2001. The Lure of the Exotic, Gauguin in New York Collections, Colta Ives and Susan Alyson Stein et al., The Metropolitan Museum of Art, New York 2002. Gauguin/Tahiti, L'Atelier de tropiques/The Studio of the Tropics, George T. M. Shackelford and Claire Frèches-Thory et al., Galeries Nationales du Grand Palais, Paris, 2003-4; Museum of Fine Arts, Boston 2004. Gauguin and the Origins of Symbolism, Guillermo Solana. with contributions by Richard Shiff and Guy Cogeval, Museo Thyssen-Bornemisza, Madrid, 2004-5 (includes work by Gauguin's followers and admirers in France and Spain). Gauguin's Vision, Belinda Thomson with Frances Fowle and Lesley Stevenson, National Galleries of Scotland. Edinburgh 2005 (focused on Gauguin's Vision of the Sermon, 1888). Gauguin and Impressionism, Richard R. Brettell and Anne-Birgitte Fonsmark, Kimbell Art Museum, Fort Worth and Ordrupgaard, Copenhagen 2005. Gauguin/Van Gogh, L'avventura del colore nuovo, Marco Goldin et al., Museo de Santa Giulia, Brescia 2005-6. Paul Gauguin: Artist of Myth and Dream, Stephen F. Eisenman with Richard Brettell, Rome 2008. Paul Gauguin: Paris, 1889, Heather Lemonedes. Belinda Thomson, Agnieszka Juszczak et al., Cleveland Museum of Art 2009, and under the title Paul Gauguin: The Breakthrough into Modernity, Van Gogh Museum, Amsterdam 2010 (focused on the zincographs and paintings shown at the Volpini exhibition, Gauguin's riposte to the official Universal Exhibition). Gauguin's Paradise Remembered, The Noa Noa Prints, Alastair Wright and Calvin Brown. Princeton University Art Museum 2010. Gauguin: Maker of Myth, Belinda Thomson with Tamar Garb et al., Tate Modern, London 2010; The National Gallery of Art, Washington, DC 2011. Gauguin and Polynesia, ed. Suzanne Greub et al., Ny Carlsberg Glyptotek, Copenhagen; Seattle Art Museum 2011-12. Gauguin Metamorphoses, Starr Figura et al., Museum of Modern Art, New York 2014 (an exploration of his later printmaking). Paul Gauguin, Beyeler Foundation, Basel 2015. Gauguin: Artist as Alchemist, Gloria Groom with Claire Bernardi, Ophélie Ferlier-Bouat et al., Art Institute of Chicago; Musée d'Orsay, Paris 2017-18.

With Eyes Closed: Gauguin and Munch, Ute Kuhlemann Falck with Gerd Woll, Munch Museum, Oslo 2018. Gauguin, A Spiritual Journey, Christina Hellmich, Line Pedersen et al., Fine Art Museums of San Francisco 2018

List of Illustrations

All works are by Paul Gauguin unless otherwise stated Measurements are given in centimetres and inches, height before width

- 1 Portrait de l'artiste (Portrait of the Artist), 1893–4. Oil on canvas, 46 × 38 (18½ × 15). Musée d'Orsay, Paris. Photo RMN-Grand Palais (musée d'Orsay)/Franck Raux
- 2 Gauguin devant son chevalet (Gauguin at his Easel), 1885. Oil on canvas, 65×54 ($25\% \times 21^{1/4}$). Kimbell Art Museum, Fort Worth, Texas
- 3 Pastorales Tahitiennes (Tahitian Pastoral), 1892. Oil on canvas, 87.5×113.7 ($34\frac{1}{2} \times 44\frac{7}{8}$). The State Hermitage Museum, Saint Petersburg
- 4 Mette Gauguin en robe de soir (Mette Gauguin in Evening Dress), 1884. Oil on canvas, 65 × 54 (25⁵% × 21¹/4). Nasjonalmuseet, Oslo. Photo Nasjonalmuseet, Oslo
- 5 La Mère de l'artiste (The Mother of the Artist), c. 1889. Oil on canvas, 41×33 ($16\frac{1}{8} \times 13$). Staatsgalerie, Stuttgart
- 6 Portrait of the Artist's Mother (Eve), 1889–90. Gouache, 17×13 (6 $^{3}/_{4} \times 5^{1}/_{6}$). Art Institute of Chicago. Gift of Edward McCormick Blair
- 7 Paysage avec peupliers (Landscape with Poplars), 1875. Oil on canvas, $81 \times 101 \ (31\% \times 39\%)$. Indianapolis Museum of Art. Estate of Kurt F. Pantzer
- 8 Paysage (Landscape), c. 1873. Oil on canvas, 50.5 × 81.6 (19% × 32%). Fitzwilliam Museum, Cambridge. Photo akg-images/De Agostini Picture Library
- 9 Les Maraîchers de Vaugirard (The Market Gardens at Vaugirard), 1879. Oil on canvas, $66 \times 100 (26 \times 39^{1/2})$. Smith College Museum of Art, Northampton, MA
- 10 Camille Pissarro, *The Côte des Bœufs at L'Hermitage, near Pontoise*, 1877. Oil on canvas, 115 × 87.5 (44¹/₄ × 34¹/₂). National Gallery, London 11 Georges Manzana Pissarro, *An Impressionist Picnic*, c. 1881. Pen and ink. Private Collection

- 12 Portrait bust of Mette Gauguin, 1877. White marble, height 34 (13¹/₄). The Courtauld Gallery, London. Photo Samuel Courtauld Trust, The Courtauld Gallery, London/Bridgeman Images 13 Les Pommiers de l'Hermitage, III (Apple Trees at l'Hermitage, III), 1879. Oil on canvas, 65 × 100 (25⁵/₈ × 39³/₈). Aargauer Kunsthaus, Aarau 14 La famille du peintre au jardin, rue Carcel (The Artist's Family in the Garden, rue Carcel), 1881. Oil on canvas, 87 × 114 (34¹/₄ × 44⁷/₈). Ny Carlsberg Glyptotek, Copenhagen. Photo akgimages/Erich Lessing
- 15 Etude de nu. Suzanne cousant (Study of a Nude. Suzanne Sewing), 1880. Oil on canvas, $115 \times 80 \ (45^{1/4} \times 31^{1/2})$. Ny Carlsberg Glyptotek, Copenhagen
- 16 La Petite rêve, étude (Little Girl Dreaming, study), 1881. Oil on canvas, 59.5 \times 73.5 (23% \times 28%). Ordrupgaard, Copenhagen
- 17 Bust of Clovis Gauguin, 1881. Head of wax, painted, torso of carved walnut, height 40 (15³4). Private Collection
- 18 Camille Pissarro, Paul Gauguin sculptant la Dame en promenade (Paul Gauguin sculpting Woman Walking), 1880. Black chalk, 29.5 × 23.3 (115% × 91%). National Museum, Stockholm 19 Intérieur du peintre à Paris, rue Carcel (Interior of the Painter's House, rue Carcel), 1881. Oil on canvas, 130 × 162 (511% × 6334). Nasjonalmuseet, Oslo. Photo Nasjonalmuseet, Oslo
- 20 Le Port de Rouen (The Port of Rouen), 1884. Oil on canvas, 47 × 65 (181/8 × 25%). Private Collection. Photo Boltin Picture Library/Bridgeman Images 21 Nature morte dans un intérieur (Still Life in an Interior), 1885. Oil on canvas, 60 × 74 (23% × 29). Private Collection
- 22 Paul Cézanne, *Montagnes, l'Estaque* (*Mountains at l'Estaque*), *c.* 1877–8. Oil on canvas, 54.2 × 74.2 (213/8 × 291/4). National Museum of Wales, Cardiff. Photo National Museum of Wales/Bridgeman Images
- 23 Paysage provençal d'après Cézanne (Provençal Landscape after Cézanne), 1885. Fan, gouache, $28 \times 55 \ (11 \times 21\%)$. Ny Carlsberg Glyptotek, Copenhagen
- 24 Eugène Delacroix, *Le naufrage de Don Juan* (*The Shipwreck of Don Juan*), 1841. Oil on canvas, 135 × 196 (53½ × 77½). Musée du Louvre, Paris. Photo RMN-Grand Palais (musée du Louvre)/ Gérard Blot
- 25 Vaches au repos (Landscape with Cows), 1885. Oil on canvas, 64×80 ($25^{1/4} \times 31^{1/2}$). Museum Boijmans-van Beuningen, Rotterdam. Photo Boijmans van Beuningen, Rotterdam
- 26 Baigneuses à Dieppe (Bathers at Dieppe), 1885.

Oil on canvas, 38.1×46.2 ($15 \times 18^{1/4}$). National Museum of Western Art, Tokyo

27 Georges Seurat, *Un Dimanche à la Grande Jatte, 1884* (*A Sunday on the Island of La Grande Jatte, 1884*), 1884–6. Oil on canvas, 207.6 \times 308 (81 3 4 \times 121 1 4). Art Institute of Chicago. Helen Birch Bartlett Memorial Collection

28 Pascal Dagnan-Bouveret, *The Pardon in Brittany*, 1886. Oil on canvas, 114.6 \times 84.8 (45 $\frac{1}{8}$ \times 33 $\frac{3}{8}$). The Metropolitan Museum of Art, New York. Photo The Metropolitan Museum of Art/Art Resource/Scala

29 Vase with Breton Girls, 1886–7. Glazed stoneware, height 29.5 (11½). Musées Royaux d'Art et d'Histoire, Brussels

30 Ceramic designs, 1886–7. Musée d'Orsay, Paris, held by the Département des arts graphiques, Musée du Louvre. Photo RMN-Grand Palais (musée d'Orsay)/Adrien Didierjean 31 *Bretonne assise*, 1886. Black fabricated chalk and pastel on ivory laid paper, 32.9 × 48.3 (13 × 191/8). Art Institute of Chicago. Mr and

Mrs Carter H. Harrison Collection

32 Bretonne (Study for Les Quatre Bretonnes), 1886. Coloured chalk, 48×32 ($18\% \times 12\%$). The Burrell Collection, Glasgow Museums and Art Galleries 33 Les Quatre Bretonnes (The Four Breton Girls) 1886. Oil on canvas, 72×90 ($28\% \times 35\%$). Neue Pinakothek, Munich. Photo Scala, Florence/bpk, Bildagentur für Kunst, Kultur und Geschichte, Berlin

34 Edgar Degas, *Femme nue debout (Standing Nude)*, c. 1880–3. Pastel and black chalk on paper, 49.5 × 30.7 (19½ × 12½). Musée d'Orsay, Paris. Photo RMN-Grand Palais (musée d'Orsay)/Hervé Lewandowski

35 Study for *Deux baigneuses (Two Bathers)*, 1886–7. Black chalk and pastel on paper, 58.4×34.9 (23×13^{34}). Art Institute of Chicago. Gift of Gilbert W. Chapman in Memory of Charles B. Goodspeed 36 *Deux baigneuses (Two Bathers)*, 1887. Oil on canvas, 87×69 ($36^{14} \times 28$). Museo Nacional de Bellas Artes, Buenos Aires

37 Nature morte au profil de Laval (Still Life with Profile of Laval), 1886. Oil on canvas, 46×38 ($18\frac{1}{8} \times 15$). Indianapolis Museum of Art. Samuel Josefowitz Collection of the School of Pont-Aven through the generosity of Lilly Endowment Inc., the Josefowitz Family, Mr and Mrs James M. Cornelius, Mr and Mrs Leonard J. Betley, Lori and Dan Efroymson, and other Friends of the Museum

38 La Bergère Bretonne (Breton Shepherdess), 1886. Oil on canvas, 60.4×73.3 ($23\% \times 28\%$). Laing Art Gallery, Newcastle upon Tyne. Photo Tyne & Wear

Archives & Museums/Bridgeman Images
39 La Baignade au Moulin du Bois d'Amour
(Bathing Place at the Bois d'Amour Mill), 1886.
Oil on canvas, 60 × 73 (235/8 × 283/4). Hiroshima
Museum of Art. Photo akg-images/Erich Lessing
40 Cup decorated with the figure of a bathing
girl, 1888. Stoneware, height 29 (113/8). Private
Collection

41 Vase decorated with the half-length figure of a woman, 1886–7, exhibited 1893. Stoneware, height 21.6 (8½). Kunstindustrimuseum, Copenhagen 42 Vessel with women and goats, c. 1886–7. Stoneware, 50 × 11.7 × 11.1 (7½ × 4½ × 4½). The Metropolitan Museum, New York. Robert A. Ellison Jr Collection, Purchase, Acquisitions Fund; Louis V. Bell, Harris Brisbane Dick, Fletcher, and Rogers Funds and Joseph Pulitzer Bequest; and 2011 Benefit Fund, 2013
43 Rectangular Jardinière, 1887. Stoneware and barbotine, 27 × 40 × 22 (10½ × 15¾ × 8½). Private

44 Martiniquaises (Two Women from Martinique), 1887. Charcoal and pastel on paper, 48.5 × 64 (191/8 × 251/8). Musée du quai Branly, Paris 45 Les Mangos, Martinique (Mango Pickers, Martinique), 1887. Oil on canvas, 89 × 116 (35 × 451/2). Rijksmuseum Vincent Van Gogh, Amsterdam. Vincent van Gogh Foundation 46 Allées et venues, Martinique (Comings and Goings, Martinique), 1887. Oil on canvas, 72 × 92 (283/8 × 361/4). Thyssen-Bornemisza Museum, Madrid. Photo Colección Carmen Thyssen-Bornemisza/Scala, Florence

Collection

47 Végétation tropicale, Martinique (Tropical Vegetation, Martinique), 1887. Oil on canvas, 116 × 89 (45 % × 35). National Galleries of Scotland, Edinburgh. Photo National Galleries of Scotland, Edinburgh/Bridgeman Images 48 Bord de mer, Martinique (By the Sea, Martinique), 1887. Oil on canvas, 54 × 90 (21 4 × 35 1/2). Ny Carlsberg Glyptotek, Copenhagen 49 Hiver, ou petit Breton arrangeant son sabot (Winter or Young Breton Boy Adjusting his Clog), 1888. Oil on canvas, 90 × 71 (35 1/2 × 28). Ny Carlsberg Glyptotek, Copenhagen. Photo akg-images

50 Les Premières fleurs, les Bretonnes aux Avins (First Flowers, Breton Women at Les Avins), 1888. Oil on canvas, 70×92 ($27\frac{1}{2} \times 36\frac{1}{4}$). Private Collection. Photo Josse/Scala, Florence 51 La Ronde des petites Bretonnes (Breton Girls Dancing, Pont-Aven), 1888. Oil on canvas, 73×92.7 ($28\frac{3}{4} \times 36\frac{1}{2}$). National Gallery of Art, Washington, DC. Collection of Mr and Mrs Paul Mellon 52 Lutte Bretonne (Breton Boys Wrestling), 1888.

Oil on canvas, 93×73 ($36\frac{1}{4} \times 28\frac{3}{4}$). Musée du Louvre, Abu Dhabi

53 Edgar Degas, Danseuse ajustant son soulier (Dancer Adjusting her Slipper), 1880. Pastel, 60×46 (23 $\frac{5}{8} \times 18\frac{1}{8}$). Ordrupgaard, Copenhagen

54 Page of sketches after Degas, c. 1888–9. Black chalk, 34 × 22.5 (133/8 × 87/8). Musée d'Orsay, Paris, held by the Département des arts graphiques, Musée du Louvre. Photo RMN-Grand Palais (musée d'Orsay)/Jean Schormans

55 Louis Anquetin, Avenue de Clichy, cinq heures du soir (Avenue de Clichy, Five O'Clock in the Evening), 1887. Oil on canvas, 69 × 53 (27½ × 20½). Wadsworth Atheneum, Hartford. Ella Gallup Sumner and Mary Catlin Sumner Collection 56 Madeleine Bernard, 1888. Oil on canvas, 72 × 58 (28½ × 22½). Musée de Grenoble. Photo Ville de Grenoble/Musée de Grenoble/J.L. Lacroix 57 Emile Bernard, Les Bretonnes dans la prairie (Breton Women in the Meadow), 1888. Oil on canvas, 74 × 82 (29 × 32). Photo Private Collection/

Bridgeman Images
58 La Vision du Sermon. La lutte de Jacob avec
l'Ange (Vision of the Sermon. Jacob wrestling with
the Angel), 1888. Oil on canvas, 73 × 92 (28¾ ×
36¼). National Galleries of Scotland, Edinburgh
59 Autoportrait. Les Misérables (Self-Portrait),
1888. Oil on canvas, 45 × 55 (17¾ × 21½).
Rijksmuseum Vincent Van Gogh, Amsterdam.
Vincent van Gogh Foundation

60 Volpini Suite: Misères humaines (Human Misery), 1889. Zincograph with sanguine ink on canary yellow wove paper, 28.6 x 23.2 (111/4 × 91/8). Indianapolis Museum of Art. Gift of Samuel Josefowitz in tribute to Bret Waller and Ellen Lee by exchange, Caroline Marmon Fesler Fund, Beeler Fund, Anonymous IV Art Fund, Mr and Mrs William R. Spurlock Fund, Mrs Pierre F. Goodrich Endowed Art Fund, Nancy Foxwell Neuberger Acquisition Endowment Fund, Gift of the Alliance of the Indianapolis Museum of Art, Russell and Becky Curtis Art Purchase Endowment Fund, Roger G. Wolcott Fund, E. Hardey Adriance Fine Arts Acquisition Fund in memory of Marguerite Hardey Adriance, Mary V. Black Art Endowment Fund, Cecil F. Head Art Fund, Delavan Smith Fund, Emma Harter Sweetser Fund, Mr and Mrs Theodore P. Van Vorhees Art Fund, Mr and Mrs Richard Crane Fund, Richard W. and Rosemary W. Lee Memorial Funds

61 Vendanges à Arles. Misères humaines (Grape Harvest at Arles. Human Anguish), 1888. Oil on canvas, 73 × 92 (28¾ × 36¾). Ordrupgaard, Copenhagen. Photo Ordrupgaard, Copenhagen/ Bridgeman Images

62 Vincent Van Gogh, Le café de nuit (The Night Café), 1888. Oil on canvas, 72.4×92.1 ($28\frac{1}{2} \times 36\frac{1}{4}$). Yale University Art Gallery, New Haven, CT. Bequest of Stephen Carlton Clark, B.A. 1903 63 Café de nuit à Arles (Night Café at Arles), 1888. Oil on canvas, 73×92 ($28\frac{3}{4} \times 36\frac{1}{4}$). Pushkin Museum, Moscow. Photo Pushkin Museum, Moscow

64 *L'Arlésienne. Mme Ginoux (The Woman from Arles)*, 1888. Charcoal, 56×48.4 (22 \times 19). Private Collection

65 Volpini Suite: Les vieilles filles (Arles) (Old Women from Arles), 1889. Zincograph, 50 × 65 (19³4 × 25⁵4). Cleveland Museum of Art. Dudley P. Allen Fund

66 Arlésiennes au jardin public, mistral, 1888. Oil on canvas, 73×91.5 ($28^3/4 \times 36$). Art Institute of Chicago. Mr and Mrs Lewis L. Coburn Memorial Collection

67 Vincent Van Gogh, Memory of the Garden at Etten, 1888. Oil on canvas, 73.5 × 92.5 (29 × 36%). The State Hermitage Museum, Saint Petersburg 68 Van Gogh peignant des soleils (Van Gogh painting Sunflowers), 1888. Oil on canvas, 73 × 92 (28% × 36%). Rijksmuseum Vincent Van Gogh, Amsterdam. Vincent van Gogh Foundation 69 Dans les foins. En pleine chaleur (In the Hay. In the Heat of the Day), 1888. Oil on canvas, 73 × 92 (28% × 36%). Private Collection 70 Dans les vagues (Ondine), 1889. Oil on canvas,

 92×72 ($36\frac{1}{4} \times 28\frac{1}{4}$). The Cleveland Museum of

Art. Gift of Mr and Mrs William Powell Jones
71 Eugène Delacroix, *La Mort de Sardanapale*(*The Death of Sardanapalus*), 1844. Oil on canvas,
73.7 × 82.4 (29½ × 32½). Philadelphia Museum
of Art. The Henry P. McIlhenny Collection in
memory of Frances P. McIlhenny, 1986
72 *Autoportrait* (*Self-Portrait*), *c.* 1888–9. Oil on
canvas, 46 × 38 (18½ × 15). Pushkin Museum,
Moscow. Photo Heritage Images/Fine Art Images/
akg-images

73 Femmes se baignant. La vie et la mort (Women Bathing. Life and Death), 1889. Oil on canvas, $92 \times 73 \ (36^{1}/4 \times 28^{3}/4)$. Mohammad Mahmoud Khalil Museum, Cairo

74 Vase autoportrait (Self-Portrait Jug), 1889. Stoneware, height 19.5 (7%). Kunstindustrimuseet, Copenhagen

75 Peruvian mummy from the northern Andes, 1100–1400. Musée du quai Branly, Paris

76 Nature morte à l'estampe japonaise (Still Life with Japanese Print), 1889. Oil on canvas, 85 × 115 (33½ × 45¾). Private Collection. Photo Private Collection/Bridgeman Images

- 77 La Belle Angèle. Portrait de Mme Satre (Portrait of Mme Satre), 1889. Oil on canvas, 92×72 ($36\frac{1}{4} \times 28\frac{1}{4}$). Musée d'Orsay, Paris
- 78 La Famille Schuffenecker (The Schuffenecker Family), 1889. Oil on canvas, 73×92 ($28\frac{3}{4} \times 36\frac{1}{4}$). Musée d'Orsay, Paris
- 79 Autoportrait au Christ jaune (Self-Portrait with Yellow Christ), 1890–1. Oil on canvas, 30×46 ($11\% \times 18\%$). Musée d'Orsay, Paris. Photo RMN-Grand Palais (musée d'Orsay)/René-Gabriel Ojéda 80 Volpini Suite: Bretonnes à la barrière (Breton Women at the Gate), 1889. Zincograph on yellow paper, 16×21.4 ($6\% \times 8\%$). The Metropolitan Museum of Art, New York
- 81 Volpini Suite: Les Cigales et les fourmis (The Grasshoppers and the Ants), 1889. Zincograph on yellow paper, 20.3 \times 26 (8 \times 10¹/4). National Gallery of Art, Washington, DC. Lessing Rosenwald Collection
- 82 Aux Roches noires (At the Black Rocks), frontispiece of the Volpini exhibition catalogue, 1889. Zincograph, 15.4×24 ($6\frac{1}{8} \times 9\frac{1}{2}$). Art Institute of Chicago. Regenstein Endowment Fund
- 83 Eve. Pas écouter li li menteur (Eve. Don't Listen to the Liar), 1889. Watercolour and pastel on paper, 33.7 × 31.1 (13¹/4 × 12¹/4). McNay Art Museum, San Antonio, Texas. Bequest of Marion Koogler McNay
- 84 Paul Sérusier, *Le Talisman*, *le bois d'amour (The Talisman, Landscape in the Bois d'Amour)*, 1888. Oil on wood, 27 × 22 (10³/₄ × 8³/₄). Musée d'Orsay, Paris. Photo Musée d'Orsay, Dist. RMN-Grand Palais/Patrice Schmidt
- 85 The Palais des Colonies at the Universal Exhibition 1889, Paris. National Gallery of Art, Washington, DC
- 86 Étude de personnages annamites à l'Exposition Universelle (Page of studies of figures in costume at the Universal Exhibition (Annamites and Arabs)), 1889. Black chalk, 30.5 × 23.5 (12 × 9½). Musée d'Orsay, Paris, held by the Département des arts graphiques, Musée du Louvre. Photo RMN-Grand Palais (musée d'Orsay)/Jean-Gilles Berizzi 87 Vénus noire (Black Venus), 1889. Stoneware, height 50 (19¾). The Division of Museum Services, Nassau County, NY. Department of Parks, Recreation and Museums
- 88 Nirvana. Portrait de Meijer de Haan, 1889. Oil on silk, 20 × 29 (8 × 11). Wadsworth Atheneum, Hartford. Ella Gallup Sumner and Mary Catlin Sumner Collection. Photo akg-images
- 89 The Red Cow, 1889. Oil on canvas, 90.8 \times 73 (35 34 \times 28 34). Los Angeles County Museum of Art. Mr and Mrs George Gard De Sylva Collection

- 90 En Bretagne, 1889. Watercolour, gold paint and gouache on paper. Whitworth Art Gallery, The University of Manchester. Photo Whitworth Art Gallery, The University of Manchester/Bridgeman Images
- 91 Moisson en Bretagne (Harvesting in Brittany), 1889. Oil on canvas, $92 \times 73~(36^{1/4} \times 28^{3/4})$. The Courtauld Gallery, London
- 92 *Haystacks in Brittany*, 1890. Oil on canvas, 74.3×93.3 ($29\% \times 36^34$). National Gallery of Art, Washington, DC. Gift of the W. Averell Harriman Foundation in memory of Marie N. Harriman 93 *Rentrée des vaches à Pont-Aven*, 1889? Pencil on paper, 13×25.5 ($5\% \times 10$). Private Collection.
- Photo Sotheby's, London 94 Ramasseuses de varech (Seaweed Gatherers), 1889. Oil on canvas, $87.5 \times 123 \ (34\frac{1}{2} \times 48\frac{3}{4})$. Folkwang Museum, Essen
- 95 Crucifix from the chapel at Le Trémalo, near Pont-Aven. Photo Bernard Annebicque/Sygma/ Getty Images
- 96 Study for *Le Christ jaune*, 1889. Pencil on paper, 26.7×18.2 ($10^{5}\% \times 7^{1}$ 4). Carmen Thyssen-Bornemisza. Collection on loan to the Museo Nacional Thyssen-Bornemisza
- 97 Le Christ jaune (The Yellow Christ), 1889. Oil on canvas, 92 × 73 (36¹/₄ × 28³/₄). Albright-Knox Art Gallery, Buffalo, New York. General Purchase Fund. Photo Albright Knox Art Gallery/Art Resource, NY/Scala, Florence
- 98 Deposition from the calvary at Nizon, near Pont-Aven. Photo Alain Le Bot/Gamma-Rapho/ Getty Images
- 99 Yann D'Argent, *Le Calvaire de Quillinen près de Quimper (The Calvary of Quillinen, near Quimper)*, 1893. Oil on canvas, 98 × 56 (38½ × 22). Musée des Beaux-Arts, Quimper
- 100 Le Christ vert. Le Calvaire Breton (The Green Christ. Breton Calvary), 1889. Oil on canvas, 92 × 73 (36½ × 28¾). Musées Royaux des Beaux-Arts de Belgique, Brussels. Photo Musées Royaux des Beaux-Arts de Belgique, Brussels/Bridgeman Images
- 101 Soyez amoureuses vous serez heureuses (Be in Love and You Will be Happy), 1889. Carved and painted linden wood, 95×72 ($37\% \times 28\%$). Museum of Fine Arts, Boston. Arthur Tracy Cabot Fund 102 Breton *lit clos* (box bed)
- 103 Paul Gauguin and Emile Bernard, *Paradis terrestre* (*Earthly Paradise*), 1888. Chestnut and pine (carved and polychromed), glass, metal hardware, 101 × 120 × 60.5 (39% × 471/4 × 23%). Art Institute of Chicago. Through prior gift of Henry Morgen, Ann G. Morgen, Meyer Wasser and Ruth G. Wasser; restricted gift of Edward M. Blair

104 Le Christ au Jardin des Olives (Christ in the Garden of Olives), 1889. Oil on canvas, 73 × 92 $(28\frac{3}{4} \times 36\frac{1}{4})$. Norton Museum of Art, West Palm Beach, Florida. Photo Norton Museum of Art, West Palm Beach, Florida/Bridgeman Images 105 Marc-Antoine Verdier, Le Christ couronné d'épines. Portrait d'Alfred Bruyas (Christ Crowned with Thorns. Portrait of Alfred Bruyas), c. 1850. Oil on canvas, 55×65 (21\square) \times 25\square). Musée Fabre, Montpellier. Photo Musée Fabre de Montpellier Méditerranée Métropole/Frédéric Jaulmes 106 Letter to Vincent Van Gogh, November 1889, with sketches of Soyez amoureuses and Le Christ au Jardin des Olives. Rijksmuseum Vincent Van Gogh, Amsterdam, Vincent van Gogh Foundation 107 Reconstruction of the interior of the dining room at the inn of Marie Henry at Le Pouldu, with murals by Gauguin and Meijer de Haan. Photo Pool Georgeon/Rossi/Gamma-Rapho/Getty **Images** 108 Portrait charge de Gauguin (Caricature

Self-Portrait), 1889. Oil on wood, 79.2×51.3 (311/4 × 201/4). National Gallery of Art, Washington, DC. Chester Dale Collection 109 Bonjour M. Gauguin (I) (Good Day, M. Gauguin), 1889. Oil on canvas, 93 × 74 (365/8 × 291/4). National Gallery of Prague 110 La Moisson au bord de la mer (Harvest: Le *Pouldu*), 1890. Oil on canvas, 73×92 (28³/₄ × 36¹/₄). Tate, London. Photo Tate, London 111 Portrait de femme à la nature morte de Cézanne (Portrait of a Woman with Cézanne Still Life), 1890. Oil on canvas, 65×55 ($25\frac{5}{8} \times 21\frac{5}{8}$). Art Institute of Chicago. Joseph Winterbotham Collection 112 Paul Cézanne, Nature morte, compotier, verre et pommes (Still Life, Fruit Dish, Glass and Apples), c. 1880. Oil on canvas, 46.4×54.6 ($18\% \times 21\%$). Museum of Modern Art, New York. Gift of Mr and Mrs David Rockefeller. Photo A. Burkatovski/Fine Art Images/Superstock

113 Olympia (copie d'après Manet) (Copy of Manet's 'Olympia'), 1891. Oil on canvas, 89×130 ($35 \times 51^{1/4}$). Private Collection. Photo O. Vaering/Bridgeman Images

114 La Perte de pucelage (The Loss of Virginity), 1890. Oil on canvas, $90 \times 130~(35^{1/2} \times 51^{1/4})$. The Chrysler Museum, Norfolk, Virginia. Gift of Walter P. Chrysler Jr.

115 Portrait de Stéphane Mallarmé, 1891. Etching on brown paper, 18.2 × 14.3 (7^{1/8} × 5^{5/8}). The Metropolitan Museum of Art, New York
116 Paul Gauguin photographed with his children Emile and Aline in 1891 in Copenhagen
117 Eve exotique (Exotic Eve), 1890. Oil on board, 43 × 25 (17 × 9^{7/8}). Pola Museum of Art, Hakone.

Photo Pola Museum of Art/DNPartcom 118 Henri Lemasson, *Street in Papeete*, 1897–8. Musée du quai Branly, Paris. Photo RMN-Grand Palais (musée du quai Branly – Jacques Chirac)/ René-Gabriel Ojéda

119 Montagnes Tahitiennes (Tahitian Landscape), 1891. Oil on canvas, 68×92 ($26^{3/4} \times 36^{3/6}$). The Minneapolis Institute of Art. Julius C. Eliel Memorial Fund

120 Suzanne Bambridge, 1891. Oil on canvas, $70 \times 50 \ (27\frac{1}{2} \times 19\frac{5}{8})$. Musées Royaux des Beaux-Arts de Belgique, Brussels. Photo J. Geleyns – Art Photography/Musées royaux des Beaux-Arts de Belgique

121 Deux femmes sur la plage (Two Women on the Beach), 1891. Oil on canvas, 69×91.5 ($27\frac{1}{8} \times 36\frac{1}{8}$). Musée d'Orsay, Paris.

122 Vahine no te tiare (Woman with a flower),
1891. Oil on canvas, 70.5 × 46.5 (27³/₄ × 18¹/₄). Ny Carlsberg Glyptotek, Copenhagen
123 Le Repas (The Meal), 1891. Oil on canvas,

73 × 92 (28³⁄4 × 36¹⁄4). Musée d'Orsay, Paris. Photo RMN-Grand Palais (musée d'Orsay)/ Adrien Didierjean

124 Te faaturuma (The Brooding Woman), 1891. Oil on canvas, 92 \times 68 (36 1 /4 \times 26 3 /4). Worcester Art Museum, MA. Photo Worcester Art Museum, MA/Bridgeman Images

125 A Tahitian Woman with a Flower in her Hair, c. 1891–2. Charcoal, pastel, and wash, 39×30.2 ($15\frac{3}{8} \times 11\frac{7}{8}$). The Metropolitan Museum of Art, New York. Bequest of Miss Adelaide Milton de Groot (1876-1967), 1967

126 *Tahitian Woman* (related to the painting *Te faaturuma*), 1891. Charcoal on cream wove paper (discoloured to tan), 55.5 × 48 (217/8 × 19). Art Institute of Chicago. Margaret Day Blake Collection

127 Odilon Redon, *La Mort, mon ironie dépasse toutes les autres (Death, My Irony Surpasses All Others*), 1889. Lithograph, 26.2 × 19.7 ($10^{1/4} \times 7^{3/4}$). National Gallery of Art, Washington, DC 128 Relief from the Temple of Borobudur, Java 129 Jules Bastien-Lepage, *Jeanne écoutant les voix (Joan of Arc*), 1879. Oil on canvas, 254 × 279.4 (100×110). The Metropolitan Museum of Art. Gift of Erwin Davis, 1889

130 Luc-Olivier Merson, *Je vous salue, Marie* (*Hail Mary*), *c.* 1885. Oil on canvas, 81.3 × 59.7 (32 × 23½). The High Museum of Art, Atlanta. Gift of the Piedmont Driving Club
131 *Ia Orana Maria* (*Hail Mary*), 1891. Oil on canvas, 113.7 × 87.7 (44¾ × 34½). The Metropolitan Museum of Art, New York. Bequest of Sam A. Lewisohn

- 132 I Raro Te Oviri (Under the Pandanus), 1891. Oil on canvas, 73×91.4 ($28^34 \times 36$). Minneapolis Institute of Art. The William Hood Dunwoody Fund
- 133 E Haere oe i hia? (Where are you going?), 1892. Oil on canvas, 92 × 69 (36¹/₄ × 27¹/₄). Staatsgalerie, Stuttgart. Photo Scala, Florence/bpk, Bildagentur für Kunst, Kultur und Geschichte, Berlin 134 L'Homme à la hâche (Man with an Axe), 1891. Oil on canvas, 92 × 70 (36¹/₄ × 27¹/₂). Private Collection. Photo De Agostini/Superstock 135 Man with an Axe, 1891–3. Thinned gouache, with pen and black ink, over pen and brown ink, on cream wove paper (discoloured to tan).
- 136 Parau na te varua ino (Words of the Devil), 1892. Oil on canvas, 91.7 × 68.5 (36 1/6 × 27). National Gallery of Art, Washington, DC. Gift of the W. Averell Harriman Foundation in memory of Maria N. Harriman

laid down on cream Japanese paper, 37.1×22.8

McCormick Blair

 $(145\% \times 9)$. Art Institute of Chicago. Gift of Edward

- 137 *Une fille* (Study for *Parau na te varua ino*), 1892? Charcoal and pastel with watercolour, 78-7 × 34-7 (31 × 13³/₄). Kunstmuseum Basel. Kupferstichkabinett
- 138 Te poipoi (Morning Ablutions), 1892. Oil on canvas, $68 \times 92 (26^{3/4} \times 36^{1/4})$. Collection of Mr Joseph Lau Luen Hung
- 139 *Aha oe feii? (What, are you jealous?)*, 1892. Oil on canvas, 66×89 ($26 \times 35\%$). Pushkin Museum, Moscow. Photo Scala, Florence
- 140 Aha oe feii? (What, are you jealous?), 1894. Watercolour monotype from a glass matrix, with brush and white gouache, reddish-brown and black watercolour, on cream wove paper (an imitation Japanese vellum), 19.5 \times 23.2 ($7^{3/4} \times 9^{1/4}$). Art Institute of Chicago. Gift of Edward McCormick Blair
- 141 Study for *Nafea faa ipoipo?*, 1891–3. Pastel over charcoal, selectively stumped, on cream wove paper (discoloured to tan), squared in black chalk on cream wove paper (discoloured to tan), 55.5×48 ($21\% \times 19$). Art Institute of Chicago. Margaret Day Blake Collection
- 142 Nafea faa ipoipo? (When will you marry?), 1892. Oil on canvas, 105 × 77 (41% × 30½). Musée du Louvre, Abu Dhabi
- 143 Vahine no te vi (Woman with a Mango), 1892. Oil on canvas, 72.7×44.5 ($28\% \times 17^{1/2}$). The Baltimore Museum of Art. The Cone Collection, formed by Dr Claribel Cone and Miss Etta Cone of Baltimore, Maryland
- 144 Joseph et la femme de Potiphar (Joseph and Potiphar's Wife), 1894. Oil on canvas, 89×116

- $(35 \times 45^{5/8})$. Private Collection
- 145 Pierre-Paul Prud'hon, Joseph et la femme de Potiphar (Joseph and Potiphar's Wife), c. 1820. Reproduced in Ch. Clement, Prud'hon, sa vie, ses oeuvres et sa correspondance, 1872. Photo Bibliothèque Nationale, Paris
- 146 Egyptian fresco from a tomb at Thebes of the XVIIIth Dynasty. British Museum, London 147 *Ta Matete (We shall not go to Market Today)*, 1892. Oil on canvas, 73.2 × 91.5 (28% × 361/4). Kunstmuseum, Basel
- 148 Eugène Carrière, *Portrait de Paul Gauguin*, 1891. Oil on canvas, 54.6×65.4 ($21\frac{1}{2} \times 25\frac{3}{4}$). Yale University Art Gallery, New Haven, CT. Bequest of Fred T. Murphy, B.A. 1897
- 149 Merahi metua no Teha amana (The Ancestors of Teha amana), 1893. Oil on canvas, 75×53 (29½ \times 20¾). Art Institute of Chicago. Gift of Mr and Mrs Charles Deering McCormick
- 150 *Vairaoumati tei oa (Her Name is Vairaoumati)*, 1892. Oil on canvas, 91 × 68 (35¾ × 26¾). Pushkin Museum, Moscow. Photo Pushkin Museum, Moscow/Bridgeman Images
- 151 Letter to Sérusier, 25 March 1892, with sketch of *Vairaoumati*. Reproduced in P. Sérusier, *A.B.C. de la peinture*, 1950
- 152 *Idole à la perle (Idol with a Pearl*), 1892–3. Tamanu wood, stained and gilded, height 25 (978). Musée d'Orsay, Paris
- 153 *Idole à la coquille (Tii with a Shell)*, 1892–3. Wood, pearl, tooth and bone, height 34.4 (13%). Musée d'Orsay, Paris. Photo RMN-Grand Palais (musée d'Orsay)/Gérard Blot
- 154 Study for Parahi te marae (There is the Temple), c. 1892. Watecolour over graphite. $18.5 \times 22.9 (7^{1/4} \times 9)$. Harvard Art Museums/Fogg Museum. Bequest of Marian H. Phinney. Photo President and Fellows of Harvard College 155 Parahi te marae, 1892. Oil on canvas, 66×88.9 (26×35) . Philadelphia Museum of Art. Gift of Mr and Mrs Rodolphe Meyer de Schauensee, 1980 156 Manao tupapau (The Spirit of the Dead keeps watch), 1892. Oil on jute mounted on canvas, 73×92 (283/4 × 361/4). Albright-Knox Art Gallery, Buffalo, NY. A. Conger Goodyear Collection 157 Manao tupapau (The Spirit of the Dead keeps *watch*), 1894. Lithograph, 18.1×27.3 ($7\frac{1}{8} \times 10^{3}$ 4). National Gallery of Art, Washington, DC. Rosenwald Collection
- 158 *Ia Orana Maria (Hail Mary)*, 1891. Woodcut pasted into the Louvre manuscript of *Noa Noa*. Musée d'Orsay, Paris, held by the Département des arts graphiques, Musée du Louvre. Photo RMN-Grand Palais (musée d'Orsay)/Hervé Lewandowski

159 *Ia Orana Maria*, 1894. Brush, 34×18 ($13\frac{1}{2} \times 7\frac{1}{8}$). Rijksmuseum, Amsterdam. Purchased with the support of the Stichting K.F. Hein Fonds 160 *Ia Orana Maria* (inscribed 'Au Comte de La Rochefoucauld'), *c*. 1893–5. Fabricated charcoal, red chalk, and white pastel on formerly blue wove paper, mounted on millboard with strips of rose-coloured wove paper along two edges, 59.7 × 37.5 ($23\frac{1}{2} \times 14\frac{3}{4}$). The Metropolitan Museum of Art, New York. Bequest of Loula D. Lasker, New York City, 1961

161 Fatata te miti (Near the Sea), 1892. Oil on

canvas, 67.9×91.5 ($26\frac{3}{4} \times 36$). National Gallery of Art, Washington, DC. Chester Dale Collection 162 Otahi (Alone), 1893. Oil on canvas, 50 × 73 $(19\frac{1}{2} \times 28\frac{5}{8})$. Private Collection. Photo The Print Collector/Heritage Images/Scala, Florence 163 Hina Tefatou (The Moon and the Earth), 1893. Oil on canvas, $112 \times 62 (44^{1/8} \times 24^{3/8})$. Museum of Modern Art, New York. Lillie P. Bliss Collection. Photo A. Burkatovski/Fine Art Images/Superstock 164 Georges Manzana Pissarro, Portrait de Gauguin en pied (Standing Portrait of Gauguin), c. 1906. Gouache heightened with gilded bronze, 45×32 (17³/₄ × 12⁵/₈). Private Collection 165 Pape moe (Mysterious Water), 1893-4. Watercolour, with black fabricated chalk, pen and brown ink (originally purple) and touches

of brush and black ink on heavily textured ivory

wove paper, 35.4×25.5 ($14 \times 10^{1/8}$). Art Institute

of Chicago. Gift of Emily Crane Chadbourne 166 Pape moe (Mysterious Water), 1893. Oil on

canvas, 99×75 (39×29 %). Private Collection.

Photo Oronoz/Album/Superstock

167 Noa Noa, 1894. Woodcut, 19.8 × 36.2

(7% × 14%). Musée du quai Branly – Jacques
Chirac, Paris. Photo musée du quai Branly –
Jacques Chirac, Dist. RMN-Grand Palais/image
musée du quai Branly – Jacques Chirac

168 Page 57 from the Louvre manuscript of Noa Noa, with woodcut of Hina and Tefatou from Te Atua, photograph of Tahitian girl and a watercolour. Cabinet des arts graphiques, Musée du Louvre, Paris

169, 170 Pages 67 and 75 from the Louvre manuscript of *Noa Noa*, with woodcuts and watercolours. Cabinet des arts graphiques, Musée du Louvre, Paris

171 Gauguin and friends, including Paul Sérusier and Anna la Javanaise, in his studio at 6 rue Vercingétorix, 1894

172 Aita Tamari Vahine Judith Te Parari (Anna the Javanese), 1893–4. Oil on canvas, 116 \times 81.5 (45 3 4 \times 32). Private Collection. Photo Private Collection/Bridgeman Images

173 Mahana no atua (Day of God), 1894. Oil on canvas, 68 × 91 (267/8 × 36). Art Institute of Chicago. Helen Birch Bartlett Collection
174 Nave nave moe (Delicious Water), 1894. Oil on canvas, 74 × 100 (291/4 × 393/8). The State Hermitage Museum, Saint Petersburg. Photo State Hermitage Museum, Saint Petersburg/ Bridgeman Images

175 Two standing Tahitian women, 1894.
Watercolour monotype, printed in blue,
terracotta, black, pink and grey, on thin oriental
paper, mounted on textured watercolour paper.
British Museum, London. Photo The Trustees of
the British Museum

176 Te nave nave fenua (Delightful Land), 1892. Oil on canvas, 91 × 72 (35% × 28%). Ohara Museum of Art, Kurashiki. Photo Ohara Museum of Art, Kurashiki

177 *Oviri*, 1894–5. Monotype, watercolour and oil, on tan Asian paper, 29.3×20.7 ($11\frac{5}{8} \times 8\frac{1}{4}$). Harvard Art Museums/Fogg Museum. Gift of the Woodner Family Collection, Inc. Photo President and Fellows of Harvard College

178 *Oviri*, 1894–5. Stoneware, glazed in parts, painted, height 74 (29½). Musée d'Orsay, Paris. 179 The new room in the South Wing of the Museum at Auckland, New Zealand, opened in 1892, showing carved panels used in decorating Maori dwellings

1801 Cylinder with Christ on the Cross, 1896/1960. Bronze with brown patina, height 50 (19³/₄)
1807 Cylinder with Christ on the Cross, 1896. Patinated plaster, height 50 (19³/₄). Private Collection. Photo Christie's Images/Bridgeman Images

181 Menhir de Pleuven, Pleumeur-Bodou, Côtes du Nord. Photo Musée de Bretagne, Rennes 182 Lucas Cranach the Elder, *Nymphe endormie* (*Sleeping Nymph*), 1537. Oil on wood, 48.5 × 74.2 (1978 × 2914). Musée des Beaux-Arts et d'Archéologie, Besançon. Photo musée des Beaux-Arts et d'Archéologie, Besançon/Bridgeman Images

183 *Te arii vahine (Woman with Mangos)*, 1896. Oil on canvas, 97 × 128 (38¾ × 51⅓). Pushkin Museum, Moscow. Photo Pushkin Museum, Moscow

184 *Te tamari no atua (The Birth of Christ)*, 1896. Oil on canvas, $96 \times$ 126 ($37\% \times 50\%$). Neue Pinakothek, Munich

185 Poèmes Barbares, 1896. Oil on canvas, 64.8 × 48.3 (25½ × 19). Harvard Art Museums/ Fogg Museum. Bequest from the Collection of Maurice Wertheim, Class of 1906. Photo President and Fellows of Harvard College

186 Te Rerioa (The Dream), 1897. Oil on canvas, 95×132 ($37\% \times 52$). The Courtauld Gallery, London

187 Nevermore, O Taiti, 1897. Oil on canvas, 60×116 (23% $\times 45$ 34). The Courtauld Gallery, London

188 DOù venons-nous? Que sommes-nous? Où allons-nous? (Where Do We Come From? What Are We? Where Are We Going?), 1897–8. Oil on canvas, 139.1 \times 374.6 ($54^{3/4} \times 147^{1/2}$). Museum of Fine Arts, Boston. Tompkins Collection – Arthur Gordon Tompkins Fund. Photo Museum of Fine Arts, Boston/Scala, Florence 189 Squared up study of DOù venons-nous?, 1897–8. Watercolour on pasted-up tracing paper, 20.5 \times 37.5 ($8^{1/6} \times 14^{3/4}$). Musée du Quai Branly, Paris. From the Collection of Musée de la France d'Outremer. Gift of Lucien Vollard

190 Paul Sérusier, *La Cueillette des Pommes, Pont-Aven Triptych* (*Apple Harvest, Pont-Aven Triptych*), *c.* 1891. Oil on canvas, 73 × 133 (28¾ × 52¾). Triton Foundation, Wuustwezel. Photo Triton Foundation/Hugo-Maertens Brueges

191 Paul Signac, *Au Temps d'Harmonie (In the Age of Harmony)*, 1894–5. Oil on canvas, 300 × 400 (118 × 157½). Mairie de Montreuil, Paris. Photo akg-images/Erich Lessing
192 Pierre Puvis de Chavannes, *Inter Artes et Naturam (Amid the Arts and Nature)*, *c*. 1890. Oil on canvas, 40.3 × 113.7 (15½ × 44¾). The Metropolitan Museum of Art, New York. Gift of Mrs Harry Payne Bingham, 1958
193 *Faa Iheihe (Tahitian Pastoral*), 1898.

Oil on canvas, 54 × 169 (21½ × 66½). Tate, London. Photo Tate, London 194 First page of a letter to Daniel de

Monfreid, February 1898, with sketch of D'Où venons-nous? Musée d'Orsay, held by the Département des arts graphiques, Musée du Louvre

195 Etude de force, c. 1900. Mixed media on paper, 31.8 \times 25.1 (12% \times 10). Private Collection

196 Le Sourire; Taiti, 1899. Woodcut on transparent laid tissue paper, 13.7 \times 21.8 ($5\frac{1}{2}\times8\frac{5}{8}$). The Metropolitan Museum of Art, New York. Harris Brisbane Dick Fund, 1936 197 Caricatures of Gauguin and Governor Gallet, with headpiece from Le Sourire, 1900. Watercolour, with black-coloured pencil, and touches of pen and black ink, over a transfer drawing in black, and wood-block print in black ink with blue watercolour on

cream wove paper, 29.8 \times 20.4 (11 3 4 \times 8 1 8). Art Institute of Chicago. Gift of Walter S. Brewster

198 Femme Tahitienne accroupie vue de dos (Crouching Tahitian woman seen from the back), 1901–2. Gouache monotype, 53.3×28.3 (21 \times 11½). Private Collection

(21 × 111/8). Private Collection 199 *The Pony, c.* 1902. Gouache monotype touched with gum or varnish on laid paper, 32.7 × 59.7 (127/8 × 231/2). National Gallery of Art, Washington, DC. Rosenwald Collection 200 *Nature morte avec 'L'Espérance' de Puvis (Still Life with Puvis' 'Hope'*), 1901. Oil on canvas, 65 × 77 (255/8 × 301/4). From the Collection of Mrs Joanne Toor Cummings,

201 Contes barbares (Barbarous Tales), 1902. Oil on canvas, 130 \times 89 (51% \times 35). Folkwang Museum, Essen

New York

202 Invocation, 1903. Oil on canvas, 65.5×75.6 (25% × 29%). National Gallery of Art, Washington, DC. Gift from the Collection of John and Louise Booth in memory of their daughter Winkie 203 Christmas Night (The Blessing of the Oxen), 1902-3. Oil on canvas, 71×82.6 $(28 \times 32^{1/2})$. Indianapolis Museum of Art. Samuel Josefowitz Collection of the School of Pont-Aven, through the generosity of Lilly Endowment Inc., the Josefowitz Family, Mr and Mrs James M. Cornelius, Mr and Mrs Leonard J. Betley, Lori and Dan Efroymson, and other Friends of the Museum 204 Cavaliers sur la plage (Horsemen on the *Beach*), 1902. Oil on canvas, 66×76 (26 × 35). Folkwang Museum, Essen 205 Two Tahitian Heads, c. 1902. Traced monotype, $32.1 \times 51 (12\% \times 20\%)$ British Museum, London

Index

References in italics indicate captions to illustrations

Δ

Académie Colarossi 15 Académie Iulian 91 Adam, Paul 37 Ancien Culte Maorie 150, 151, 153, 171 Anderson, Wayne 81 Anguetin, Louis 52, 63, 86, 89;55 Antoine, Jules 89 Arles 61, 66, 67-79, 80, 97 Arnaud, Captain Charles 131 Arosa, Gustave 11, 14, 15, 17, 140 Aubé, Jean-Paul 21 Auckland 182; 179 Aurier, Albert 89, 92, 108, 118, 119, 130, 148, 161, 163, 170, 182, 191

В

Ballin, Mogens 113 Bambridge, Suzanne 120 Barbizon school 15, 17 Bastien-Lepage, Jules 34, 86, 135; 129 Bernard, Emile 52, 63-7, 69, 73, 86, 87, 89, 103, 108, 111, 113, 117-19, 120, 160, 161, 181; 57 Bernard, Madeleine 63; 56 Bertin, Paul 11 Besnard, Albert 60, 192 Bevan, Robert 177; 175 Bizet, Georges 69 Bonnard, Pierre 160 Bonnat, Léon 46 Borobudur 134; 128

Botticelli, Sandro 188 Bouguereau, William 86 Bouillot, Jules Ernest 21 Boulanger, General 93 Bracquemond, Félix 41, 49 Brandes, Edvard 159 Breton, Jules 63 Brittany 40-46, 54, 55-8, 63, 64, 66, 69, 79, 92, 94, 103, 111, 113, 125, 128, 134, 181, 182, 192, 193, 206, 207, 208; 28, 29, 31, 32, 33, 38, 49, 50, 51, 52, 57, 66, 80, 90, 91, 92 Brussels 84, 87, 107, 173 Bruyas, Alfred 110; 105 Buffalo Bill 92

С

Caldecott, Randolph 42 Camargue 69 Carlyle, Thomas 95, 192 Carolus-Duran, Charles 86 Carrière, Eugène 118, 148; 148 Cassatt, Mary 23 ceramics 41, 42, 46, 63, 80; 29, 30, 177, 178 Cézanne, Paul 9, 17, 19, 20, 21, 33, 46, 60, 113, 119, 153, 159, 181, 188, 204; 11, 22, 23, 112 Chaplet, Ernest 41, 46, 49, Charlopin, Docteur 113, 117 Chazal, André 12 Christ figure 134-7 Gauguin's identification with 107-10, 183, 194-5; 104 Clémenceau, Georges 148 cloisonnism 46, 63 Cochin, Denys 167 Colonial Exhibition, Paris 92 Concarneau 177 Cook, Captain James 125 Copenhagen 11, 28, 31-2, 36, 44, 119, 135, 148, 156, 159-60 Cormon studio 52, 63 Corot, Camille 11, 15 Courbet, Gustave 11, 24, 110 Cranach, Lucas the Elder 183; 182 Cross, Henri-Edmond 192

D Dagnan-Bouveret, Pascal 41, 63, 86; 28 Daniellson, Bengt 127 Daubigny, Charles-François 73 Daudet, Alphonse 69 Daumier, Honoré 21, 73 Degas, Edgar 9, 21, 23, 24, 42, 51, 56, 57, 58, 59, 73, 77, 78, 80, 81, 84, 86, 133, 153, 159, 163, 167, 170, 177, 178, 192, 197; 34, 53 De Haan, Jacob Meijer 95, 97, 113, 122, 197; 88, 107 Delacroix, Eugène 11, 34, 73, 77; 24 Delaherche, Auguste 92 Delaroche, Achille 170 Denis, Maurice 9, 90, 92, 135, 160, 167, 192 Derain, André 202 Diaz, Narcisse 15 Dieppe 36: 26 Dubois-Pillet, Armand 60 Dufy, Raoul 202 Dujardin, Edouard 63 Durand-Ruel, Paul 17, 27, 36, 52, 159, 161, 164, 170 Dürer, Albrecht 131

Ε

Ecole des Beaux-Arts 34 Egypt 147 Ethnographical Museum, Paris 81 Expressionism 173, 204

F

Fauves 204 Fénéon, Félix 37, 38, 58–9, 60, 89, 119, 164 Field, Richard 125 Filiger, Charles 113, 134, 161 Fontainas, André 192–3, 194, 197 Forain, Jean-Louis 21 Frie Udstillung 148, 160 Fry, Roger 168

C

Gad family 31
Gauguin, Aline (Gauguin's daughter) 14, 24, 168, 188; 116
Gauguin, Aline (Gauguin's mother) 12; 5, 6
Gauguin, Clovis (Gauguin's father) 12

Gauguin, Clovis (Gauguin's son) 14, 23, 36; 17 Gauguin, Emil (Gauguin's son) 15, 18, 28; 116 Gauguin, Mette (Gauguin's wife) 11-12, 28-30, 36, 52, 119, 120, 126, 127, 147, 148, 149, 156-9, 174; 4, 12 Gauguin, Paul as a stockbroker 15, 27 childhood 12, 49 death 202 early career as a painter 17-30 in Arles 61, 66-79, 97; 61, 63, 65,66 in Brittany 55-61, 63-7, 95-113, 174-7 in Tahiti 122-77 journalism 26, 94, 160, 182, 195, 197 marriage 11-12 wood carvings 113, 182, 183 woodcuts 151, 171, 173; 168, 169, 170 Gervex, Henri 34 Goupil, Auguste 149 Goupil gallery 51, 57, 117, 128 Gray, Christopher 183 Greenaway, Kate 41 Guillaumin, Armand 17, 19, 21, 27, 35, 38, 39, 51, 52, 60, 86; 11

Harpignies, Henri-Joseph 15 Haviland studio 41, 42 Heegaard, Marie 12 Henry, Marie 110; 107 Hiva-Oa 197 Hodges, William 125 Hokusai 64 Holbein, Hans 80 Huet, Juliette 114, 148 Hugo, Victor 68 Huysmans, Joris-Karl 24, 26, 35, 42, 205

Ibsen, Henrik 160-61 Ile de Groix 114 Impressionism 17-30, 31, 35-42, 57, 64, 68, 86, 89, 119, 159, 170 Indépendants 86 Ingres, J. A. D. 73, 157, 173

J Japan 57, 133 Java 134 Joyant, Maurice 128

Krysinska, Marie 101

La Farge, John 125 La Fontaine, Jean de 9, 87 La Rochefoucauld, Count Antoine de 117, 161; 160 Laval, Charles 46, 49, 64, 67, 86, 89; 37 Le Barc de Boutteville 160, 173 Leleux, Alphonse 63 Lepère, Auguste 173 Le Pouldu 70, 95, 99, 103, 110, 113, 114; 107 Lerolle, Henri 167, 192 Le Sourire 195; 196, 197 Les Vingt 60, 84, 86, 107, 173 Le Trémalo 101, 104; 101 Lévv 181 Lisle, Lecomte de 149 London 36 Loti, Pierre 94, 157, 163, 164 Luce, Maximilien 60 Lugné-Poe, Aurélien 160 Luxembourg Museum 92, 113, 174

Madagascar 92, 94, 113 Maillol, Aristide 9, 91, 197 Mallarmé, Stéphane 118, 170; 115 Manet, Edouard 60, 92, 113, 114, 178, 183 Manet, Eugène 23 Maoris 147, 157, 182; 179 Marquesas islands 157, 182, 197 Marseilles 122, 159 Martinique 49-51, 52, 55; 46, 47,48 Marx, Roger 161, 168, 192 Mataiea 128, 137, 146 Matisse, Henri 9, 202 Mauclair, Camille 182, 192 Maugham, W. Somerset 29, 205

Maus, Octave 86

Merson, Luc-Olivier 135; 130 Milton, John 95 Minne, Georges 124 Mirbeau, Octave 36, 108, 117 118, 119, 123, 161, 164, 192, Moerenhout, J. A. 149, 150, 153, 171 Molard family 173 Monet, Claude 9, 23, 24, 38, 92, 118, 119 Monfreid, Georges Daniel de 86, 131, 151, 156, 181, 189, 190, 192, 202; 194 Monod, E. 93 Montpellier, Musée Fabre 72, 110 Morice, Charles 128, 148, 157, 161, 163, 164, 170, 182, 194, 202

Nabis 91, 160, 173, 181, 182, 192 Nantes 40 Natanson, Thadée 167, 194, 197 Neo-Impressionism 38, 40, 55, 60, 70, 86, 192 New Zealand 182 Nizon 101, 103; 98 Noa Noa 127, 137, 148, 151, 157, 170, 171, 173, 182, 203; 167, 168, 169, 170 Notes Synthétiques 26, 34

Olin, P. M. 107 Orléans 12, 174

Paea 137 Panama canal 49 Papeete 126, 127, 128, 140, 147, 195; 118 Parkinson, Sydney 125 Péladan, Sâr 161 Peru 12, 14, 30, 49, 56, 59, 81; Philipsen, Theodor 148 Picasso, Pablo 203 Pissarro, Camille 9, 11, 17, 18, 19, 20, 23, 24, 27, 28, 30, 33, 34, 39, 40, 42, 51, 52, 60, 86, 92, 93, 118, 168, 170, 199, 204; 10, 11, 18

Pissarro, Georges Manzana 19, 167; 11, 164
Pissarro, Lucien 52
Poe, Edgar Allan 186
Pont-Aven 9, 40, 42, 50, 54, 55, 56, 61–5, 67, 80, 84, 89, 91, 95, 101, 113, 174, 175; 93, 190
Pontoise 18
Portier, Arsène 49, 51, 52
Prado (murderer) 80
Proust, Antonin 118
Prud'hon, Pierre-Paul 140; 145
Punaauia 181
Puvis de Chavannes,
Pierre 151, 191, 192, 193; 192

R

Rachilde 118
Raffaëlli, Jean-François 23, 24
Ranson, Paul 160
Raphael 73
Redon, Odilon 118, 123, 133
Rembrandt 26, 190
Renan, Ary 118
Renan, Ernest 108
Renoir, Pierre Auguste
23, 24, 86
Rohde, Johann 148
Rose + Croix 161
Rotonchamp, Jean de 114, 181
Rousseau, Théodore 73
Roussel, Ker-Xavier 160

S

Saint-Briac 63 Salon 15, 17, 23, 41, 52, 55, 63, 86, 103, 124, 135, 191, 192 Salon d'Automne 202 Salon de la Libre Esthétique 173 Salon du Champ de Mars 173 Satre, Mme 80, 84; 77 Schuffenecker, Emile 32, 35, 36, 39, 50, 55, 56, 60, 64, 81, 84, 86, 104, 111, 117, 130 Schuffenecker family 84; 78 Schuré, Edmond 95, 146 Séguin, Armand 113 Sérusier, Paul 91, 92, 95-7, 113, 122, 125, 149, 151, 159, 160, 192; 84, 151, 171, 190 Seurat, Georges 35, 38-9, 60, 86, 89; 27 Signac, Paul 9, 39, 52, 60, 167, 192, 204; 191

Sisley, Alfred 38
Slewinski, Wladyslaw 113
Society of the Friends of
Art 31-2
Spain 36
Spitz, Charles 125
Strindberg, August 178
Sudan 195
Symbolism 37, 62, 110, 118, 119, 124, 163, 204
Synthetism 62, 66, 89, 91

Taboga 49
Tahiti 7, 29, 86, 92, 94, 118,
120, 122–55, 156–75, 180, 182,
186, 192, 194, 195, 197, 205;
3, 119
Teha'amana 148, 157; 149
Thaulow, Frits 30
Titi 146
Tonkin 92, 93, 94
Toulouse-Lautrec, Henri de 52,
182
Tristan, Flora 12

U Universal Exhibition 1889, Paris 86, 92, 93, 95, 113; 85, 86

V

Vallette, Alfred 182

Vallotton, Félix 173 Van Gogh, Theo 51, 56, 60, 61, 69, 86, 94, 95, 107, 110, 111, 113, 117, 128 Van Gogh, Vincent 36, 51, 52, 54, 56, 60, 62-79, 84, 89, 91, 97, 107, 110, 117, 119, 122, 159, 160, 204; 62, 67, 68, 106 Vaugirard 17, 18; 9 Verdier, Marc-Antoine 110; 105 Verhaeren, Emile 123 Verkade, Jan 91, 113 Viellard, Fabien 169 Vollard, Ambroise 181, 192, 197 Volpini, M. (Café des Arts) 86, 89, 90-92, 113, 207; 65, 80, 81,82 Vuillard, Edouard 160, 161, 192

Wadley, Nicholas 171

Ferdinand 113

Willumsen, Jens

Y Yann D'Argent, Jean-Edouard 103; 99

z Zandomeneghi, Federico 23 Ziem, Félix 73 Zola, Emile 24

World of Art

'The single most influential series of art books ever published' *Apollo*

'Outstanding ... exceptionally authoritative and well-illustrated' *Sunday Times*

Comprehensive in coverage and accessible to all, the World of Art series explores both the newest and the perennial in all the arts, covering themes, artists and movements that straddle the centuries and the gamut of visual culture around the globe.

You may also like:

Fauvism Sarah Whitfield

Impressionism Belinda Thomson **Matisse** Lawrence Gowing

Monet James H. Rubin

Be the first to know about our new releases, exclusive events and special offers by signing up to our newsletter at www.thamesandhudson.com